AN INTRODUCTION TO COMMUNITY DANCE PRACTICE

An Introduction to Community Dance Practice

2nd edition

Edited by
DIANE AMANS

First published 2008

This edition published 2017 by
PALGRAVE

Palgrave in the UK is an imprint of Macmillan Publishers Limited,
registered in England, company number 785998, of 4 Crinan Street,
London, N1 9XW.

Palgrave® and Macmillan® are registered trademarks in the United States,
the United Kingdom, Europe and other countries.

ISBN 978–1–137–60374–6 hardback
ISBN 978–1–137–60375–3 paperback

This book is printed on paper suitable for recycling and made from fully
managed and sustained forest sources. Logging, pulping and manufacturing
processes are expected to conform to the environmental regulations of the
country of origin.

A catalogue record for this book is available from the British Library.

A catalog record for this book is available from the Library of Congress.

for Phil

Contents

List of Figures and Tables

Figures

a heady mix of self-determination and a succession of different experiences of community, which give us the feeling of belonging but without the commitment. Arguably this only works when you're feeling strong and independent, but in any case it only works if you can afford it, and many people are lonely and fearful in the city. Anyone looking at the totality of American film-making must be struck by the pre-eminence of fear as a theme: fear of nature, the dark, aliens, ghosts – 'the other' in a hundred guises. The problem is that if you make people afraid – or you make yourself afraid – sooner or later violence will follow. We need to counter fear with trust and care, and that's where dance has so much to offer.

Rudolf Laban wasn't the first person to argue that industrialisation was damaging communities, but he was probably the first dancer to use movement in groups as part of a conscious programme to counter what he saw as destructive individualism. Peter Brinson wasn't the first person to recognise the potential of dance in this respect, but he was the first to call it community dance in the context of a programme of institutionalisation which would make it a profession with its own values, philosophy, training and praxis. Today, around 30 years on from Peter's support for seminal practitioners like Fergus Early, and his founding of the training course at Laban, we can genuinely speak of the community dance profession. Still growing and developing, certainly, but a body of professional practice that is increasingly admired and emulated by dancers and policymakers worldwide.

This book is therefore timely and important. It offers a range of perspectives from some of the most experienced and thoughtful practitioners we have, and it includes practical guidance as well as insightful thinking about values and processes. Diane Amans has set out to provide an eminently useful book, and at the same time one that will stimulate debate and further thought. I have long argued that we need a rigorous debate and a common language in which to conduct it if we want to make our practice both transparent and shareable. This book makes a hugely helpful contribution, and the chapters by Diane, Sue Akroyd and Keyna Paul offer clear analysis, grounded in practice, that will be greatly helpful to students and others learning about this type of dance provision. Other writers – other voices – combine reflection and analysis, asking very important questions about process and, for example, the nature and role of performance in community dance and issues around power and learning. Helen Poynor, Heidi Wilson and Louise Katerega all look at participatory work and ask searching questions about its nature and structure, whilst Sara Houston tackles the always difficult question of just how we define and articulate the distinctiveness of community dance, at the same giving a valuable historical overview of thinking on this issue. Case studies describing work by Diane, Cecilia Macfarlane with Crossover Intergenerational Dance Company, Jabadao and Alan Martin all give interesting firsthand insight into processes and outcomes.

There are also contributions by four pre-eminent practitioners and leaders in the field. Rosemary Lee, Penny Greenland, Ken Bartlett and Adam Benjamin all offer personal perspectives which distil an enormous amount of experience and thought. These are provocative, moving and inspirational, as is their work, always.

Community dance is primarily a social activity, uniting creativity and physicality in a way that offers the experience of *communitas*, of solidarity and significance, in an immediate and grounded way. It's in that experience of belonging and being valued that human beings flourish, that we open up to learning and develop the ability to trust and be trusted. And it's on this that our survival depends, because unless we match our concern and care for individuals with a corresponding care for the natural world and for the injustices daily visited upon the poor and other minority groups we won't be living up to the values that inspire and sustain our practice.

Rosemary Lee, in her reflective and moving contribution, touches on these vital issues and asks if we 'in our small, local, unspoken way' can change the world. I think community dancers already have changed the world, and they'll continue to do so by changing individual people's experience of the world and of others, creating those magic moments in a workshop or performance that don't necessarily show us perfect community, but do give us the feeling of *what it would be like*. We all know there's so much more to do – I think this book will help inspire and equip us to do it.

Christopher Thomson
Director, Learning and Access, The Place, 2008

Foreword to the Second Edition

Snapshots

On the grass in a sunny park in Tampere, Central Finland, a group of older men are dancing with energy and sly humour. They are *Tosimiehet* ('Real Men') and the occasion is the second biennial Finnish Community Dance Festival, in 2012. The piece has been directed, as is the group, by Marjo Hämäläinen, a dancer, trained physiotherapist and, since 1999, one of Finland's leading community dance artists and founding member of Finland's Community Dance Association. The men are eventually joined by Marjo's 60+ women's dance group and together they dance with affection and a wry humour that plays gently on the rivalry between the sexes.

A second: it is Birmingham International Festival of Dance 2016 and in the festival hub, the old Municipal Bank building on Broad Street, a group of a dozen or so non-professional performers, including a number of martial art practitioners, are dancing with intense focus and control. They are moving in and through *Cells*, a stunning installation of suspended concentric steel rings, created by kinetic sculptor Shun Ito, former technical manager of Saburo Teshigawara's internationally renowned Japanese dance company KARAS. The immersive soundscape is by avant-garde band Ex-Easter Island Head, and the piece is lit by Shun and celebrated lighting designer Chahine Yavroyan. Choreographer Kei Miyata, also performing in the piece, is a former principal dancer with KARAS.

And one more: Malmö, Sweden 2016, and *Perfektion*, a dance theatre performance born of a collaboration between Skånes Dansteater and the National Theatre's Tyst Teater who specialise in work accessible to deaf and hearing-impaired audiences. Conceived and directed by Josette Bushell-Mingo, the piece, based on the play *Yerma* by Frederico García Lorca, is 'a poetic challenge to our timeless quest for the flawless'. The cast of three includes hearing-impaired dancer Hajan Jabar, and Marie Lander, a dancer who as well as being hearing-impaired has cerebral palsy. The third performer Johanna Lindh has danced for many years with the prestigious Cullberg Ballet. Since they have used Marie's movement as the

starting point for the choreography of the whole first section, for a long time it is impossible and totally unnecessary to know who, if anyone, is disabled. As Melody Putu who choreographed the piece says, 'All bodies have their own unique way of dancing. When we accept them, they become perfect.' The performance is intense and beautiful, and the diverse audience includes many recently arrived immigrants and refugees from the Middle East and who have been invited by the dynamic outreach and community team of Skånes Dansteater.

These are just brief glimpses of work I have seen and they barely hint at the extent and international reach of community dance. But in their diversity and range of reference they point to the ways in which community dance has continued to come of age over recent years, developing not only an incredible diversity of forms and structures around the world, but a new level of integration and equality with other professional practice.

The 'British model' of community dance emerged 40 years ago out of a desire to share classical, contemporary and creative dance more widely – indeed out of an insistence that everyone can dance and should have the opportunity to do so. The Finnish Community Dance Association, possibly the longest-standing outside the United Kingdom, was established in 1999 and, like community dance practice around the world, the work there built on traditions of community practice and has developed in response to the dance and wider social and cultural context of the country. Kai Lehikoinen gives a fuller account of the community dance scene in Finland in a new chapter for this edition. As to KARAS, the company's links with community dance were forged in youth dance projects pioneered by LIFT and The Place in the United Kingdom, whilst in Sweden, as elsewhere, creative artists and community practitioners have inspired one another in new and innovative collaboration spanning a wide range of contexts from audience engagement to healthcare. Across Europe, in Australia and New Zealand, Africa, India, the Americas and Canada, in China and Japan, the idea that dance is for everyone has taken root and flowered in forms that are sometimes familiar to us in the United Kingdom, but which equally often take us aback with their creativity and innovation.

This new edition of what has rightly become a standard text responds in a timely way to recent developments, new forms and current thinking. The practical advice has been updated and extended, and a new chapter explores the international dimension with examples of practice from around the globe. Several chapters, particularly those relating to professional development and career pathways, have been considerably revised to make sure they are up to date and relevant to current practice. In addition to her invaluable core material Diane Amans includes a comprehensive chapter on Project Coordination, a thought-provoking one on 'challenges and tension lines' in community dance practice, and has added new material from a 2016 interview to her conversation with Caroline Bowditch

Preface to First Edition

This book is intended for readers who are interested in the purpose and defining values of community dance together with the practicalities of delivering participatory dance projects. Although the profession is over 30 years old, and community dance work forms part of many dance artists' portfolios, we have surprisingly few reference texts for students and others who are preparing for employment in community dance. Following discussions with a group of senior practitioners, I decided to write a textbook which would focus on some of the key issues and debates, together with a set of resources for existing and emerging practitioners. It includes the kind of information and discussions that I would have found useful in my journey as a dance artist working with people in community settings.

Anyone who has ever tried to explain the rather bewildering world of community dance to students, staff from a different sector (such as health and social care) or someone who has never heard the term before will appreciate just how complex an undertaking this is. There is enough material for an encyclopaedia, never mind a textbook! The very diversity of practice is exciting, but it can seem confusing to someone who is trying to understand what community dance actually *is*. We need to be able to draw on the accumulated experience of practitioners in order to develop a theoretical framework for our profession. We already have a substantial collection of articles commissioned by the Foundation for Community Dance and published in their quarterly journal. I intend to add to this theory base and also refer the reader to other excellent sources of information.

The book contains a number of 'voices' – contributing authors are established artists, practitioners and academics who have all made significant contributions to dance. As these are a range of individuals with very different writing styles I hope this will appeal to the book's diverse readership. Some people enjoy analytical, issues-based discussion; others prefer shorter chapters with experiential accounts, case studies, interviews and examples of community projects. My own chapters have focused on a selection of core themes and practical guidance. I have also included a Resources section containing 'toolkit' materials such as session plans, risk assessment forms, music list, contact details of useful organisations and examples of policies. Exercises throughout the book will suit learners who

want to gain understanding and engage with key issues yet do not want to read lengthy texts.

As the value of participatory arts is now widely recognised, other sectors have become interested in working in partnership with dancers. We need to be able to explain what we do and how we might connect with other people's agendas. With the growth of community dance and the increasing diversity of settings in which dance artists are working, issues and challenges emerge. The more we engage in discussion and debate the better equipped we are to evaluate our work and develop a shared ownership of our extraordinary profession.

Diane Amans

Preface to Second Edition

During the nine years since the first edition was published community dance has continued to evolve and, inevitably, there have been a few changes. Some dance organisations have ceased to exist and new ones have evolved. Others have changed their name: for example in 2014 the Foundation for Community Dance became People Dancing and began a new phase of development.

In this edition I and the other contributors have revised many of the chapters and there are details of international community dance practice. The Resources section has been updated and includes more recent materials and additional resources to promote discussion and give practitioners new ideas. Hopefully these will also be of interest to tutors and mentors who work with community dance artists.

Acknowledgements

Thanks to the many people who have shared their dances, ideas, thoughts and time. In over forty years of community dance work I have met dancers and other colleagues who have delighted me with their creative energy. I can't mention you all by name but I am grateful for your generosity and friendship.

Thanks to participants and performers in Laughing Knees Dance projects and community dance students in the United Kingdom, Japan, Australia and New Zealand. Thanks to People Dancing, the Courtyard Arts Centre and Marple Movers.

Thanks to the contributors who have written chapters and the many organisations who have allowed me to include their material in the Resources section of this book; thanks to Arts Council England for funding research and development. Thanks to Sylvia Christie, Heidi Wilson, Mileva Donachie, Paula Turner, Anna Leatherdale, Kasy Wang-Lennard, Chris Stenton, Ken Bartlett and Chris Thomson, who have given valuable comments during the actual writing. Thanks to Joe and Jack Amans for the technical support and thanks to Palgrave Macmillan for advice with publishing the book.

Part I
Definitions and Contexts

Introduction

As you read through this book you will notice that several contributors deal with the question 'What is community dance? The first two chapters provide a historical perspective and include definitions and descriptions of qualities that characterise the work. The issue of whether anyone can call themselves a community dance practitioner is debated in Chapter 1 and continues to be a theme later in the book. (For example, Chapter 11 contains case studies which contribute to the debate by illustrating the very different backgrounds of four practitioners.) The questions raised in Part I are intended to provide a framework for discussion. Sometimes there are no easy answers; or there may be several answers, all of which are valid.

If you are new to community dance you may want to start with Chapter 3 to get a feel for the activities and people involved. You could then go back to look at definitions and historical contexts. If you are a dance artist who is looking for practical guidance in delivering projects you may decide to start with Part V, together with the Resources section, and return to look at issue-based discussion when you have more time for reflection.

At the end of each chapter there are some points for discussion with tutors, students and colleagues. You may prefer to discuss different questions which are more relevant to your situation. One area which does deserve consideration is the use of language. Although the early chapters deal with some definitions, I suggest that you think about other terminology and notice the ways different contributors write about their work. The word 'professional', for example, is sometimes seen as controversial when it is used as a comparison with community dance. Other terms which are often used interchangeably are 'performers', 'participants' and 'dancers'. Dance is a performance art, so participants in a dance session are performing – they are dancers. Others see participants as performers only when they are involved in some kind of event where there is an audience made up of people who are not involved in the weekly sessions.

Definitions of Community Dance

People Dancing, which is the lead body for the profession, offers the following definition:

> Community dance is about community dance artists working with people. What makes it 'community dance' as distinct from other kinds of participatory dance activity, is determined by:
>
> - The contexts in which it takes place (where, with whom and why).
> - Approaches to dance practice that are informed by a set of beliefs and philosophies.
> - The values that it embodies and promotes. (People Dancing, 2016)

On their website **People Dancing** gives further details about the range of settings where community dance takes place and the values that underpin the work. Often community dance takes place outside statutory provision such as education or professional performance contexts and financial support may be provided by grants from funding organisations.

In 2006 a survey of community dance workers produced these responses to the question 'What is community dance?' (Amans, 2006):

> Community dance is working with people using movement. Community dance can include set dance steps and free movement, it inspires and motivates. Community dance gets people moving who may not normally dance.

> Dance which mainly takes place with non-professional practitioners (though often facilitated by professional artists/teachers).

> Any dance activity, led by professional dance practitioners, which involves participants from an identified community and which is publicly funded, is community dance.

> Creating opportunities for anyone, regardless of gender, race, religion, physical or mental health, and ability, preconceptions (their own or others) or anything else, to be able to participate in a group dance experience that is positive for them.

> Community dance is about dance not being elitist ... it can be about creating pieces of work that break the stereotypes of what dance is and what dancers are, it can be about performing dance in non traditional places. It can be anything that we, the community, want it to be.

The people who produced these definitions reflect a cross-section of the profession and include lecturers and artistic directors as well as dance artists delivering projects. They were asked to attempt a definition for someone who has never

come across community dance. Compare their responses with these comments written twenty years earlier, when there was already discussion about the nature and purpose of community dance.

What *Is* Community Dance? What Is Its Purpose?

In 1984 Sarah Rubidge outlined the following aims and objectives of the 'community dance movement' (Rubidge, 1984):

- To de-mystify dance as an art form.
- To provide opportunities for as large a part of the population as possible to engage in dance activity of some sort or another, irrespective of their age, class, or cultural background.
- To reinstate dance as an integral part of the life-style of our society.

Chris Thomson's article, given at the 1988 Dance and the Child international conference at Roehampton Institute, made an important contribution to our understanding of what community dance actually is (Thomson, 1988):

> the community dance movement in the UK sees itself as offering dance to everyone in a given community, on the premise that dance is the birthright and the potential of all human beings, and that this fundamentally human activity is in our rational and logocentric culture undervalued and marginalized the experience of dance is often simply unavailable. The community dance movement… has been seen by many as having the potential to redress the balance in favour of dance, to start bringing dance back into the mainstream of our culture

In 1996 the Department of Dance Studies at Surrey University hosted a conference *Current Issues in Community Dance*. The speakers raised questions that continue to be debated.

> Twenty years on and though we have some broad agreements in community dance there are apparently almost as many philosophies as individuals involved in the work. We have not yet agreed a public account of the aesthetics and philosophy of community dance. (Peppiatt, 1997)

> Community dance has its own values, principles, methods – and it is more than education. It is also about converting the population, establishing dance colonies across the country and creating a dance empire. (Siddall, 1997)

> The definition of Community Dance is an ongoing debate because of the apparent diversity of practice in the field: how is it possible to define something that by its very essence is individual to different geographical areas, funding structures, populations and aspirations of practitioners? (Jasper, 1997)

Community Dance Qualities (What Is It About?)

As part of a Professional Code of Conduct People Dancing has included a section on Definitions and Values.

Community Dance is about:

- People enjoying dancing, expressing themselves and their life experiences creatively, learning new things, and connecting to each other, their communities and cultures.
- An equal concern for people and art: providing high quality dance experiences, and having a belief in participants that enables them to achieve high quality outcomes in which they can take pride and have a sense of achievement.
- Challenging aesthetic norms and broadening perceptions of who can dance, what dance is, and what it might be.
- Providing opportunities to explore the art of dance and to have critical engagement with their own dance and the dance of others: asking artistic questions, seeking solutions and reflecting on their dance experiences.
- Offering opportunities to gain new skills and insights: learning about dance, in dance and through dance.
- Placing people, their aspirations, rights and choices at its heart: recognising the individuality of participants and working with them in ways that support them to find their own dance 'voice'.
- Creating a 'safe' space where individuals can fulfil their human and creative potential, where they feel positive about themselves and are respected and valued by others, enabling them to grow, develop, and build positive and active relationships within their wider communities.

(People Dancing, 2016)

Who Delivers Community Dance – and What Should We Call Them?

- Are they artists, dance teachers or therapists?
- It depends on what the individual wants to be called. Definitely not therapists – although practitioners often say there is a therapeutic value in their work.
- Artists then? What's artistic about doing a session with special needs children or old people?

There are a number of terms to describe people who work in community dance. Originally the term *dance animateur* was used to identify dance practitioners who

were working in community contexts. They were usually in full- or part-time posts supported by public arts funding. Thomson (1988) pointed out that some community dance workers preferred not to be called 'animateurs' – a term which the community arts movement had been using in the 1960s:

> … interestingly it was not long before the word was seen as patronising in its assumption that communities needed 'animating' and it was dropped in favour of 'community arts worker'.

Other job titles at the time included 'dance co-ordinator', 'dance development officer', and 'dancer in residence'. Since then workers in the field have adopted a range of job titles including community dance practitioner, community dance artist, dance teacher, dance artist, dance worker, community dance leader and community dance worker. In 2006 'Community dance artist' and 'community dance practitioner' seemed to be the two most commonly used terms (Amans, 2006).

More recently, in 2015, the vacancies on the People Dancing Jobs E-news service reflect the fact that dance professionals often combine their community dance work with dance activities in other settings. In addition to adverts for community dance artists and freelance dance workshop practitioners there are

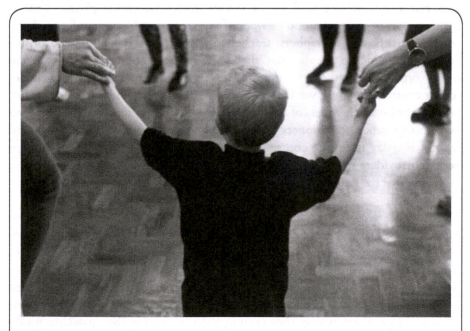

Figure 1.1 Freedom in Dance Intergenerational Project (*Linda Boyles*)

The extent to which individual practitioners are working in a way that reflects the above values is determined by their experience, training and personality together with the aims of the organisation or project in which they are working. These will vary considerably in different parts of the United Kingdom and further afield in other countries.

Discussion Points

- What are some of the difficulties involved in defining community dance? (Chapter 2 also addresses this question.)
- What term do *you* think best describes people who work in community dance – artist/teacher/community dance practitioner/or one of the other titles mentioned in this chapter?
- Look at the examples of international community dance practice in Chapter 15 and consider the extent to which these examples reflect the process-oriented values described earlier.

Note
1. In Chapter 12 Sue Akroyd and Anna Leatherdale discuss developments in recognised standards and benchmarks for community dance practice.

2 Dance in the Community
Sara Houston

Sara Houston is a dance academic who has made a significant contribution to research and debates about dance. Here she discusses some of the tensions in defining community dance and summarises theories by key contributors such as Chris Thomson, Peter Brinson, Linda Jasper and Penny Greenland. This chapter explores the values associated with the concept of 'community' and the challenges of trying to find a generic term which satisfies people involved in what we call 'community dance'.

What is 'community dance'? It is a question that I often get asked and it is easy to churn out a pat answer: 'it's participatory dance activity that's done by amateurs and often led by professionals'. Yet such a statement does not do justice to the area of work in question. It is an introductory answer that raises many more questions and leaves out much that could be included in a definition. Community dance in the United Kingdom has been a success story where structures have been embedded into institutions to support the delivery of dance to a broad section of the population, and yet still community dance commentators debate the umbrella term used to describe the work. What is it about the term, or about the dance happening, that makes it such an area of contention?

The debate ensued when it was feared that by using a separate term for community dance, the community dance movement risked being marginalised as a second-rate appendage to Professional Dance. Sue Hoyle gave an interview in *Animated* in 1994 when she was Dance Director of the Arts Council of Great Britain. Even though the movement influenced much contemporary dance and education, Hoyle maintained that it was unhelpful to segregate it. In her view, because of this influence, dance ought to be seen as an integrated 'culture' (Hoyle quoted in Ings, 1994, p. 2). More than two decades on, the fear of marginalisation is alleviated by the current interest and cross-participation by the dance profession in projects and workshops for and by members of the public. The high profile of People Dancing as a policy-forming body contributing to national

debates on dance has also encouraged cross-participation. It has given a certain legitimacy to the separate term 'community dance'.

The debate continued, however, with issues that are still current. In discussing the tensions in the definition of community dance, Linda Jasper remarked that, 'there are problems with retaining a separate title for what can be seen to be an activity that crosses many sectors' (Jasper, 1995, p. 189). In the cited article, she debated whether community dance 'should be distinguished as separate from other dance practice, or be included within all Dance fields' (Jasper, 1995, p. 181). It can be seen as an educational practice, a life-empowering formula, an artistic outlet, an enjoyable pastime, or even several of these definitions at the same time. As well as crossing these sectors, community dance also traverses many styles of dance, a variety of venues and spaces and a large demographic. A weekly North Indian Kathak class for adults in a church hall can be labelled 'community dance', just as much as a three-month project in a theatre for aspiring young ballet dancers. A one-off workshop in Street Dance on a strip of waste ground for anyone inquisitive enough is still characterised in a similar fashion to an intensive year-long course in contact improvisation for visually impaired adults. Some, such as Frank McConnell (2006), have also argued that traditional folk dance can also be regarded as community dance.

In an attempt to order such a variety of dance, Chris Thomson's categorisations (1994) have been useful. Thomson expounded the view that there were three types of community dance practice: 'alternative', 'ameliorative' and 'radical'. He describes the 'alternative' as emphasising a holistic approach incorporating the execution of the physical with therapy for the mind. In this way, the practice also links to other complementary and therapeutic services. He sees alternative community dance as seeking 'to create meaningful ritual and "boundaryless" experience' (Thomson, 1994, p. 25). It is not clear exactly what this entails and even whether a 'boundaryless' experience can happily sit alongside ritual that has strict patterns and boundaries. Nevertheless, whether the experience for participants is 'boundaryless' or not, Thomson argues that practitioners working in an alternative fashion subscribe to a holistic, therapeutic philosophy. The 'radical', in contrast, emphasises empowerment for participants to overcome discrimination or oppression. It is based around ideas on community action, with the activity often associated with social welfare provision. The 'ameliorative', promotes the participant's sense of well-being and offers a wide range of dance activity. It is often associated with recreation and leisure and as a result is, as Thomson says, 'well integrated into [the] economic and institutional order' (*ibid*). According to him, in contrast, radical community dance helps participants challenge this institutional order where it has failed them in some way.

In a conference paper published in 1995, Linda Jasper argued that the majority of community dance groups could be considered ameliorative. She suggested that this is because of a belief amongst practitioners in 'dance for all', which is

grounded in the tradition of dance as education. Jasper also pointed to another classification of community dance that involves 'community building', which is clearly distinguished by Jasper from mainstream community dance. It can be aligned with Thomson's 'radical' term. She argues that (Jasper, 1995, p. 187):

> these are distinctive working principles that seem directly to address the concept of dance as a medium for community development, and in particular the individual within the community. These working practices could not be particularly mistaken for dance in other contexts.

In the visual arts, community building is characterised by terms, such as 'socially engaged art', or 'participatory art' (Bishop, 2012). Often where the term 'participatory art' is used, it is characterised by professional artists using non-trained artists *in* their works, rather than creating or facilitating work *with* them. Socially engaged art has a broader remit and may encompass some of the ideas inherent in 'radical' community dance, which has at its basis values of collective ownership of the dance work, equality of opportunity to dance, inclusion of participants from diverse backgrounds and abilities. Community building has at its heart a belief that communities can grow through movement, which is a powerful communication tool that everyone possesses in however small a quantity.

It is principles like these that occupy the rhetoric attached to arts projects coordinating with British and European government schemes, such as the urban regeneration programme of the 1980s, 1990s and 2000s and more recently, for example, in dance and health projects, for those with chronic conditions and disease, such as Parkinson's or cancer. In connecting to social policy, François Matarasso (1998) suggests that the arts can become 'a force for development in a complex world'. Arguably, one of the reasons that community dance has developed a relatively high profile is that there has been a burgeoning of work with the socially excluded – for example, young people at risk, offenders, marginalised older people – which has been funded by channels made available through a government agenda that has made social inclusion a priority. The radical has become mainstream, as Thomson noted in 2006, and in doing so, community dance has established itself as an institution. A term that becomes institutionalised does not solve any of the debates, but it does provide a standard label that can be used to describe the area of dance. The terminology becomes useful then when it is necessary to give pointers, rather than an in-depth explanation. Thomson (2006, p. 6) writes:

> Clearly, in specific contexts we can talk about youth dance, or dance with young people at risk, or dance with older people, so we have – or can create – practice-specific terms that aren't as vague as 'community dance'. However in some situations I find I need the overarching term, not least when I am talking about the phenomenon in other countries, or to anyone who doesn't have a clue about what community dance is.

He goes on to acknowledge that the term would still need explaining, but so would any other label, which is also noted by Alysoun Tomkins (2006, p. 33):

> As I write this article I can observe people dancing and participating in dance activity in a studio at Laban [one of the UK contemporary dance conservatoires], but they are not partaking in community dance. Titles such as 'Participatory Dance' are non-specific.

Replacing 'community dance' with 'participatory dance' merely replaces one set of complications with another.

Why was – and is – the word 'community' used instead of, for example, 'participatory'? The concept of 'community' is a slippery idea that fails to sit comfortably, or quietly around any complex praxis. Perpetually challenging previous definitions of the notion, 'community' has been used as a principle upholding a particular way of acting or living by divergent commentators.

One theorist, Benedict Anderson, in his 1983 analysis of nationalism, pronounced that, 'all communities larger than primordial villages of face-to-face contact (and perhaps even these) are imagined' (Anderson, 1991, p. 6). He argued that because members of a nation do not have a face-to-face, communicative relationship with all other members, even though they consider themselves as belonging to the same community through a 'deep and horizontal comradeship' (Anderson, 1991, p. 7), the nation is an imagined community. His work is significant in that it highlights, to the people involved, the importance of inventing a community.

The sanctioning of the label 'Community Dance' as an entity in itself precipitates something imagined. As with a national identity (singular) that includes many different cultural affiliations, the community dance movement (singular) also, as noted above, contains a great variety of projects with different aims, for a wide cross-section of people. Anderson's concept is working here in the sense that with so many different types of project, the classification 'community' as a cohesive term seems too limited. There is no one community that binds diverse dance projects together.

Dance as an activity links the groups, but the difference in the movement forms, aesthetics and specific aims could seem to give the umbrella term 'dance' an opacity that sits uneasily with the defining adjective of community. One collective characterisation of community dance is the fact that projects are designed for the amateur, rather than for the professional dancer. Yet why title it *community* dance? Why should the term mean 'for those who do not do this for a living'? Is this what is meant by a community? Do all amateurs – whatever their aims and intentions – form a unified group to the exclusion of professional dancers? In fact, as noted above, the dance profession plays an important role in the sector. So with the above discussion borne in mind, it is possible to

see why the label 'community dance' cannot be thought of as a singular defining entity unless it is taken as imagined.

But there is another way of looking at the word 'community', which has to do with values, rather than material descriptions. It is more than one hundred years since the German sociologist Ferdinand Tönnies (1963[1887]) published his ideas on 'community' and 'society'. According to him, nineteenth-century industrialisation forced the decline of the community. One hundred years later, it was again a common theme amongst academics, politicians and other social commentators. Post-modern philosophers such as Frederick Jameson (1991) and Communitarians such as the philosopher Charles Taylor (1992), have decried the fast-paced, superficiality of modern life. Communities are being devoured by an encroaching alienation, spawned by versions of the modern, consumer society (Featherstone, 1995). Politicians worldwide on both the left and right have preached for the return of a sense of community, either through a nostalgic vision of shared traditions, or through an emphasis on civic responsibility. Some religious organisations have also called for the reintegration of a value system into the core of Western secular life to reignite feelings of community and to counteract alienation and radicalisation. The threat of terrorism that occupies many governments can be seen as part of the need to cement community relations.

Theorists and advocacy groups have had diverse attitudes as to why a sense of community has been lost, what should be done about it and what it exactly means in the first place. There are also views (Nancy, 1993; Cavarero, 1997) that not only support the notion of community as being relevant to present-day society, but also hold that a sense of community can still be found in many situations and will always be there. It is not a question of it being 'lost' as much as being created or people being ready to experience it. These views hold that active participants are the keys to establishing a sense of community.

Following this thread, Peter Brinson argued that community arts created communication between people through collective creativity (Brinson, 1991, p. 130). Tomkins reminds us that the origin of the word 'community' comes from the Latin to give amongst each other (Tomkins, 2006, p. 31). The idea behind the term 'community dance' is not to signify geographical allegiances (although it might), but to alert us to its guiding principles nurtured within an activity that brings people together to work in reciprocity. Not all projects will engender long-term, harmonious relationships or deep social bonding, but fundamentally dance is a practice that requires cooperation and communication, a sharing of physicality and mental agility that may precipitate creative energy and communal feeling in the moment of the dance.

The word 'community' might not translate in the same way in other languages (Ames, 2006), but the notion behind the dancing transcends semantics. Those projects that uphold the ideal that dance is about a communion amongst

participants are buying into the notion espoused by the community dance movement. Even though some groups may not outwardly engage with the idea, the values maintained by community dance practitioners within their work signify an attachment to the notion behind the term in question. As long as there is identification with the ideals for which community dance stands, then arguably the term 'community dance' is a valid one.

Discussion Points

- Do you think there are any problems in seeing community dance as something distinct from other dance practice?
- Sara Houston mentions 'the ideals for which community dance stand'.
 - What do you think she means by this?

3 Community Voices
Diane Amans

Taking part in dance activity can be a powerful and life-enhancing experience. In this chapter people tell their very different stories about what dance means to them. In addition to participants from a range of community dance projects there are the voices of artists and other community workers involved in projects.

Dancing Nation – Young Performers

In 2000 the Foundation for Community Dance (now People Dancing) commissioned a film to show examples of some of the dance activities taking place in community settings. Amayra and Simon were two of the young people featured in the *Dancing Nation* film. Many years later their experiences are still reflected in participatory dance projects.

Amayra

Amayra is a young woman who has been dancing since she was ten years old. She combines street and African dance and performed with a group called DC (Dance Creators).

> We've become known around the area as the young black kids performing – people want to know what we're getting up to. We express old 'African' and new 'street' – something our younger and older audiences relate to. We perform to parents and grandparents, generations who didn't get to dance, to celebrate the way that they would wish to. Our generation has now got that chance.

> I love to perform, I like what the audience can give me… if I do something right I know by their reaction. If they're feeling it, I'm definitely feeling it. Movement is motion, emotion – if we're feeling it, it comes across stronger when we're performing. (FCD, 2001, p. 40)

Simon

Simon was a member of a break dance group in Warrington. He was 15 at the time of this interview and had been dancing with 'Street Beat' for 18 months.

> What would I be like if I didn't dance? I'd probably be a bad boy. I'd probably be on the streets doing things, getting into trouble, stuff like that. Dance changes me – it takes the aggression off the street, diverts it into dancing, onto the dance floor. Inside me is a fire – when I'm dancing it's let out. It's another side of me if you know what I mean. (FCD, 2001, p. 16)

Stride

More recently some young men in Greater Manchester expressed similar feelings about taking part in dance projects

> If it wasn't for STRIDE¹ I wouldn't be the boy I am
> Now... STRIDE has helped me to keep away from trouble.

> I dance for a lot of reasons... I dance to take my mind off things if I'm annoyed or had a bad day... I'll put my headphones on and I'll just dance.

> STRIDE helps you to come out of your shell and get involved with everything. So it's made me feel good in myself.

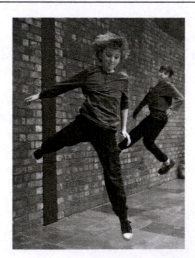

Figure 3.1 Dance Manchester STRIDE 2015 (*Brian Slater*)

Impact on Adult Performers

The experience of dancing in front of an audience is both exhilarating and terrifying for some community performers.

Sylvia

Sylvia is a woman in her 70s who had been dancing with a local community group for six months when she took part in a performance project. Here she describes how she felt in the early stages of the project.

> The second weekend, doubts didn't just creep in, they burst, screaming, into my brain. You can't do it, they yelled. You're too old, too fat, too stupid, too inhibited. You'll let them all down. I was seriously worried about my own brain – my memory was letting me down left right and centre. I bought some gingko biloba, but you can't expect miracles. Surely I should be able to remember a sequence of actions? I can remember poems, quotations, shopping lists, names of plants – why did I find myself dithering about wondering what the hell to do next? It felt like senility was waiting in the wings to grab me. I hated the idea of going on and letting the group down; I also hated the idea of giving up and giving in to old age and lack of confidence.

Six weeks later Sylvia performed at the Lowry in Manchester, as part of a community dance showcase.

> An extraordinary thing happens on a real stage, in a real performance. A huge euphoria grips you; you find yourself grinning insanely in the direction of the audience – look at me! Look at me! – and you find, for the first time that day, that you know what to do, when and where to do it, and look like you're having the time of your life.

> Which you are, actually. I wouldn't have missed it for the world. (Christie, 2005)

Chrissie

Chrissie is an active retired woman who had been dancing with Amici Dance Theatre for 20 years when she took part in the *Dancing Nation* film.

> Performing to an audience is quite heady, 'champagne like'. And that feeling – that heady feeling – comes from the audience. If you're enjoying the production and you know the audience is enjoying it, you feel as if your feet are just an inch above the stage ... it's like an aircraft taking off – you lift into the air – take off. But the excitement of dancing doesn't only take place on the stage in front of an audience, it takes place in our ordinary sessions, every Wednesday, when we perform or improvise – the music speaks to your soul

Feedback from Support Staff

Jean

Jean is a special needs teacher who acted as support worker on a dance project involving adults with learning disabilities. She was surprised at the amount of time the dance artist allowed for responses and said it was the first time she had seen a real person-centred approach.

> It's not simply about getting through the exercise/activity but about offering it and observing/working with/assessing the response, if any. This enables the practitioner/facilitator to give a measured and individual response to the participant. It also allows you to assess, over a period of time, some notion of development and sense of enjoyment. I'm thinking of Ricky and the feather blowing exercise and how giving him his own time to do things enabled both his own and the group's enjoyment at his response. (Amans, 2003)

Lorraine

Lorraine is an activity leader at a care home in Herefordshire. She also commented on the person-centred approach of the dance artist.

> Dance means David can join in with an activity instead of having to sit and watch. We have many great exercise activities in the care home but not everyone can join in because of their limited mobility.
>
> However, Dance Magic Dance[2] has allowed others to join in as it is not prescriptive. The dance lady, Faye, does not even talk throughout the session – she engages everyone using her facial expressions and gestures. The slight movements that some of the residents are able to contribute are valued. I know that they are valued because often Faye will spend time copying someone's movements making them feel special. Many of the residents said at the start of the project 'I can't dance' but they have all joined in in some way or another. Dancing really has brought magic to the care home.

Case Studies

So far the 'community voices' have revealed different ways in which dance has impacted on a range of individuals. The following case studies give a more detailed account of some community dance projects and include:

- Crossover Intergenerational Dance Company.
- Creative Dance with Older People.

- Integrated Dance.
- Dance with School Children.

Case Study 1: Intergenerational Dance
Cecilia Macfarlane

Cecilia Macfarlane is an independent dance artist with a national and international reputation for her work as a dancer in the community. She created Crossover Intergenerational Dance Company in 2003. Here she describes her work and includes quotes by members of the audience who watched performances of 'Dragon's Tale', one of the company's early pieces.

Crossover Intergenerational Dance Company is the result of a natural evolution in a dance journey. Since coming to Oxford in 1986 as an independent dance artist, my work in the community has evolved very organically. I started two creative contemporary dance classes for children and this led to the creation of Oxford Youth Dance, which offers children and young people of all ages the opportunity to create and perform their own work with direction from professional dance artists. We celebrated our 30th birthday in 2016.

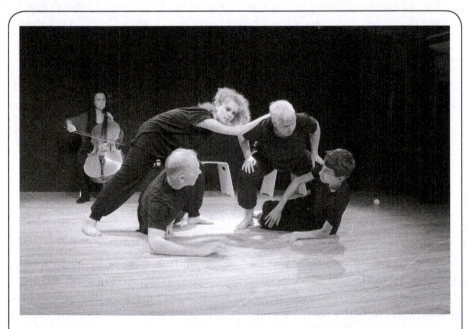

Figure 3.2 Taut: Crossover Dance Company (*Stu Allsopp*)

In 1992 DugOut Adult Community Dance Company was formed, offering parents and other adults the opportunity to discover and celebrate the dancer in them. This led naturally to projects in which parents and their children could dance together. In 1997–98 I created and directed 'That's What Parents Were Created For' – two projects for fathers and their sons and mothers and their daughters, performed at Pegasus Theatre and at the Richard Attenborough Centre in Leicester. This, I realise, was the beginning of my intergenerational work, although without the label I had of course been working this way for much longer. Parents danced with their under 5's in weekly classes and Dug Out, with ages from mid-twenties to mid-eighties and above, was naturally intergenerational.

Crossover has allowed me to work both as a dancer and as a director with a small group of dancers of widely different ages for a significant and regular amount of time. We started with eight dancers, four female, four male, aged between 7 and 66.

I wanted to look at the stereotyping that goes with specific ages and particularly research the movement that can accompany these conventions. I wanted to explore the diverse ways in which we think, feel, and move at different ages and the similarities that we share and to challenge the familiar stereotypes that surround my art form.

> I saw Crossover alongside two other dance performances. I haven't seen live dance before … and of the other two performances I would say they were kind of what I expected – athletic young people doing interesting energetic things with their bodies. Whilst I enjoyed those performances I wasn't especially moved and wouldn't rush back to see dance of that type. With Crossover however, the interest/energy was still there, but not just of the youthful athletic type – the nature of the troupe meant that the expression seemed far more expansive – due to the fact that your troupe contains people of a variety of ages and different abilities. It made the other performances seem limited – as if they were musical instruments with fewer notes available, whereas Crossover expresses a more diverse range of humanity and human experience. I found that very beautiful, real and inspiring. There must be so much more you can do with such a lovely set of notes like that!

Crossover aims to offer dance performances and workshops by and for intergenerational audiences aged 0–100 that are physically demanding, artistically challenging, socially inclusive and fun. We promote the idea that people of all generations can find a common language through dance. This common language is not only accessed by the people involved in the making of work but by the audiences that come to see that work.

I don't find dance easy to get close to – shape and movement doesn't necessarily work for me – but with Crossover's performance I really didn't want it to end; it spoke to me and had such resonance. It spoke to me of working together, of finding areas that are of common interest and making things collectively and how there is so much strength and joy in this; this is important and vital to us as human beings.

Dragon's Tale

Dragon's Tale was the third substantial piece that the company made. It explores the history and heritage of fairgrounds: from the afternoon merry-go-rounds enjoyed by toddlers and grandparents to the edgy techno beat of the late night twisters and dodgems, the piece looks at how the different generations can occupy the same public space alongside each other and find their own way of playing. It was performed first at Warwick Arts Centre to an audience of one thousand 7- and 8-year-olds and their teachers and then was next performed at Oxford Playhouse. This event included not only the eight company dancers but also two hundred dancers aged from 2 to 86 to celebrate how different generations can come closer through dance. These two hundred dancers truly embodied the notion of community as they represented the history of my work in Oxford, spanning generations and families, some of whom had been dancing with me for 21 years.

For the next stage of *Dragon's Tale* we toured rural Oxfordshire to include local communities and give them an opportunity to dance in this piece.

'I found the whole evening truly inspiring … Your wonderful piece showed how neither age nor disability is a barrier to creating and performing an interesting and thought provoking and well balanced piece. I say balanced because everyone was able to show their true talents and for those talents to be used sensitively without patronising.' Although I created Crossover originally as a research tool for my work as an artist and had thought that it would be an 18 month event, it went on in its original form for many more years with the younger dancers being replaced by even younger dancers as the 'children' grew up. More recently we are now renamed as Crossover Intergenerational Dance Projects. This moves us from the original tighter research format to something much more flexible and changeable. Sometimes we are only four dancers and more often much bigger casts coming together for specific projects. Our latest piece 'The Flight of the King Bee' was created with a cast of 37 dancers aged between 6yrs and 78yrs to celebrate OYD's 30th birthday and performed in Pegasus Theatre, Oxford 2016.

I realised quite early on in my career that, as an artist in the community, I don't work in a vacuum. It isn't just about giving, it's also about receiving and

with Crossover it is a perfect balance. It's an opportunity to create and be creative in an environment that is totally committed to the task of dance exploration and therefore, importantly, continually feeds my practice as a dancer.

Case Study 2: Creative Dance with Older People
Diane Amans

This pilot project was my first experience of leading dance sessions with older people. It took place in Stockport over a period of six weeks. Participants met twice a week for a two-hour session which included afternoon tea. The aims of the project were to explore themes of interest to participants using movement, music and words. Additional aims were to promote mobility, confidence and creative expression.

I had funding to do a pilot project with older people and a perfect venue in our local theatre. It was an exciting opportunity to work with other artists and offer something different to the senior adults in my community, but initially I found it really difficult to recruit participants. I went to speak to residents in some of the local care homes, but they were not very enthusiastic:

> You don't know what it's like at our age – you get too tired to do things. What do you mean, creative movement?

I was sure I could devise activities that they would enjoy if only I could persuade them to join me. In the end I stopped mentioning dance and invited people to join me for free afternoon tea with home-made cakes. That seemed to work – I soon had a group who liked the idea of an afternoon outing with a free taxi ride.

After the refreshments we sat in a circle and introduced ourselves. I was joined by a writer and two other dancers who acted as support workers. There were 10 participants, aged from 69 to 86 years; some people lived in residential homes and others lived independently in the community. They were all mobile but several used walking aids and were not able to walk very far.

I explained that we would like them to join us in a creative project and they agreed to take part – with the understanding that they did not need to return next week if they did not enjoy it. After some gentle breathing exercises and name games I led seated warm-up activities and then some standing exercises using the chair for support. They soon seemed more relaxed and enjoyed a tango dance with their hands.

I introduced creative work by mirroring in pairs and by the end of the session they were all keen to come back. It soon became clear that they were very interested in learning how they could increase their mobility and were eager to talk about how the dance sessions were benefiting them.

Doris: This dance work – it's given me the confidence to go upstairs without using the lift. I've surprised the staff.

Edie: I felt 'down' when I came but it's made me feel better.

Hilda: I'm starting to use my hands again – writing and tying my shoelaces. I haven't done that since my stroke. It's these exercises and the movement. Coming here and seeing the others dancing – it motivates you.

The participants attributed their sense of well-being to the warm-up exercises but I observed that it was the creative dance which seemed to really motivate people. Taking part in stimulating and unusual activities increased the range of movement and encouraged interaction between members of the group. We used different props such as light floaty scarves, balloons, fans and masks. We also experimented with body shapes and balanced on each other with chairs for additional support.

In one session I wanted to help participants experience a greater range of movement and feel strength in their bodies. I had noticed that many of their dances were rather tentative and I wondered how they would respond to different qualities of movement. In the warm-up they enjoyed stamping and pushing and we developed this into a seated contact improvisation. Participants sat in a circle facing outwards and the dance artists moved from one to another, making hand contact with members of the group who pushed us away. Even a gentle push acted as an impulse for a dynamic lively response from a dancer. Participants smiled and leaned forward in their chairs, anticipating the next contact. They really seemed to come alive in this session and we could feel a greater energy in the group.

One particularly successful feature of this project was the collaboration with a writer. Sylvia made notes and created poems based on observations and comments she overheard. One afternoon we used natural objects as a starting point for discussion and movement. Participants were invited to choose something and describe it with their hands. Jessie focussed on a blue shell – her hands following its spirals and curves. She became totally absorbed in her dance whilst Doris and George moved their hands along the twisted convoluted shapes formed by the willow twigs they held.

At first Mary was reluctant to join in this activity. When we invited her to look at the willow twigs she shrank back in disgust, saying they looked like worms. 'No thank you' she said when offered a piece of driftwood. Later Kath, one of the dance artists, brought the driftwood back and encouraged Mary to touch it. They talked about where the wood might have come from – what kind of tree, what kind of weather it had experienced.

Mary said 'I would never have thought of this – never have looked at a piece of wood. I would have thrown it away'. As she left that day Mary raised her arm

in a farewell salute and said 'Thank you... I will look... I will look'. Mary often found communication difficult, but Sylvia incorporated her words into a poem and Mary was delighted.

> Looking
> I would never have thought
> An old, dead piece of wood
> Had something to give me.
>
> I would never have thought of this
> This touching ... feeling ...
> I would never have felt its velvet skin
> Never have touched its rough heart.
>
> I would have thrown it away, unvalued
> But now I have imagined
> the tree it came from,
> the wind that swayed it,
> the sky it reached for.
>
> Now I will look at other things –
> Unvalued
> I will look, I will look
> I will turn my hand to something new

The optimism expressed in this poem captured the atmosphere of this group.

Although the project lasted only six weeks it definitely had an impact on the confidence of participants. It also had a powerful impact on the artists involved. Each week there was something to surprise and delight us. A 'special moment' we will all remember is when Jessie told the group she'd been into town to have her ears pierced. 'It's the first time since my stroke that I've felt able to go out and cross the road on my own. Doing this dance – it's made my legs stronger. I've always wanted my ears pierced and look – I've had it done!'.

Case Study 3: Inclusive Dance Workshops
Alan Martin

The late Alan Martin, a former student at LIPA (Liverpool Institute of Performing Arts) was a dance practitioner who led workshops for disabled and non-disabled people. He used an electronic voice communication aid and adapted activities for participants in a wide range of settings. Here he describes what dance meant for him.

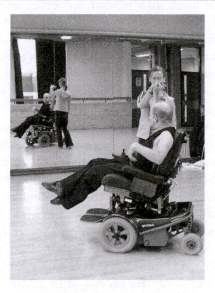

Figure 3.3 Alan Martin (*Frank Newman*)

Until I was about 32, the only thing I did that you could loosely call 'dance' was after several pints in the pub during karaoke sessions. I really enjoyed this, but mainly because of the company and the alcohol. I thought that the idea of *me* dancing was completely crazy until I attended a short dance course run by Can-doCo in Liverpool (just for a laugh!) and they showed me a little of what creative dance was all about, and that absolutely anybody who has a pulse can join in dancing.

I'd thought that a person like me, with seriously restricted control over my movements, and a wheelchair user, would never be able to do what I now do, which is to earn my living from giving inclusive creative dance workshops and performances to all sorts and ages of people, all around the country.

In the 12 years since I first 'saw the light', I have joined many community dance organisations, attended as many workshops as possible to build my skills and knowledge, learned workshop leadership skills at LIPA in Liverpool, worked to share my enthusiasm voluntarily for several years, and now I have my own thriving business. My work is much in demand, and I'm delighted at my success.

Dance, to me, is a great means of communicating feelings and emotion. This is significant in my case, as I have no natural speech and use an electronic speech aid to communicate and lead my workshops. I believe that I'm the only dance workshop leader (in this country at least) who uses an electronic speech aid and also an electric wheelchair.

Dance is so much more than just an art, or an exercise. It's a means of self-expression and a statement about myself. It says, 'Here I am, look at me, value my physical difference, and appreciate what I am doing'.

It says that I'm confident in my body, and have lots to teach you about valuing people who are 'different'. I'm proud of myself, but not in a conceited way. I just want to show everyone the joy and benefits of creative dance, and teach people how to make dance fully inclusive.

Inclusion, to me, means planning sessions so that all the activities can be adapted to fit any ability, not, as is still often the case, making sessions for non-disabled dancers and tagging on accessible bits to fit the rather embarrassing presence of a disabled dancer. Sadly, inaccessible studios and performance spaces and discrimination are still the norm in dance – even in community dance settings. A few years ago, on approaching a local dance group, I was told that I wouldn't be able to keep up and do the right steps, and basically to 'forget it, and get lost'. It's very satisfying to now be entering my school groups in dance festivals, and showing the 'mainstream' dance world just what people with disabilities can accomplish.

Here is an account of a two-day project with children in a special school in Haslingden, East Lancashire. As with most of my work in schools, many unexpected challenges cropped up and had to be worked around. Getting up at 5 a.m. to travel there was a difficult start for me and finding the school was not easy. The room we had to work in (although mostly an uninterrupted space) was small, and looked even smaller when five pupils arrived in wheelchairs, one on a bed, one in a frame and eight walking. They were accompanied by several members of staff.

We began with introductions; pupils quickly accepted that I communicated with an electronic speech aid, and a couple of my class also did. It was not an issue.

Who needs to tell me anything about themselves? Is everyone OK with being touched? Let's warm up our imaginations first. Let's see who can do what with this Liverpool Football Club scarf! *Was that the fire alarm?* Everyone went outside for an hour, whilst this was sorted out. Quick rethink about warm-ups.

Back inside, after the break (everyone took the interruption in their stride).

Let's start warming up our bodies now! We began warming up, first everyone copying my moves, soon progressing to the pupils leading, with their own moves. We could have carried on with this all day. Barriers fell; confidence grew; communication with movement developed and leaders were emerging. Everyone was happy and excited as there was a performance next day to think about. Not much space to do moving around the room exercises, so find a friend to work with, and stay in the same place! Learn to focus on your friend's movements and pretend you are looking in a mirror. Change the leader when I shout 'change'. Stop now. Show us all what you've been doing, one pair at a time. This gave most of the group a short rest, whilst they watched the others.

Soon it was lunchtime and I enjoyed a smashing school dinner. We were just starting the afternoon session when the press arrived wanting to get pictures of our performance. Children were taken outdoors and pictured in artificial poses – again and again. Back inside and warm up again. See how many hands you can shake in one minute!

Let's get on with choosing a theme for our dance. (Thank goodness they chose 'under the sea' – a subject I had ample props and music for.)

What's under the sea? Frogs? Well, possibly! Mermaids, sea horses, whales, jellyfish, crabs, dolphins. We all chose a creature to make a dance about. What a lot of different ways those beasts get around! Let's show the rest of the group how you each move. Soon we had many moving creatures. What else? Seaweed. Flowers? Well, perhaps. Water, pebbles, gravel, sand. What sounds do those make? A performance was coming together. How can we show the water, waves etc.? As luck would have it, I had a long piece of sparkly blue fabric in the van.

There were too many bodies to develop this dance in the space we had (tomorrow we would perform in the big school hall). For the time being, a small group chose to work in a side room with one of my assistants. They created sea sounds by moving in the Soundbeam[3] – this is an excellent device which can produce sounds of all sorts from even the tiniest movements. One of my better investments! The end of the school day came too soon, and the children went home full of ideas about how animals under the sea move and sound, and how the waves perform. Next morning (another 5 a.m. get up!) we started promptly. No fire alarm, but, even more interesting, a team of inspectors arrived who 'had to see what we up to'. They almost joined in the dancing – if I'd had longer, I could really have done something with them! The morning flew, with costume fittings, trying out the music (my own composition), practices and so on. Then another photographer arrived – different newspaper. Who can be photographed? Who cannot? I suppose publicity is great, but it takes up too much 'dancing time'.

After the dining hall had been cleared of tables and chairs we had half an hour to set up. No time for a rehearsal – but then again, the audience don't know what it's supposed to look like. Go and have 5 minutes break, then we're on!

The whole school assembled, some showing interest in the 'funny bloke in the wheelchair, with the voice box'. We were ready, so I gave a quick introduction and backed into the audience space, from where I was able to conduct the dance without the rest of the audience realising what I was doing.

The magic of live performance happened, and it went better than perfectly. Pupils who had little movement during practice found hidden reserves and amazed everyone. Nobody knew that the frog was not meant to stay in front when the dolphin was dancing.

Case Study 4: Dance with School Children
Paula Turner

Paula Turner is a freelance dance artist who works with a range of different community groups. Paula has been the dance artist at Marine Park Primary School since 2005. Dance is seen by the head teacher, Alison Burden (a passionate enthusiast for the arts), as physical learning and an absolutely crucial part of each child's experience of school.

There is not a separation from normal school curriculum when I work with the children because all learning takes place in the body – how can it not? We do not therefore trot off to the gym or hall, changing our clothes to 'do dance'. Quite often my practice is within the classroom and centres on how we understand ourselves. How do we pay attention to our minds and bodies, who and what are we right now? In this way I hope to embed in the children a deep respect for the information they can access through their bodies.

How I work with children is basically the same as the way in which I work with all groups and I continue to be curious about how I negotiate this process; less of a leader more of a 'suggester' – or as the children might say a Jester! All my work is underpinned by the invitation to be playfully mindful about when and how we move and this not being seen as a rarefied thing that requires you to have special clothes, special dance shoes and a special room. Dance can happen anytime, even right now – if you choose to let it.

Figure 3.4 Paula Turner (*Frances Anderson*)

One of the most rewarding aspects of my dance practice at Marine Park School has been the children's participation in several residencies in local care homes. The atmosphere of sheer delight and enjoyment affected everyone who got involved: dancing together became part of everyone's expectation – as normal as having a cup of tea.

The Intergenerational work with Grand Gestures Dance Collective and children from Marine Park has included dancing and being in the landscape: jumping in puddles, watching the particularities of puffins and racing waves as they crashed over harbour walls. We saluted the sun, danced like the starlings and made drawings of our physical experiences with sea coal and sandstone. We watched and absorbed the movements of marsh harriers, starling murmurations and short-eared owls, but above all we shared experiences which will enliven and enrich all our futures. The work seeks to celebrate landscapes both personal and physical and is above all about a sense of embodied belonging.

My practice is always developing and am really enjoying being very involved in the process of wondering about what this thing we call dance is – how it's perceived and how I can make this offer as inclusive and as meaningful to everyone as I possibly can.

Conclusion

This chapter included a diverse range of 'community voices' – people of different ages and backgrounds who have shared some very positive experiences. Their stories illustrate the wide-ranging impacts of being involved in community dance activities, from the point of view of participants, facilitators and dance artists. Although projects take place in many different contexts, participant reactions reveal a remarkable unanimity in the beneficial results experienced.

Discussion Points

- Consider the comments by participants in these dance projects and look at People Dancing's community dance qualities outlined in Chapter 1. To what extent do you think the projects described in this chapter have these qualities?
- In Case Study 1 Cecilia Macfarlane mentions stereotypes associated with different age groups and stereotypes surrounding dance as an art form. What are these stereotypes and how can dance artists challenge them?

- In the project described in Case Study 2 there were initial difficulties in recruiting people to join a dance group for senior adults. Why might older people be reluctant to take part in such a project? What can dance artists do to encourage participation?
- Case Study 3 gives us the flavour of an inclusive workshop run by Alan Martin. He plans sessions 'so that all the activities can be adapted to fit any ability'. Think of three dance activities with which you are familiar (they might be warm-up exercises, a set dance or a creative dance task). How would you adapt the activities to suit the needs of *either* a 10-year-old child who uses a wheelchair (manual) and has a moderate learning disability and autism *or* an adult who has done little exercise for 30 years and cannot see?

Notes

1. Comments from film https://www.youtube.com/watch?v=ScN-Uqzvv6A accessed 2 June 2016. See Chapter 14 for more information about STRIDE, which is a dance project for young men in Greater Manchester.
2. Dance Magic Dance is part of the Creative Ageing project run by the Courtyard Arts Centre, Hereford.
3. Soundbeam is an electronic device which converts body movement into sound and images.

Part II
Issues and Challenges

Introduction

The introductory chapters looked at the defining values of community dance and drew attention to some of the many issues and challenges experienced by those of us who have chosen to work in this profession. This next section includes critical reflection in the areas of diversity, inclusive practice, power relationships and duty of care. To begin with, Ken Bartlett invites us to 'love difference' and his chapter outlines the differences that he believes we need to value and support. He is also particularly keen that dance artists are able to understand what people have in common when they are involved in dance – as participants, observers and makers of dance. 'Finding common humanity' is how Ken describes it. Whilst Chapter 4 is a fairly brief look at diversity it does include a number of key themes which are referred to in other chapters: if you are interested in how community dance values are nurtured in our emerging practitioners, you will find Sue Akroyd's perspective very interesting (see Chapter 12). The question of diverse aesthetics comes up time and time again, particularly in Part III, which deals with community performance.

Another challenge for dance artists working on participatory projects relates to 'inclusive practice'. In Chapter 1, I argue that 'inclusive practice' is one of the process-oriented values that characterise community dance. It means encouraging people to engage in dance and being flexible enough to accommodate their different ranges of needs. So, should community dance projects be open to all comers? Do we need general practitioners who can make dances with any diverse group of people? Actually, I think we probably do. If you're not sure about whether community dance projects should be open to anyone and everyone, ask yourself what would be a reason for excluding people? Sometimes it is appropriate to have a closed group because of the context of the work (an after-school club or a project in the criminal justice system for example), or because the funding specifies work with a particular section of the community. Whatever the context of your work

you need to have thought through, beforehand, who the participants will be and what you need to do to engage them in a positive dance experience.

Louise Katerega's chapter deals with inclusive practice and some challenges presented by power relationships in an integrated project. Louise worked as executive assistant to Tom St Louis, who is a disabled dance artist. She describes her role as staying in background whilst supporting Tom, who acted as artistic director and choreographer. I find it fascinating to read about how Tom managed the support staff in this project. He is clear about defining roles, and his ground rules for support staff highlight awareness of the need for these staff to experience the workshops as dancers (rather than carers) so that they have a better awareness of how they might best support disabled dancers. In the Resources section you will find an interview with Caroline Bowditch, who makes some interesting observations about inclusive practice and her own approach as a disabled artist leading dance sessions.

In Chapter 6, Penny Greenland argues for community dance practitioners to have an understanding of duty of care measures so they can create 'shared standards'. This is about having a responsibility to take 'reasonable care' to protect

Figure PII.1 Freedom in Dance Intergenerational Project (*Matthew Priestley*)

people from risk of harm. Few would argue with this, but when it comes to defining 'reasonable care' there are some contentious areas. One of these is the practice of filling in health questionnaires – part of the duty of care procedures in many dance agencies. What do you do if participants refuse to complete them? How do you keep people safe if you have no information about their health background? On the other hand, individuals have a right to privacy and may have good reason to be suspicious of yet another form-filling exercise.

There are no easy solutions. I do find health questionnaires useful – I have included an example of one of mine in the Resources section. However, they are only one small part of 'reasonable care' and there are times when it is neither appropriate nor practical to use them – when working with people who do not read, for example, or vulnerable people who do not have an understanding of their own health status. Also, in one-off 'drop in' sessions it may make sense to just make sure the activities are low impact and that people are reminded to take a rest when they need to. As dance artists working on community projects we need to be flexible and imaginative in order to exercise our duty of care to others and to ourselves.

As you read through Penny's chapter I encourage you to try and answer her quiz questions and discuss them with other people. Make a note of any areas where you are unsure or feel you don't have the knowledge or experience to answer the question.

Further Reading

Arts Council England (2005) *Keeping Arts Safe: Guidance for Artists and Arts Organisations on Safeguarding Children, Young People and Vulnerable Adults*. Arts Council England, London.

Greenland, P. (2000) *Hopping Home Backwards: Body Intelligence and Movement Play*. JABADAO, Leeds.

Jasper, L. and Siddall, J. (1999) *Managing Dance: Current Issues and Future Strategies*. Northcote House, Horndon.

Juhan, D. (2003) *Job's Body: A Handbook for Body Work*. Station Hill, Barrytown.

Thompson, N. (2003) *Promoting Equality – Challenging Discrimination and Oppression*. Palgrave Macmillan, Basingstoke.

Todd, M. (1997) *The Thinking Body*. Dance Books, London.

Quin, E., Rafferty, S. and Tomlinson, C. (2015) *Safe Dance Practice*. Human Kinetics, Champaign, IL.

4 Love Difference: Why is Diversity Important in Community Dance?

Ken Bartlett

Ken Bartlett was formerly the Creative Director of the Foundation for Community Dance. In this chapter he discusses the importance of recognising and valuing our differences whilst also seeing what we have in common. As community practitioners we have significant opportunities for contributing to an inclusive culture in dance – this chapter sets out some of the reasons to 'love difference'.

Community dance practice over the past thirty years has built up a tradition of being excited by the possibilities offered by different people and different dance traditions. Community dance artists have sought to extend access to and participation in dance to the widest range of people in their communities and have also chosen specific identifiable groups within those communities with whom to work. They have taken on the challenges set out by successive governments to demonstrate the value of the arts, and dance in particular, in the fields of health, education, disability, social exclusion, youth, aging and criminal justice. And there is now a growing body of evidence to demonstrate that being involved in community dance activities does contribute positively to people's lives, individually and collectively.

The United Kingdom is one of the most ethnically and culturally diverse nations in the modern world. Immigration has been part of how our nation has developed for centuries and has happened for a range of reasons – escaping oppression and fear, and seeking better economic opportunities being key features.

Community dance as a body of practice has, as it has developed, sought to make links with people not usually closely engaged with mainstream arts practice – young people, older people, disabled people, culturally diverse people

and people with low incomes. In addition, community dance artists have actively sought to engage with services and agencies where they think dance has a positive contribution to make – the health service, the criminal justice system and education.

Community dance artists demonstrate a range of purposes in their work – teaching the skills of specific dances, developing people as artists, introducing people to specific dance genres, promoting creativity, promoting self-worth and self-confidence and promoting social inclusion and social cohesion.

However, underpinning these different purposes, a set of values has developed which distinguish community dance from those dance experiences based on more straightforward curricula. These include a belief that everybody can dance with intention and purpose; that we build on what people bring to the engagement – personality, individual body signature, previous experience, personal expectations and aspirations, family and cultural background; and the importance of the individual within and as part of the group, of personal and social development alongside artistic development, of the arts process from creative experiment to effective performance, and the necessity of including everyone, whatever their difference. We build on what people *can* do, rather than what they can't achieve.

There is also a multitude of dancing communities across the United Kingdom that are based on historical associations with places and cultures and on particular styles of dance that appear in different contexts and at different times – some of which are based on sophisticated and developed rule systems, whilst others emerge apparently spontaneously from within wider popular culture, seemingly without rules or regulation. With each of these dancing communities there are diverse audiences who seek out the dance and dancers with whom they identify and in which they see themselves appear.

If we accept that everybody can dance and that we can apply the underpinning principles and values of effective community dance to any dance style or any culturally inspired dance tradition, we also have to accept that there are diverse aesthetics at work in dance that are not based on the Western European tradition of how the dance looks but on how it feels.

Working within the frame of 'world dance' – to borrow a term from popular music – challenges us to think of different ways of transmitting or teaching dances based on approaches which recognise that, culturally, dances have different origins, meanings and modes of transmission. 'Western dance forms share a commitment to the role of the gifted who have a special talent, whilst many non-Western forms still have an inclusive function in community life where it is assumed that everyone will participate' (Greenwood, 2007). We also need to recognise that individual participants have different ways of learning and may not respond positively to a pedagogy that is dominated by sorting the gifted and the talented from the rest. In the narrow framework of the professionalised

aesthetic, set out in ballet and Western contemporary dance, the majority fail. So we have to find ways of teaching and transmitting an engagement with dance that allows 'everyone to reveal their individual signature' (Macfarlane, 2007) and where 'everyone has their turn "centre stage"' (*ibid*).

So what are the differences that are important to support and value in community dance?

- Differences between individuals.
- Differences based around cultural identity and what is important in our worlds.
- Differences of aesthetics in different dance situations.
- Different reasons for participating in dance.
- Different learning needs amongst individuals and groups.
- Different methodologies and pedagogies to ensure that people have the most positive experience in their dancing.
- Different bodies that can produce different dancing opportunities and solutions.
- Different contexts in which dance takes place and has meaning.
- Different audiences that widen the opportunity for dance to be valued in wider society.

Whilst I believe it is important to recognise and value all these differences, and that it is important for community dance artists to embrace them into the core of their practice, I think we should understand why we need to. For me, it is in the sharing of our differences in our dancing, that we see and recognise what we have in common, for if, when we engage in community dance, we can enter dialogue about our differences, we can promote greater understanding for the individual within the group and for the group as part of its wider community.

I also believe that we need a more compelling and inclusive narrative for dance in this country, one that allows us not only to see the differences and use them, but also to see what is common when people dance, make dances and watch dances. This inclusive narrative would be characterised by people striving for excellence, doing the best they can – paying attention to the quality of their dancing, having a say in what the dance is about and how it is made, having a voice about who the audience is and the context in how the dance is seen and experienced. Also, they would reflect seriously and critically about how successful or otherwise the dance was in achieving their vision and aims. If we look for the 'Common Wealth' of dance and the people taking part then dancing truly achieves its potential in making a difference to people's lives and those of our communities.

In embracing the different, as Janet Archer, Chief Executive of Creative Scotland says in an article from the Spring 2007 edition of *Animated*: 'I really hope that everyone can keep seeing those sharp, silvery, beauteous moments that come

out of embracing each other's individuality with warmth and openness. I profoundly believe that we can move towards a more secure and humane society if we do' (Archer, 2007).

Discussion Points

- Do you agree with Ken Bartlett that 'there are diverse aesthetics at work in dance'?
- Can you think of any practical ways to value and celebrate diversity within a community dance workshop? (The Resources section has suggestions for recognising, managing and celebrating diversity together with inclusive activities and ideas for special occasions).

5 Whose Voice is it Anyway?
Louise Katerega

In 2005, Louise Katerega was an independent dance artist who had worked in a range of community settings with considerable experience of working on projects involving disabled people. In this chapter she describes 'Station Master' – a performance project with Dance Dangerous, which was a Northampton-based community company run by disabled people. Louise gives an honest account of how she dealt with an interesting dilemma and raises some thought-provoking issues about power relationships in community dance practice.

First Stop

It's my favourite kind of phone call.

At the end of line is the familiar voice of a trusted friend and colleague. She is representing the collective voice of a community dance organisation whose aims and practices, I believe, represent all that's best about British community dance. I have the advantage of long trusting relationships with the owners of both that individual and that collective voice and, what's more, here they are offering to pay me to do my favourite thing – choreograph – in my favourite setting – one including both disabled and non-disabled dance enthusiasts.

The caller is Miriam Keye, a former mentee of mine, now a friend and colleague, like me, living and working freelance in the East Midlands.

She is calling in her capacity as part-time administrator for 'Dance Dangerous', a community project governed exclusively by disabled adults providing inclusive workshops and performance opportunities in Northampton. The company had decided to make a performance piece based on 'Starlight Express'. They were looking for a choreographer to help them create a piece in time for the forthcoming STOP Disability Festival at The Castle Theatre.

All Aboard?

Miriam puts their cards on the table: 'The company has been considering all the artists they have worked with in the past year to choose one to make a piece on them. You and Tom St Louis got equal votes, so we feel we really have to offer it to you as you have the experience of running a project start to finish. Tom could maybe come and assist'.

Tom St Louis is a disabled dance artist – a wheelchair user like the majority of Dance Dangerous – with a couple more years' experience of inclusive practice than me. It's also been a more consistent part of his career. Although he was a builder for more than 20 years before he became disabled, unlike me, he has a formal qualification (HND) in dance. Tom's my senior in years (24 to be precise), life experience and this area of dance generally, having worked nationally and internationally as performer/demonstrator/teacher with acknowledged master in the field Adam Benjamin, co-founder of CandoCo. He has also worked as an actor with acclaimed Graeae Theatre. A few weeks prior to this conversation, I saw him produce his first 20-minute professional choreographic work on 'Cultural Shift', East London Dance's breakthrough programme to encourage the country's first disabled choreographers, where all of this experience patently shone through.

How come I just got offered his job? And, more importantly, what are the consequences all round if I take it?

I believe the answer to the first question lies in the fact that it is difficult for a disabled person to train in the practical side of dance in the United Kingdom harder still in the organisational aspect. Yet self-management is a key aspect of working freelance and, crucially, inspiring an employer's confidence.

Add to this that, in Tom's individual case, his paralysis causes him difficulty writing and emailing – skills often needed when setting up a project or taking notes in rehearsal. The difficulties go deeper than this, however. Despite completing his HND successfully, he has always battled against a limited early education and always had difficulty speaking and writing in standard English – it being his third language after the French dialect of his native Dominica and Caribbean 'patois'.

In other words, Tom may not simply come across as 'the self-managing leader type' in terms of the very middle-class conventions which pervade British arts practice. I, though my degree is in Film & Literature, have always been comfortable with speaking and writing, find it easy to use 'artspeak' and thus may come across as more adept in my communications with an employer. Of the two of us, I probably appear the quickest and easiest person to employ. Making dance happen is an arduous road for all of us involved in doing so. If there's a quicker simpler path, of course, we want to take it. And I fully include myself in that!

Having known Tom for a decade, however, and watched him successfully run a disabled children's dance workshop series in Soweto, South Africa, I am convinced of Tom's innate intelligence, organisational skills and leadership abilities. So what if it's simply the case that, linguistically, like any non-native English speaker, he sometimes simply needs a translator?

In terms of the second question about the consequences of my taking the work: well, a piece gets done, I get paid, and Tom need never know the conversation took place. Or, yes, I could ask him to assist me. Dance Dangerous would get what they ask for. But would I be giving Dance Dangerous what they *stand* for? Their very existence is a model of empowerment for disabled people in decision making about art. Wouldn't my taking the job over Tom undermine that?

If the only issue is that Tom might need support first-time managing a full choreographic project, what if I was *his* assistant instead?

I look at the consequences again: Dance Dangerous gets an experienced dance artist with in-depth personal experience of wheelchair use and mechanics; an emerging choreographer gets a national opportunity to expose his work, and the STOP Festival gets work by an artist it exists for – a disabled artist. Dance Dangerous continues to build its national reputation for innovative practice – and I still get all I *really* need, which is pay for the time I put in and not to let down a group of a group of people whose enterprise I so believe in. By standing aside, it seems I might in fact do us all more good...

'What's your total budget?' I ask Miriam. 'Can we go back to square one and reconfigure the project so Tom and I combine his artistic skills and my mentoring ones? We will still guarantee you the quality work and positive creation process you're asking for.' And Miriam, sharing Dance Dangerous values as she does, trusting my judgement based on our past relationship, generously does so.

Here's how it all panned out.

Ready for the Off

During project planning in April/May Dance Dangerous was between administrators. Miriam had finished her contract and Linzi Lee, the new administrator, was about to start, so my organisational skills were doubly useful. Tom and I met and drew up a document for Dance Dangerous – not unlike a mentoring agreement for us, but which also communicated to Dance Dangerous our roles and responsibilities in relation to each other.

Conducting Ourselves 1: Getting Tom in the Driver's Seat

Tom's role as choreographer was to:

- research 'Starlight Express', which Dance Dangerous had asked be the starting point for the work
- complete the choreography
- decide on lighting for the work.

Tom achieved all of this with no difficulty other than the unfortunate fact that 'Starlight' was not touring as a production at the time. However, he was able to work from illustrated programme information and the musical score.

He comments: 'The whole idea for the commission was an interesting challenge. I saw an obvious link between roller skates and wheelchairs. I had the idea of keeping the wheels of the chairs close together the way they are on a train. Disabled dancers could create the idea of a train the way able-bodied [sic] couldn't. I had ideas about trains, platforms and barriers… I used the actual "Starlight" music to inspire me. Though in the studio I found more contemporary music went with what we'd made'.

Signs and Signals

Tom stated his personal aim for the project as 'recognition', defined in detail in the wish list below:

- to be credited on a poster for historical record end up with a quality DVD/ video to keep for further self-promotion
- receive some positive comments by dancers and audience
- to see a written article about myself as a disabled choreographer – for example, in a newspaper.

Linzi, even though this was one of her first administrative jobs, proved to be both meticulous and brilliant in all aspects of it – especially marketing. Tom had local media coverage including TV and, at the end of the project, he left with excellent quality photographic and DVD evidence of his work. Participant and audience feedback on the work was universally positive.

Conducting Ourselves 2: Keeping Louise in the Back Seat

My role was that of 'Executive Assistant', a role defined by Australian dance artist Philip Channels (who went on to lead education at Stopgap). He supported Tom in a similar way during 'Cultural Shift'. 'Executive' refers to having an excellent dance skills/literacy base and 'assistant' refers to playing second fiddle artistically plus compensation for Tom's loss of manual dexterity.

I was to be:

- literally Tom's 'right hand' writing notes in rehearsal, typing emails and if necessary fetching and carrying equipment in rehearsals (All written work, artistic or administrative, was to be written as dictated by Tom.)
- a sounding board for the choreographic and leadership process
- facilitator of Tom's lighting design in technical rehearsal so that Tom could concentrate on the group. (In the event, this proved to be doubly necessary

as the lighting box, like many in theatres happily equipped for disabled audience, was not wheelchair accessible for a disabled arts leader.)

The practical timetable of my input was:

- five meetings – one preparation, three during rehearsal, one to contribute to the evaluation of the project
- plus up to five phone calls about the piece
- and no more than two quick calls per week re practical things.

In the event, Tom asked for, and in my view needed, no help at all choreograph-ically or with leadership of the group. He prepared meticulously for each session in ways that surprised even me, always on the ball with CDs and track numbers and, though it was a physical struggle to do so, always providing basic notes for whoever was videoing or operating the music. Rehearsals ran smoothly and he held an easy authority over participants and attendant care staff. Tom puts this down to laying down clear ground rules in his first session. We agreed that I wouldn't be present at this session, which may also have helped establish his leadership.

Conducting Others – We Hope You Enjoyed Your Journey

Maintaining effective relations with support staff in integrated projects is vital in freeing a choreographer to deal only with artistic and not personal participant needs. Tom's ground rules, which were aimed at creating an appropriately profes-sional and continuous working atmosphere, were as follows:

- no support staff in the final performance unless they were performing as dancers themselves
- support staff encouraged to join in introductory workshops (as dancers not carers) to boost their own confidence and widen their understanding of physical interaction with disabled people
- after the initial session each disabled participant to be responsible for his/ her care needs on the dance floor. For example, if the belt to keep you in your chair becomes undone it is your responsibility to alert your support worker to fix it, not for the support worker to enter the dance floor and fix it whilst you are working.

Tom had to reinforce this latter point at first:

> In the beginning any slight thing wrong and the carers [sic] were in there… they soon got the message, however, not to come onto the dance floor unless asked and to go as soon as their job was done. The dancers' job is to look out for themselves and each other – as they will have to on stage in

performance. ... I avoid spending much one-to-one time with individuals. This helps them become more self-reliant and when they leave the workshop they can take that discipline back into their own environment. I got the impression the disabled participants were only too glad to be away from their carers.

Pulling the Communication Cord

Crucially, we laid down the ground rules of communication between Tom, Dance Dangerous and myself over the project from the beginning:

> All correspondence to be copied to Linzi, Tom and Louise. Tom is central leader and decision maker on the project, so although information may pass by/be copied to me, it must come to Tom first or at the same time and any actions on it eventually be decided upon by Tom.

This was where we felt there was most danger in power relations swaying in my favour rather than Tom's, simply because I might be seen as more senior and/ or simply have this mantle thrust upon me as I was first point of contact for the project. Tom did feel that there was a slight tendency to turn to me as first. We stood firm, however, sticking to our plan to keep me out of the picture much of the time.

I wasn't present for the final casting of the piece, which, according to Tom, was a turning point when he began to be acknowledged as leader. He said 'The penny finally dropped with them when I wouldn't have any arguments and I wanted the three able-bodied [sic] dancers who were there to all be in the piece'. In other words, Tom's authority as project leader stemmed from the moment he asserted his artistic authority, which was the message we were hoping to get across.

Indeed, the most interesting, tense and revealing moments of the whole process revolved around the inclusion of the non-disabled dancers. Another crunch point came when one of them spoke to Tom privately about feeling uncomfortable with a duet he'd included because it was not with a disabled partner. Discussion arose as to whether Tom was obeying the 'rules' of an 'integrated' piece.

Tom came to me with this dilemma wanting to stand his ground as, choreographically, he felt the piece needed this dynamic duet to lift and balance the energy of what was a generally slow piece. I backed Tom in his thinking and encouraged him to stand his ground asserting that it was his right, as the artist Dance Dangerous had brought in, to be just that – an artist trying to create the art he wanted to, to express his experience, for the benefit of the company.

This incident does raise eternal questions for me, however, about where the lines between art and politics are drawn in inclusive practice. Who draws them, when and why? Perhaps the only answer *Station Master*[1] offers is that each project

is different, each partner must work out beforehand where he/she draws own their lines, lay them down in relation to the project's agreed priorities and negotiate throughout.

The duet was included and there were no objections from the disabled cohort. Tom explained that his choice was for the artistic good of the piece and 'because it belongs to Dance Dangerous, which includes – not excludes – non-disabled dancers'. Tom's own personal take on the dancers he works with is that: 'as a choreographer it's important to me that I become known as not working with just disabled people. A choreographer works with anyone'.

Looking Back Down the Line ...

So did Tom's presence as a disabled role model make a difference to Dance Dangerous as an integrated group? Evaluation questionnaires describe participants as feeling 'more confident, more comfortable and more at ease' with a disabled choreographer at the helm. As a fellow choreographer, I definitely felt that Tom used the many wheelchairs with far more innovation and efficiency that I would have done.

Looking back, *Station Master* stands for me as one of my proudest achievements in community dance – not so much for what I did as for what I stopped myself from doing; not so much because of what happened when I was there, but because of what occurred because I strategically absented myself. Writing this – which is last thing on Tom's recognition wish list – I realise the weight of our responsibility and the wonderful *possibility* we have as community dance artists to influence whose voices get heard through our practice. And not just by the dances we make, but with whom and how we choose to make them. And from the moment the phone rings, not just the moment we step into the studio.

If I had said yes at the end of the line that day, whose voice would have been heard in *Station Master*? Mine. Fine – but I *had* to ask the question: does the world need one more non-disabled choreographer working on more disabled dancers right now? Answer: not really.

Because I said no – a creative 'no' but 'no' nonetheless – I saw three communities benefiting from an exchange of voices, none of them mine. First of all I got out of the way, so that Dance Dangerous could communicate directly with one of their own – who understood their choreographic needs far better than I ever could; secondly, I got out of the way so that the public and dance community could hear Tom's choreographic voice; lastly it seems this has now helped a community miles from all of us to celebrate and benefit from the return of a prodigal son.

The experience of 'Station Master' led to a wonderful next step in Tom's career and to his voice reaching a community even closer to his heart and life experience – his own. Having now called the shots and watched me up close

running a community dance project, in summer 2007 Tom was creating work in his home village, Colihaut, in his native Dominica:

> The project gave me the confidence to set up a 1 month site-specific project for Fete La Saint Pierre, the yearly festival of the village's patron saint. I'll create a dance/drama piece for 18 non-disabled people aged 10–50 years, about friends and family, harvest and Saint Peter. I will probably go back to some of our old *Station Master* paperwork to help me with the organisational side. I might have given it a go without having done that project, but, as things are, I *know* I can deliver.

So, clearly, no careers were harmed in my refusal of this project. And of course you are now hearing all the many community voices raised in this project through mine here. Which keeps me wondering … next time the phone rings … is there anything any of us could *not* do for the future of community dance?

Discussion Points

- What do you understand by the term 'inclusive practice'?
- Should community dance projects be open to everyone?
- How important is having direct experience of living/working with an impairment in the leadership of community dance by for and with disabled people?
- When you have discussed these two questions have a look in the Resources section, where Caroline Bowditch gives her perspective on the same questions. Caroline is a performer and choreographer who has created exciting pieces which promote disability equality.

Note
1. *Station Master* was the title of the dance piece that Tom St Louis choreographed for Dance Dangerous.

6 Reasonable Care

Penny Greenland

In this chapter Penny Greenland challenges us to think about how we keep people safe in community dance work. The light-hearted quiz questions do not come with a handy set of 'correct answers' – this is deliberate. I suggest you imagine yourself in these different situations, explore your options and discuss them with other people. This will help you to really engage with the issues and identify what you need to do to equip yourself to 'take reasonable care' of the people you dance with.

I realise that many readers will want more than open-ended discussion and, immediately after this chapter, there is a quiz which does give some concrete answers. Also, you may decide to go on training courses in Safe Dance Practice, Duty of Care and Safeguarding (Protection of Children, Young People and Vulnerable Adults). The Resources section will signpost you to information about these courses together with sample risk assessment forms and health and safety questionnaires. See Quin, Rafferty and Tomlinson (2015) for more detailed information about Duty of Care and Safe Practice in Dance.

Here's a quiz for you.

1. You are running a high-energy street dance workshop in a lively youth club and the work is going well. You ask the group not to chew gum as it is potentially dangerous. Two lads laugh at you and refuse. Do you:
 a. Stop the session. You can only continue if no-one chews gum.
 b. Let them continue, because it's their club after all, and they need to take responsibility for themselves.
 c. Try to get them to stop, but when they go on refusing back off because you don't want to spoil things for the whole group.
2. You arrive at a residential home for frail older people to run the first session with a group of residents. Unfortunately, there has been a death today and the activity leader, who was going to join you in the group, can no longer

51

attend. Because everything is in turmoil she asks you to carry on, on your own – 'It will be a nice distraction on a grim day'. Do you:

 a. Willingly agree, glad to help out in such sad circumstances.
 b. Politely refuse, saying you don't know the group well enough and you don't feel it would be safe to go ahead with movement activities on your own.
 c. Compromise and suggest you could spend time chatting with a group instead, using the time to get to know residents a little better.

3. At the start of a community class one of the participants, attending for the first time, comes to you and says, 'I have a pain in this part of my back (indicating lower left). What do you think it is? And can you advise me which bits of the class I should miss out?'. Do you:

 a. Welcome her to the class and say that exercise will probably do her good, but advise she takes it easy if something really hurts.
 b. Tell her not to join in until she has sought advice from a health practitioner.
 c. Tell her you cannot give specific advice, but your class will emphasise the need for everyone to take care of themselves throughout, so carry on anyway[1].

How did you do? I haven't supplied the bit which usually follows this sort of quiz, and certainly no thumbnail sketch that tells you just what sort of community dance worker you really are. You know the sort of thing: 'Score 1–20. Watch out! You are so keen to please everyone you avoid taking important decisions and the people in your sessions might be at risk as a result'. Or, 'Score 30–50. Wow! No-one is going to get hurt in *your* sessions. You have every insurance policy going and you'd rather sit and do nothing than risk anyone twisting an ankle'.

The truth is, in the real world there are no easy answers. In fact, each answer raises more questions. Taking care of people is a complicated business with many value judgements hidden within. Inevitably, when a society creates shared measures to try to ensure uniformly 'good enough' practice, many individual sensibilities are likely to be trampled underfoot.

'**Duty of care**' – all the questions above refer to some aspect of this catchall phrase. It is an attempt to round up, and structure, the responsibilities we owe others as we work. At the turn of the millennium the phrase was not in common usage. Now it pops up constantly, in a rather vague sort of way, clearly indicating some moral and professional imperative, but never quite defining it. It goes hand in hand with some other unsettling catchall phrases like 'employer's responsibility', 'professional indemnity' and 'civil liability' – frightening sorts of phrase that clearly have precise definitions and procedures somewhere, if only you knew

where to find them; things that feel as if they might threaten the very thing that you, as a community dancer, were put on this earth to do: dance with people.

Back to the quiz.

4. Circle the definitions that most closely fit your own position:

 a. Community dance artists automatically take good care of the people they work with. They don't need special training to tell them how to do it.

 b. Arts work is different; freedom from bureaucracy is essential or the work itself is altered.

 c. I wish I really understood what is expected of me.

 d. If we risk assess everything we do we'd never move for fear of being sued.

 e. Community dance practitioners have to join the real world if they want to be taken seriously.

 f. My work is about nurturing open, trusting relationships. Why would I want to buy into legislation that is about watching my back?

 g. There's too much paperwork in this world; nothing changes because of it.

 h. These are the kinds of measures that are written by people sitting in offices, not people working on the ground.

 i. I just wish someone would give me some clear guidelines for all these measures and I'd happily just stick to them.

Duty of care is 'a legal or moral obligation towards an individual or group of people that upholds standards to ensure their health, safety and well-being' (Quin et al., 2015, p. 252).

As dance practitioners we are expected to take 'reasonable care' whilst facilitating our dance activities. We have a duty of care to participants, co-workers and anyone else involved in our work – such as students on placement, support workers and family members.

What is 'reasonable' has to be defined by implication, rather than definition. A legal dictionary definition of 'reasonable care' is:

> the degree of caution and concern for the safety of himself/herself and others an ordinarily prudent and rational person would use in the circumstances. This is a subjective test of determining if a person is negligent, meaning he/she did not exercise reasonable care.[2]

In a nutshell then, you have a professional responsibility to take '*reasonable care*' to protect others from '*unreasonable* risk of harm'. There is a heavy emphasis on reasonableness here. It all comes down to what you – or more pertinently, an aggrieved person in a court of law – deems to be 'reasonable'. This is tricky: most

community dance practitioners believe they take reasonable care – but different practitioners take very different views of what is, and isn't, reasonable in any given situation.

5. What do you think is reasonable here? Answer yes or no to each question:
 a. Participants are fine to wear socks as they work even though the floor is varnished wood and slippery.
 b. A participant aged 101 must be asked to sit down after dancing four dances on the trot, because you have a duty to make sure she is safe.
 c. A member of your group, returning after having an operation, should be able to make their own decision about how soon to start exercising again.
 d. A member of the group with a recent diagnosis of cancer is delighted to be part of your exercise group because it makes her feel so much better. However, you cannot let her join in unless she brings written medical approval for exercise.
 e. You run a group for a mixed group of children in a busy community centre. The changing facilities are in a public space, out of your sight, with many people having ready access. You have done a Safeguarding course and know that this is an issue. As there are few alternatives is this acceptable?
 f. The sessions you are running are high energy and involve much lifting by the men; you recommend high-protein drinks to help build their strength because you have heard, from colleagues, that they are very effective. Is it reasonable for you to give this advice?

There are some very strong preconceptions within our profession – things that have become embedded in practice which are very difficult to challenge. The sock thing is one of them: for some practitioners it is completely acceptable to work in slippery socks on a slippery floor – it is just what we dancers do. For others it is unthinkable.

Here is another tricky issue.

6. Returning for the third day of a five-day holiday project, several young women in your group say they are very stiff and found it difficult to get out of bed this morning. As the morning wears on one is quite weepy and says she doesn't think she can continue – she is just too uncomfortable. She says she will ring her dad who will come and fetch her. When her dad arrives and expresses concern, do you:
 a. Tell him stories of when you trained and say that stiffness is just part and parcel of developing strength and flexibility. She's tired; she'll be better in the morning.
 b. Tell him that this is a course for intermediate level dancers and suggest she looks for something a bit closer to her ability level next time.

 c. Tell her to go home and have a hot bath.

 d. Spend the evening reviewing the material you have given the group this week and revise it for the remaining days, taking things more gently.

As you wrestle with this one, think about this legal definition. 'Actual bodily harm' is defined as 'any harm which interferes with the health *or comfort* of the victim'. Victim? Surely not the language of a dance class? Well, is it acceptable to send someone away feeling very stiff because 'no pain, no gain'? Or is any amount of pain unacceptable?

Reasons to Consider Duty of Care

Most of us with long careers leading dance work will have had one or two incidents in which, if someone had wanted to, they could probably have sued us for negligence. Not because we were particularly careless, or because the injuries were particularly devastating, but simply because, if someone is really of a mind, it isn't difficult to contrive a situation that puts a dancer firmly on the back foot. But people don't go around trying to sue community dancers. It's good, creative work, attracting good and creative people. Paranoia is not a good basis for artistic practice.

Well, let's get really grim for a moment. Have you been stopped in the street recently and asked if you have had an accident – *any accident* – that you might claim for? Let's suppose you were someone who decided to make a spurious claim – 'I'm hurting no one but the insurance company and they can withstand it'. If you decided to have a go, and had to choose between the various knocks and bangs you have sustained over the last three years (that's how long you've got to back-track, by the way), who would you choose as a potential source of these surprise funds? The big local council or corporation, with lawyers and plenty of experience of this sort of claim? Or the community dancer, armed with all the goodwill and good intentions in the world, but with little by way of legal backing? Hmm ...

So is this the reason to develop a duty of care policy? Well, it's *a* reason, but not a good enough reason. Duty of care is not primarily about fear and blame; it is about all-round good practice. Duty of care is about bringing together all the disparate policies and procedures that we are increasingly asked to provide – by insurance companies and funders, local authorities and other organisations, each in turn covering their own backs. The real value of putting duty of care at the centre of our practice is that we can make sense of all these demands in ways that are appropriate to our practice, rather than someone else's. As we do this, we also protect ourselves against the (remote) possibility of mischievous claims against us. If our procedures are as good as they should be – *because we want them to be* – we don't even have to think about the fear and blame culture again.

There is another reason to adopt this duty of care focus. It is the way we can justify public trust in our work. My own interest in duty of care was kick-started by a health worker in a GP referral scheme who was eager to include dance within the range of activities promoted by his GP practice. He asked a group of very experienced dancers two simple questions: 'What qualifications do you have?' How can you prove that your practice is safe?' The answers he received did not reassure him about the dancers' ability to keep people safe: 'I've got a degree/years of experience', 'the work isn't dangerous', 'I've never had any problems'. He was not convinced. I have no doubt that the dancers' practice was of the highest quality; I don't doubt that their different experience and training equipped them to take very good care of the people they worked with. But they had no way of *proving* it.[3]

The good news is that since then there have been new developments in training and qualifications available for dance artists working in the community. There are courses in safe practice, safeguarding and leading dance activities with different community groups.[4]

More quiz:

7. You need a new car. Do you:
 a. Look in the Yellow Pages and ring the garage with the name you like best.
 b. Look for a dealer with membership of a professional body which offers some protection if something does go wrong.
 c. Ask for a full log book and records but don't trouble if it isn't available – 'I'm selling it for my brother who's away in the army'.
 d. Ask if you can have an AA safety check before buying, but happily agree with the seller not to bother because it would take extra time.
 e. Say nothing when you find an irreparable fault just one month after purchase. After all, it was your fault for not knowing more about cars in the first place.
 f. Count yourself very lucky when the car dealer turns out to know rather a lot about insurance as well (he's just sorted out his own), and take his advice about which company to use.

When you look for advice or services from other professionals, there are probably certain things you hope to be able to take for granted. Oddly, they are sometimes things that community dance artists don't feel they have to provide – membership of a professional body with clear codes of practice and explicit statements regarding training or competencies;[5] open record-keeping systems; clarity about what the trader is *not* competent to offer, as well as what they are competent to provide, a commitment to shared standards across their profession. These aren't frightening things that erode our individuality; they liberate us from those middle-of-the night anxieties about what it is we *should* have done in order to comply with whatever legal requirements we *ought* to know about, but don't ... quite.

Good Procedures

Keeping people's best interests at heart is not difficult or unfamiliar. It's what we want for ourselves, and what we owe others. It need not limit our creativity or compromise the relationship we have with the people with whom we work, as long as we don't let it. The grudging lip service that I often hear given to risk assessment, the writing of a new policy, or worst of all, record keeping, feels far more damaging than a refreshed, unified approach to looking after people because it is the right thing to do.

Record keeping is an essential part of duty of care. Of course it is our awareness and adaptability within the practice itself that actually keeps people safe from harm, but it is the records that *clarify and communicate* how we carry out our duty of care, and highlight the tricky bits where things threaten to, or actually do, go wrong. Records don't have to be long; but they do need to be fair and insightful. The skill of writing brief, helpful records is one that I feel should nestle, with equal importance, alongside the practical dance skills we hold dear. It is simply part of professional practice.

All of this is time-consuming of course, although not as much as many fear. Larger organisations often feel that they are already stretched to bursting simply maintaining their existence without more attention to background work; individual practitioners quake at the thought of having to write policies, or produce reports, all on their own. I sympathise, but where matters of protection from harm are concerned I can't see that anyone can be exempt.

As our profession grows up there is much to be shared between us about how to develop duty of care standards that are simple, streamlined and helpful to all concerned. As new practitioners train to lead dance work, duty of care measures should be seen as part and parcel of the necessary skills – every bit as person-centred and caring as the movement work. Keeping people's best interests at heart is not difficult or unfamiliar. It's what we want for ourselves and what we owe others. Creating shared standards for such measures within our profession will not limit our creativity or compromise the unique nature of our artistic endeavour. It will enable others to see clearly on what basis we ensure that those who work with us are protected from harm.

8. You come to the end of a day working with a mixed-age, mixed-ability group of people new to dance. It has been a huge success, but there was an injury along the way. What do you want for yourself at 2 a.m. the next morning?
 a. When the fall happened you suggested the injured party sat out for the rest of the day and had a brief chat with their mum when she arrived to pick them up, saying you thought there was no real problem but you advised no more dancing just to be on the safe side. Now you are lying awake wondering if the ankle is all right and if there will be any comeback.

b. You are lying awake having endless conversations in your head between you and your manager: what forms should you fill out tomorrow? Whose insurance would cover this accident if it does turn out to be a problem? Do you have that insurance? Who will speak to the mum if she rings?

c. Having written a brief accident report (that you have signed, dated, filed confidentially and passed to the woman who organised the event), and spoken on the phone to the injured party after they got back from A&E where you advised them to check it out, you are sound asleep.

Sweet dreams ...

Exercise 1: A duty of care quiz (with answers this time)

1. To whom do you have a duty of care?
2. What is a 'vulnerable adult'?
3. If you are working with children, young people or vulnerable adults are you considered their carer?
4. What is 'risk assessment'?
5. Do you need to have your own public liability insurance?
6. What is a DBS check?
7. Are there any recommended staffing ratios for dance workshops?

See p. 213 for the answers.

Exercise 2

Penny Greenland refers to record keeping as 'an essential part of duty of care'. Imagine you've been asked to run a 10-week dance project with a mixed age community group.

What information do you need to gather before and during the project?

Devise a simple system for recording this information (either in a notebook or a pro-forma to use in a loose-leaf file)

Where would you store your records and how long should you keep them?

Discussion Point

- In the introduction to Part II I raised the issue of health question-naires. Can you think of situations when it would not be appropriate to ask people to fill in such a form? What other ways are there of finding out what you need to know to keep people safe?

Notes

1. As community dance practitioners we are not qualified to give advice about specific injuries/medical conditions. If a participant needs such advice they should be referred to a health practitioner.
2. http://dictionary.law.com/Default.aspx?s (Accessed 27.05.2016).
3. Chapter 12 includes information about courses and professional qualifications.
4. Safe in Dance International (SIDI) offers a certificate in Healthy Dance Practice. The qualification equips dance artists to work safely in a range of contexts and evidence their knowledge of safe practice to employers, participants and parents. (www.safeindance.com) Safeguarding courses are run by NSPCC Child Protection in Sport (thecpsu.org).
5. People Dancing: The Foundation for Community Dance is the UK professional organisation for anyone involved in creating opportunities for people to experience and participate in dance. It offers members a professional code of conduct, insurance, DBS checks and a range of continuing professional development opportunities. People from outside of the United Kingdom can join People Dancing.

 http://www.communitydance.org.uk/memberservices/membership-for-individuals/international-membership.html

 http://www.communitydance.org.uk/member-services/membership-for-organisations/international.html

Figure PIII.1 Freedom in Dance *Landscape Rhythms* (*Joel Fildes*)

those special moments which occur in workshops. Rosemary Lee calls these 'the moments we aspire to' and points out that these happen far more often during sessions than in a performance at the end of a project. As you read through these and other chapters make notes on leadership styles and think about how *you* facilitate dance experiences for other people.

Further Reading

Bannerman, C., Sofaer, J. and Watt, J. (eds.) (2006) *The Creative Process in Contemporary Performing Arts*. Middlesex University Press, London.

Benjamin, A. (2002) *Making an Entrance*. Routledge, London.

Butterworth, J. and Wildschut, L. (2009) *Contemporary Choreography: A Critical Reader*. Routledge, London.

Kuppers, P. (2007) *Community Performance: An Introduction*. Routledge, London.

Lerman, L. (2011) *Hiking the Horizontal*. Wesleyan University Press, Middletown, CT.

Tharp, T. (2003) *The Creative Habit*. Simon and Schuster: New York.

7 Community Dance in Performance

Heidi Wilson

Heidi Wilson is an experienced practitioner who has carried out research into the impact of community dance performance on audience, performers, artists and project partners. Here she presents a theoretical framework for community dance in performance. This chapter contributes to discussions about 'community' and 'professional' dance and includes a consideration of the following:

- *Why hold community dance performance events?*
- *Viewing and valuing community dance.*
- *A community dance aesthetic.*
- *The process/product debate.*

Community Dance and the Wider Dance Ecology

Community dance is often characterised as being participatory in the sense that community dancers are actively engaged in the process of creating, defining and presenting their own dances. This is distinct from engagement in dance product as an audience member where influence over the event is generally restricted to whether to attend or not, where to sit, whether to remain for the duration of the performance and how hard to clap and cheer to voice your approval or otherwise. There is not usually ready access to the performers and choreographer during the making process or post performance. These two distinct practices have historically been labelled 'community' and 'professional' dance, respectively, creating an unhelpful and erroneous assumption amongst some that 'community' equates with 'amateur' and therefore of a lower standard and that 'professional' always implies excellence and excludes a participatory element. Clinton and Glen (1993) offer the following clarification of community arts: 'The activity is distinct from traditionally funded "high art" in that the activity is more than likely to have a purpose beyond its aesthetic value.' The Arts Council of Wales defines Community Arts as 'arts professionals creating opportunities in communities for

people to develop skills, and to explore and communicate ideas through active participation' (Arts Council of Wales, 1996).

This division is the result not only of differing practices but also an inevitability of historical funding structures. The problematic dichotomies of 'community dance' and 'professional dance' have been considerably challenged in recent years. Not only is the 'professional' (or dance creation and touring) sector more widely inclusive of non-professional performers, but also the community dance sector is continuing to achieve increased profile and professional recognition. Many more choreographers, following in the footsteps of pioneers including Rosemary Lee, have made active choices to work with non-professional dance performers for artistic and aesthetic reasons. Luca Silvestrini of Protein Dance reflects this in his comment on the aesthetic of community dancers in whom he values 'the truth and honesty of the body which has not been changed and sculpted by technique' (Silvestrini, 2014). Wales-based dance artist Joanna Young provoked a reconsideration of notions of beauty in her choreography (Re)defining Beauty (2015). She situated older dancers within the context of the British Museum exhibition Defining Beauty: The Body in Ancient Greek Art (2015), juxtaposing the classical aesthetic ideals of 'order, symmetry and clear delineation' with the reality of the aging body which holds its own but different 'beauty'.

New Adventures/Re:Bourne's production Lord of the Flies (Ambler and Bourne, 2014) brought together community performers with this leading international contemporary dance company. Initiated in Scotland by Theatre Royal Glasgow and the then Scottish Arts Council, it drew on a cast of 16 boys in each of the 13 cities visited. In Cardiff this facilitated a relationship between the community dance organisation Rubicon Dance and Re:Bourne which is maintained to this day (Mackenzie-Blackman, 2014). Other partnerships between the 'community' and 'professional' dance sectors continue to emerge. Ballet Cymru and GDance joined forces in the creation of Stuck in the Mud (Brew, 2013) with a cast of disabled and non-disabled performers including some community dancers. This promenade piece toured to different sites (in partnership with the National Trust and Newport Market) drawing in local dancers to join the professional team (www .welshballet.co.uk). The community dancer has also been celebrated through significant high profile national and international sporting events. These include London 2012 Olympics and Paralympics opening and closing ceremonies (the latter commissioned Kevin Finnan of Motionhouse as Movement Director).

In addition to live broadcast events, the community dancer has become more visible through online platforms for sharing dance performance. The Internet revolution, the impact of which is perhaps only just beginning to be understood, has facilitated the democratisation of culture through presenting a challenge to the notion of 'gatekeepers' of art. In 2011 pop star Beyoncé was challenged by Belgian choreographer Anne Teresa De Keersmaeker for appropriating aspects of her piece Rosas Danst Rosas (1983). This unlikely confrontation between the powerful

world of commercial music and the rarefied world of elite dance as art was resolved through the launch of *Re:Rosas!* Moved by the interpretations of her choreography posted on YouTube by community dancers, De Keersmaeker gifted her dance to the world by uploading a YouTube tutorial allowing interpretations of the piece to go viral (*Dance Rebels: A Story of Modern Dance* BBC4 31.12.15 21.00).

Big Dance has exploited virtual technology to provide access and inspiration to dance to some 350,000 community dancers in over 50 countries. Instituted in 2006 and currently in its 10th and final year *Big Dance* has exposed the work of established and well-respected choreographers to community dancers. The 2016 Big Dance features the work of Akram Khan (www.communitydance.org). These examples offer a new perspective on the notion of 'community' taking it from a local to a global perspective through the vehicle of performance. Examples such as these 'blur the distinction between artist, audience and participant' (Jasper and Siddall, 2010). They also suggest that not only have divisions between 'community' and 'professional' dance been eroded but also divisions between popular culture and dance as art.

In considering the dance ecology of the United Kingdom, Siddall goes on to reflect that, 'there is greater trust that dance can exist in many forms and locations, and that people can engage with dance in many different ways. The continuum between dance participation and performance is embraced with greater confidence' (Jasper and Siddall, 2010, p. xi). This observation has been born out in the new organisation One Dance UK (launched in 2016) which unites four established umbrella bodies for dance, each representing a hitherto discreet area of dance activity, from education and participatory dance to professional performance. It is also reflected in the renaming of The Foundation for Community Dance to People Dancing in 2014.

This prompts the question of whether or not community dance is still a distinct area of practice. It may be usefully considered by invoking the 'process/ product' continuum proposed by Peppiatt (1996). Whilst the dance ecology of the United Kingdom has changed considerably since this time, his continuum continues to provide a very workable litmus paper when trying to ascertain the main purpose of a dance performance event. This purpose (or these purposes) may help us to consider the degree to which a performance event that includes community dancers is indeed 'community dance'.

Definitions of Practice and the Process/Product Debate

The difference in intention between community and professional dance practice has been explored through identifying the emphasis which each places on the process or product of dance making. Akroyd states:

> People-centred community dance practice is characterised by an emphasis on process as opposed to product and by the conscious 'tailoring' of content and method to suit the specific context and needs of a group. (FCD, 1996)

This belief resonates through community dance practice and is often employed as one of its distinguishing features. Peppiatt (1996, p. 3) uses professional dance performance as a benchmark from which to distinguish community dance practice:

> The territory of community dance activity is everywhere except professional dance performance. The driving force[s] in the world of professional dance performance are essentially different from those in community dance. ... Professional dance performance has important links with community dance activities but is essentially focused on professional performance itself (training, creation, performance and touring).

Peppiatt emphasises the point by claiming that the territory of professional dance is 'everything FOR performance', whilst community dance is 'everything AND performance'. He further claims that the process is the main product of community dance, whether or not that process is demonstrated through a conventional product or performance.

Thomson explores this idea further but tries to avoid an either/or, professional/community split (Thomson, 1996, p. 3). He proposes the use of a curved continuum with 'process/intention' at one end of the continuum and 'product/form' at the other end. The continuum is curved to acknowledge and emphasise that all works contain both process and product (of some kind). Professional performance would tend to be at the 'product/form' end of the continuum with community dance at the other, although not always necessarily so. Akroyd cites an example where a youth group request to work in a very technical way towards a specified performance thus placing themselves at the 'product/form' end (*ibid*). Matarasso (1994, p. 9) recommends a broadening of the notion of product (Figure 7.1):

> [W]hat needs rethinking is the concept of product. Of course it may be a finished poem, the performance of a new piece of music, or a show in the local town hall, but it can mean much subtler things. A single gesture, a hand shape, a verbal image, a chord sequence, a rhythm held, a facial expression – there is no end to the things that can constitute real, tangible artistic product. Because these things are often small, they may pass unnoticed by the casual observer of a workshop. Because they can be hard to explain to someone outside the group, or someone with little or no experience of the work, there is a temptation to stress the process. But the product – the thing that each of us is trying to work towards – is what gives purpose to the learning process and its importance must not be underestimated.

Rosemary Lee (2004, p. 2) picks up this point when she reflects on her experience as a choreographer who works across the community and professional

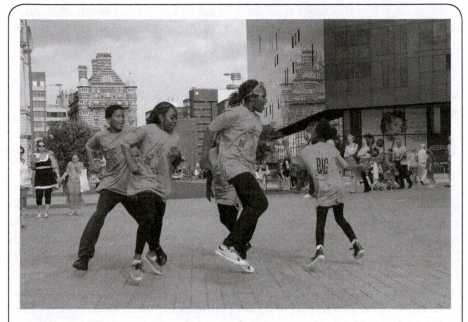

Figure 7.1 MDI – Big Dance and the Tall Ships 2012, International Mersey River Festival 2012 (*Mersey Mongoose*)

dance sectors. She is often involved in projects with non-professional dancers and describes what it is she looks for in a dancer which may not be realised in a formal performance but as part of the working process:

> It is the transformative potential of dance that I find so intoxicating and I rarely tire of seeing it if I get the scent of its possibility. My most memorable and moving moments as a viewer have been watching participants in workshops. It is the beauty of seeing something unfold before you, happening for the first and only time before your eyes.

Marks (1998) believes that Thomson's continuum implies an artistic process thus 'maintaining its identification with art rather than therapy, sport or recreation'. Being identified as artists is important for many community dance practitioners – particularly those working in contexts where other agendas have a high priority. Whilst working on an arts and health project Storey and Brown felt that what they 'perceived as an inward looking, therapy-oriented approach might militate against the potential of artistic processes that can create something that can be shared with others' (White, 2005).

In summary, performance is an established component of much community dance practice but it is commonly associated with an extension of the working process on which greater value may be placed.

Viewing and Valuing Community Dance Performances

Peppiatt's (1996) process/product continuum can perhaps also be characterised as the 'social/artistic' imperative. A consideration of which of these aims in any one dancing situation is felt to be the most important will guide subsequent assessments of 'quality', 'value' and 'worth'.

In reviewing dance analysis models aimed at the dance 'text' or performance the internal workings of the dance are generally stressed (Adshead 1998; Foster 1986; Preston-Dunlop and Sanchez-Colberg 2010). These models examine how the components of a dance are combined to create a coherent dance performance. Little focus is placed on the purpose of the performance which is assumed to be artistic, although Adshead (1981) specifies that dances exist in different contexts which she defines as social, ritual and artistic. It may be useful to consider Schechner's (2002) seven 'functions' for performance which he presents as interlocking spheres. These place more emphasis on the external significance of a performance event. These are: to entertain; to mark or change identity; to make or foster community; to heal; to teach, persuade or convince; and to deal with the sacred and/or demonic. Only one function, 'to make something that is beautiful', refers to the internal or aesthetic concerns of a performance (Schechner, 2002, p. 38). These 'functions', when considered from an ethnographic perspective, may help us to understand the meaning and significance of much community dance in performance.

To illustrate this, an extended reflection by a member of the audience at a performance called *Dance a Story Around the World* (Ysgol Cedewain, 2016) is included for your consideration. It seems that many of Schechner's (2002) 'functions' were achieved from the perspective of this parent:

> Individuality and spontaneity were encouraged, allowing the children to express themselves as they were in that moment. We watched [our son] very closely, of course, it struck us how happy, comfortable and free he was and, despite being autistic, was very much a team player in a big, shared, warm, friendly and bonded performance.
>
> Parent, *Dance a Story Around the World* (January 2016) Ysgol Cedewain

The increased visibility of (community) dance often through performance events (live and virtual) has alerted governments and other funders to the potential exploitation of the art form in service of wider societal aims and '... added layers of complexity to the relationship between dance as art and dance as participatory

activity' (Jasper and Siddall, 2010). These wider aims may sit more comfortably at the 'process' end of Peppiatt's (1996) continuum, but we can also consider a performance event to be a part of an ongoing process rather than the 'be all and end all'.

The 'third sector', in which community dance is often included, is increasingly charged with social responsibility and meeting government targets in line with Prime Minister David Cameron's 'big society' (2010). Although a devolved administration since 1997, the most recent Remit Letter from the Welsh Government (WG) to Arts Council Wales (ACW) for the financial year 2015/16 sets out 'the strategic context for, and purpose of, the Welsh Government's funding of Arts Council Wales' (www.arts.wales). In addition to the support for excellence in artistic practice ACW is working in partnership with the Welsh government to address other cross-cutting agendas. These include 'tackling poverty', closing the attainment gap between Wales' poorest and more affluent children (Andrews, 2014), and implementing the Arts and Creative Learning Plan for Wales (ACW & WG, 2014) that aims to instigate and explore creative approaches to learning and teaching in schools in light of the disappointing PISA results of recent years. The arts are also helping to address the health and well-being of the nation. The ambition to 'make Wales the most creatively active nation in Europe' (Skates, 2015) implies arts participation, as 'creators' not just 'receivers', is a central philosophy of the current Welsh government.

In this challenging financial climate where public services are finding it increasingly difficult to meet their obligations, particularly in the areas of adult social care, health and education, a space may be opening up for community dance. The challenge is to identify funding streams to support this, as traditional sources from Arts Councils and local government continue to shrink. The best community dance performances arise from a coherent and well-considered process which requires considerable commitment in terms of time and other resources. It is central to good practice that any community performance event has a positive and lasting legacy. This may take a number of forms but it requires investment at a local level that cannot always be fulfilled by the 'professional' performance sector. There is a semantic difference, albeit subtle, between the terms 'participatory' and 'community' dance. To me 'participatory dance' suggests 'turning up and joining in', whereas 'community dance' suggests a far deeper commitment from all those involved which has the potential to positively impact people's lives above and beyond the dancing itself and to realise at least some of Schechner's (2002) seven functions of performance.

Why Hold Community Dance Performance Events?

As a performing art, dance in a community context often includes a performance product of some kind. A performance event can provide a point in time where practice can be shared and validated. Existing research on community dance in

Whilst performance can build an intimate community of dancers this community extends beyond the performers to encompass the audience. Some community dance performance projects are specifically designed to achieve this. Leap of Faith, a performance group for people aged 50 and over in East London, managed to create a completely new audience in Stratford Circus (Risbridger, 2005):

> People who've lived in the area for years were surprised to discover that this venue and cultural centre existed, and were delighted to experience an event specifically for them. The sense of community was overwhelming, with people spotting friends they recognised from the borough but hadn't seen for years.

This example of community development through the vehicle of a community dance performance helps illustrate Matarasso's (1997) model of evaluation developed to explore the social impacts of participation in the arts. His research considers the areas of: personal development; social cohesion; community empowerment and self-determination; local image and identity; imagination and vision; health and well-being. He concludes that:

- participation in arts activities brings social benefits.
- the benefits are integral to the act of participation.
- the social impacts are complex but understandable.
- social impacts can be assessed and planned for.

Performance events make visible some of these impacts and provide evidence of activity. In 2006 Arts Council England explored models of good practice in dance within a range of social exclusion settings and their report refers to performance as:

> a very tangible and shared achievement (which) appears to have a great capacity to boost the confidence and self-esteem of those taking part. When asked what they had felt most proud of, many participants talked about performing in front of an audience and the reaction of an audience. (ibid, p. 21)

Beyond the Artistic: An Inclusive Framework for Viewing Community Dance Performances

Dance, like all the arts, expresses values and concerns arising from its cultural context (Matarasso, 2005). It can serve to reinforce, or expose and challenge, dominant assumptions. The refinement of the movement language, which is used to express and communicate, is perhaps the key difference between a community and a professional dancer. Aesthetic concerns codified within the execution of a technique often present a benchmark by which professional dance work is judged. This critical stance is clearly inappropriate for much community dance

and has fuelled discussions concerning a community dance aesthetic. If there is one what should be its defining features? Matarasso (2005) suggests the levels of physical virtuosity demanded by some dance techniques employed in the professional arena are 'tyrannical' in their pursuit of 'excellence'. A narrow conception of dance technique which requires athletic dancers risks reducing expressive and communicative possibilities.

What else makes a good dancer if virtuosic technique and a uniform body type are not appropriate? Val, a 67-year-old dancer with Dug Out, articulates the performance experience for her. 'When dancing I live totally in the present. I am not anticipating tomorrow or regretting today – I am totally in the now' (see Spafford, 2005). Val's perception of her performance state reflects a quality that choreographer Rosemary Lee seeks in her performers:

> What am I waiting to see? A glimmer of embodiment. A sense that the dancer is overtaken with the activity they are engaged with in such a way that every cell in their body seems involved. They are in synch, they are whole, they are present. (Lee, 2004)

(See Chapter 8 where Rosemary discusses her practice in more detail.)

A community dance performer lacking the cover of perfectly executed technique behind which to hide is more likely to appear as him or herself in performance. Their body becomes the medium and the subject of the dance:

> As a form that is inseparable from the physical presence of a person, and whose language is rooted in the communicability of experience through movement, it is essentially humanist. It claims, by its very presence, respect for the physical integrity of the person, and their autonomy of action. It values the individual, by focusing attention on them directly; and it values cooperation between individuals. (*ibid*)

When viewing and valuing community dance performances Thomson suggests that the audience is applying an 'inclusive framework' which extends beyond that of a professional performer/audience relationship. Many community dance audiences are made up of people who are connected to the performers in some way. Thomson (1996, p. 8) suggests that this relationship 'enriches rather than invalidates our appreciation of their dancing.' Woolf (1993) identifies these considerations to be the 'extra aesthetic' elements of a work. She believes that artistic value is not undermined by examining a work in its social and historical context, rather, 'the origin and reception of works is thus made more comprehensible'. Willis (1996) calls for a 'grounded aesthetic' which takes account of the context of consumption (and production) whereby quality is not judged solely upon 'the cerebral, abstract or sublimated quality of beauty' inherent in an artistic form but on its actual reception by consumers.

Conclusion

Performance is a valued element of community dance practice and appreciation of a performance event is enhanced by knowledge of the context against which achievement can be judged in a realistic and grounded manner. This does not diminish the expectation of high-quality performance but embraces it within a relative and inclusive framework where the performance is recognised as simply a moment within a longer developmental process.

Discussion Points

- Summarise Heidi Wilson's discourse on the key distinguishing features of 'community' dance and 'professional' dance. Can you identify any problems in seeing them as two separate aspects of dance practice? What do you understand by the term 'a community dance aesthetic'?
- Read my reflections on choreography and performance in the resources section (No More 'Rabbits in Headlights'). What does embodied performance look like? Think about how work is created and re-created for performance. How can we help our dance participants to become confident performers?

References

Arts Council of Wales and Welsh Government. (2014). *Creative Learning Through the Arts: An Action Plan for Wales 2015–2020*. Welsh Government & Arts Council.

Adshead, J. (1981). *The Study of Dance*. London: Dance Books.

Adshead, J. (Ed) (1988). *Dance Analysis: Theory and Practice*. London: Dance Books.

Ambler, S. and Bourne, M. (2014). *Lord of the Flies*. New Adventures and Re:Bourne, live performance.

Andrews, K. (2014) *Culture and Poverty: Harnessing the Power of the Arts, Culture and Heritage to Promote Social Justice in Wales*. Welsh Government.

Brew, M. (2013). *Stuck in the Mud*. GDance and Ballet Cymru, live performance.

Skates, K. (2015). Arts Council of Wales Remit Letter 2015-2016 www.arts.wales/33225. file.dld (accessed 18.02.16).

The British Museum (2015). Defining Beauty: the body in ancient Greek art. www.britishmuseum.org (accessed 18.02.15).

FCD (1996) *Thinking Aloud: In Search of a Framework for Community Dance*. Leicester: Foundation for Community Dance.

Foster, S. (1986) *Reading Dances*. Berkeley: University of California Press.

Jasper, L. and J. Siddall (2010) *Managing Dance: Current Issues and Future Strategies*, 2nd edn. Horndon: Northcote House.

Lee, R. (2004). The Possibilities Are Endless. *Animated*, Spring, 12–13.

Mackenzie-Blackman, J. (2014). Lord of the Flies. *Animated.* Summer 2014, pp 19–20.

Peppiatt, A. (1996). *Thinking Aloud: In Search of a Framework for Community Dance.* Leicester: The Foundation for Community Dance.

Preston-Dunlop, V. and A. Sanchez-Colberg (2010) *Dance and the Performative: A Chore-ological Perspective: Laban and Beyond.* London: Dance Books.

Risbridger, P. (2005). Peer Pleasure. *Animated,* Summer, 15–17.

Schechner, R. (2002) *Performance Studies an Introduction.* London: Routledge.

Sherwin, J. (2009) Social Role Valorisation Theory as a Resource to 'Person Centred Planning'. *The SRV Journal,* 4(2), 6–9.

Silvestrini, L. (2014) 'But Is It Art? The Artist and Participatory Practice'. Panel discussion at the People Dancing conference in Cardiff (November, 2014) www.communitydance.org.

Thomson, C. in FCD (1996) *Thinking Aloud: In Search of a Framework for Community Dance.* Leicester: Foundation for Community Dance

Spafford, J. (2005) Why Dance … ? *Animated,* Spring, 14. www.welshballet.co.uk (date accessed 18.02.16).

Ysgol Cedewain (2016) Dance a Story Around the World, audience feedback (unpublished).

Note

1. Dug Out is an adult community dance group based in Oxford and led by Cecilia Macfarlane.

8 Aiming for Stewardship Not Ownership

Rosemary Lee

Rosemary Lee is a choreographer, director, film maker and performer. Her creative output is diverse, and includes creating dance with mixed age community groups. In this chapter she reflects on her work as a choreographer in a range of varied contexts. Rosemary reveals why she does the work she does and explores our responsibilities as leaders: 'It's about the larger picture – what underlies what we are fundamentally doing – beneath the specifics'.

Over the last 20 years as a choreographer I have chosen to work in diverse, challenging settings, be they a familiar theatre, the largest red brick building in Europe or a waterfowl sanctuary; working with casts as small as 1 and as large as 237. I have made live works, dance films for broadcast and, more recently, interactive installations. There are many reasons for developing my work in this way and for the perhaps startling range of performance situations I have chosen. They have enabled me above all to reach new audiences and to explore quite different relationships with them in each context, and have also allowed me the privilege of working with a wide range of performers of all ages and of varied experience.

Early on in my career, I sought to try to ignore certain divisions: 'professional'; 'non-professional'; 'community'. Some might name a work with a cast of 13 dancers of all ages as a 'community' piece. Such labels, at least as regards my own work, seem to get in the way, making people look at the performance with different eyes. For me, each piece is firmly the next in my body of work; I aim to bring no less rigour to the so-called 'community' piece as to working with a professional dance company. I aim for the same artistic standards and production values, and I also try not to be swayed into perceiving the work with a different, perhaps less critical, lens. I want all my work, regardless of its cast or context, to be considered critically as art. If it falls short of that, the responsibility is with me as a maker.

This desire to try to avoid labels is sometimes problematic, but for the most part it keeps me asking questions of my own practice and its role in society, and helps me feel less trapped within sets of hidden rules and agendas.

My motivation and respect for working with this wide range of performers are threefold. Firstly I believe fundamentally in the positive power of groups of people coming together for a common creative purpose and the extraordinary effect that has on both individual and group. Secondly, I love to watch people dancing – whether they are trained or untrained. Their movement often speaks to me and inspires me more deeply than their words can. Thirdly, I want my works to reflect and communicate our common humanity, and sometimes I can do that more successfully by having a cast that is of all ages and of varied experience.

> I am watching an adult, a theatre director I think, in his shoes and summer linens on a hot summer day at the Festival Hall. He is partnering a nine-year-old boy who is a fantastic, natural, lithe mover and tiny. They are improvising together; the boy has his small hand stuck firmly to the adult's hand. The man looks flushed and a little dishevelled, his glasses are steaming up, but he is enthralled and exhilarated as he tries to follow the boy, who leaps and ducks, spirals and whirls. Their palms hold firm in this time of unspoken connection and energy. They come from such different worlds, different ages, different races, different economic backgrounds ... but this dance transcends all that and brings them together into an intimate *pas de deux*. The dance is unfolding before them.[1]

When I see a disparate group of people, brought together for a project, have their trepidation and anxiety melt away within an hour of dancing together, when I see an adult performer, whose daily life does not include children, begin to dance and engage with their nine-year-old partner with care and interest, when I see a child, who has rarely been in a setting of equal status with an adult, begin to value their own contribution with new-found pride – then I feel privileged to have been a facilitator and to have witnessed those moments. I feel a sense of stewardship, not ownership, as I try to create fertile settings where change and transformation can take place. Dance has a subtle but intense, powerful force. It can be a true equaliser in a society where hierarchy, divisiveness and rifts between individuals and groups seem ever greater. Is it fear and suspicion that make us perversely feel more secure if we widen these gulfs and more afraid if we build bridges to discover and trust common ground?

> The children view each other suspiciously across the grim dirty gym. I think to myself 'this is going to be tough' – and it is. The children are from different schools, a wire fence apart but with such suspicion and dread of each other. I set my expectations a little lower. I think to myself – if I can even get these children to acknowledge each other on the way to school after this project,

then it's a step forward. By the end of the project they could joke and imitate each other, learning each other's names eventually and knowing their peers' movements inside out.[2]

He is late always and in a dream. He, like his classmates, loves the part of the day when they lie down and close their eyes, and I come round and gently test to see if they are relaxed, lifting a limb and seeing if it drops down easily. They lie so still and try so hard to be relaxed, excited when they feel my hand on their arm or hear me near them. This is their favourite part every day, which puzzles me initially since they are such live wires and so unstoppable. Each time we do this, they begin to release more, allowing the ground to cushion them. Some of them have to be woken – he often. I later find out that he, at nine years old, has to get himself and his sibling to school as his mother is so ill, being addicted to drugs, that he often cannot wake her up. This sweet, sleeping, gifted lad has seen more of the horrors of life than I have. Why should I wake him and remind him of reality?[3]

Looking up the definition of the word 'community' I was reminded of its root being the same as that of the words 'communication' and 'common'. This reminder made me realise that it was in this family of words that I could find a way of linking various strands of my work with my reasons for being an artist. My work in all settings is

Figure 8.1 Rosemary Lee's Common Dance, Dance Umbrella 2009 (*Simon Weir*)

about seeking to find common ground where we can meet without the differences that divide us predetermining the relationships made. This meeting place may be between the individual participants themselves or between me (the choreographer) and them, but equally important for me as a maker is the meeting place between the work created and the individual audience member. The whole process from start to finish is about finding and making connections. Whenever I try to write about my work I find myself coming back to E. M. Forster's famous quote from *Howard's End* – 'only connect'. In all the work I make as an artist my aim is to connect with others, however subtly, and share with them something of what is precious to me, something that speaks non-verbally of our human condition. At my most idealistic I venture to say there is universality to this connection that dance alone can illuminate.

The philosopher R. G. Collingwood called dance the 'mother of languages' – preverbal, and our first means of expression (Collingwood, 1938). It is through our bodies that we encounter and experience the world and through our bodies that we communicate our responses to it. Our senses connect us to each other and to the world, they guide us through our lives, discovering as we go. We empathise easily with the loss of a sense or a limb, or the struggle to breathe, perhaps more easily than we can empathise with an emotional or belief struggle. We have this in common – we all have bodies and senses, fundamentally individual and shaped by our different life paths, but also fundamentally the same. What binds us is our ability to sense, to be aware.

Further affirmation came when speaking to the late poet Michael Donaghy, who told me that in his mind, dance was the mother of the art forms and that all words could be traced back to a physical action. Hearing this validated my trust that dance was not a frivolity, not a poor relation to text-based art forms – far from it: it has an ongoing fundamental place in our history and is at the heart of language development. There are times when we need to get beneath words, beneath the labels, that can only ever be one step removed from the experience sensed, to a more profound, unspoken method of expressing ourselves and communicating.

What excites me when I watch a child scamper across a school hall, or a senior dancer stand alone, or a highly experienced professional fling herself through the air? It's simplicity, humility and a sense that you are seeing the person without other complications. Dance can be both profoundly exposing and revealing: it comes close to reflecting truly what it is to be alive and reminds the dancer and the watcher of that life force. In these moments I feel I see a transparency in a performer – it is as if you get a clear glimpse of humanity. (Sometimes I see this more easily in untrained performers who have not been masked by the fine finish or style of a technical training – though as the training is changing this is less the case.) My wish is to make their glimpsed humanity visible and palpable to the audience. In witnessing this they may discover a moment of connection, a moment of intimacy on that common ground. Perhaps we sense something within ourselves – which we cannot put into words – made manifest in a performer in front of us. Or is it a sense of seeing the performer's own uniqueness,

potential and grace, or maybe that we feel more deeply alive and present together? It is probably all these things. There are times when it seems as if I am seeing their inner light, their potential perhaps, their 'themness', their spirit. However we explain it, it fills me with hope. In a world of cruelty and injustice, a world where market forces seem to have invaded every part of our lives, seeing this inner light reminds me of the things I cherish in being human, being alive.

> They are standing together side by side; the workshop audience is semi-circled around them. They have their eyes closed, listening and waiting. Neither knows who will make a cupping support with their hand offering it into the charged space between them. Neither knows who will glide their head out into the space searching for the hand to rest their head in. I watch this simple task, they are exposed, revealing to us their unsighted experience of waiting and sensing. The image once found of the head cupped in the other's hand concludes this patient waiting. It is times like this when I feel sane, when I feel a different sense of being alive.[4]

In a performer, whether they are highly trained or a non-dancer, old or young, I am looking for that transparency, that simplicity. When a dancer is so at one with their dancing, so unself-conscious, so engaged that the dance fills every single cell in their body, when they and the task they are engaged in become inseparable – then they become compelling and beautiful. These are the moments we aspire to, where you cannot tell the 'dancer from the dance' in Yeats' words. When I have experienced this state I sense completeness and surrender; it is simultaneously humbling and empowering. I believe that this state can promote a profound sense of healing and wellbeing, not easily found. These are transformative moments – it is actually tangible when this embodiment happens; the dancer experiences the effect of the dance and the viewer sees it. Such moments are rare, but I believe we are all capable of experiencing them.

> I am preparing children for some filming where they will be distant on a hill standing silhouetted against the sky. I want them to feel huge and powerful in order to expand their presence. I talk to them of weather gods, imagining that they can alone command the weather bringing in thunder from the north and sunshine from the south just by the vast monumental gestures they improvise with. I see one transformed from the quiet and reserved boy to a beautiful statuesque figure, dignified and powerful as he spreads his arms to the skies with utter confidence. I am stunned by his presence. Afterwards I ask him quietly if he felt that and he nods to me with a changed face, and in that moment he and I know and share. Nothing more needs to be said.[5]

In the early 1980s community art was, it seemed to me, constructed either as grand spectacle or speaking on a smaller scale of the stories of the participants in their particular situations. Seeing such work inspired me to make dance works

that involved huge casts, but without spectacular effects; work that, despite being on an epic scale, could create subtler levels of engagement for the audience and perhaps deeper levels of communication. However, I sometimes felt fraudulent that I came with ideas and an imagined sense of the work I wanted to create, say, in response to the site in a compositional way rather than devising from scratch with a group. My task then and now is to find ways to allow the dancers to take ownership of their dancing within those authorial ideas and structures that I have in my head.

> I had in mind that the dancers would swirl fast, arms held to the sky and then leap high and fall onto the ground and repeat this in a frenzy of energy and abandon. I see them all with anoraks over their floor length robes, hoods up shivering and awaiting the rain as the thunderstorm approaches. I feel it is impossible to ask them to do this and guilty for having them out in this weather and to have even entertained the idea of their dancing in this way on this hard ground. They see my concern and with more gusto and enthusiasm than I can muster as their facilitator they start to swirl and leap over and over, arms up to the rain. They are powerful and filled with the energy and spirit of this idea made physical as the rain pours down on them. I am humbled and the technicians gaze with wonder as these performers of all ages defy my doubts and exceed my expectations.[6]

Governed by practicalities and funding, my earlier work was often made in a short time frame, but recently I have been fortunate enough to be able to work for longer on projects. The dance is able to grow more from the performers and my response to them.

What I try to do in all my work, whether the dancers are highly trained or not, is to find ways of enabling the dancers to inhabit the piece that I envisage without losing *their* identity and without their being disempowered in any way. I am always treading a line between responding to the participant and responding to my artistic imperatives. I find I have to be highly attentive to both concerns, as if the balance goes awry the piece will not be successful for me. I liken it to watching my long-term collaborator, designer Louise Belson, draping cloth around the body of the wearer and pinning and cutting to their body until the shape arrives. The costumes she makes have her distinctive authorial response to the work I am making, whilst being made for and with its individual wearer, rather than being an anonymous, finished garment to be handed to them. In my work, the dancer's movement comes from their response to images and tasks that I have given them. These are highly specific images and tasks that I judge will bring, in the dancers' responses, the very particular embodied quality or energy I envision or may have glimpsed as potential.

> I imagine a character that has tremendous inner drive and passion, a kind of heated intensity that is uncomfortable to be near. We work on embodying

Figure 8.2 Rosemary Lee: PASSAGE 2000. Commissioned by The Royal Festival Hall with support from Rescen and DanceEast (*Pau Ros*)

the very essence of each of the four fundamental elements that our bodies know deeply and instinctively, being made of all of them. We come last to fire. I trust that maybe tasting the distinctive quality of fire possessing the whole body might give a flavour of this imagined energy. One of the movements we finally use in the film comes from imagining the quality and energy of fire darting up the core of the body.[7]

Imagine the steps of a wader with long jointed spindly legs and the spines of a porcupine raised on your back.[8]

She is the billowed sail of a galleon; full of air pressing her forward and you are the anchor line rooting her to the spot.[9]

A sculptor might say that, through being so closely attentive to the material they are working with, they are led to the sculpted shape. As a choreographer, I am trying to become intensely familiar with the dancers and their dynamic together so that the work created comes from them – is indeed theirs as well as mine. That is not to say I am only reactive to the present. It might be more accurate to say that I am reactive in order to be more successfully proactive. I liken some of my work to portraiture; I am trying to support and thus allow the dancer to dance in a way that is most revealing of what I see as the essential quality or spirit of that individual. However, I am keenly aware that this is my personal response to them.

I go through spells of working with film rather than creating live work in part because I find I am better able to work with the idea of portraiture in a film medium. However, the thrill of seeing a piece find its life, shape and logic once an audience is present, the exhilaration of seeing dancers claim the work and make it their own, and the joy of feeling an audience connecting with the work cannot be equalled. But live work is not, I have realised, always the best way to give the participants an experience of growth and change or to reflect their individuality. Those exquisite transformative moments I have described happen more frequently within workshops and process-led projects than in final performances. The unforgiving environment of the stage can prove too harsh for their delicacy. In performance, other issues – nerves, memory – intervene to make the situation more about the outside rather than the inside. Therefore, in certain projects, the experience of the participant might be better served in discovery rather than in trying to hone a performance.

Some of my most memorable and moving experiences as a viewer have been watching participants in workshops. This is why I continue to teach workshops so that I can witness those alchemic transformations taking place. It is the beauty of seeing something unfold before you, happening for the first time before your eyes, in the present moment right there, never to be repeated again. It feels a luxury and one I never tire of. Knowing the task that the dancers are engaged with alters your perception, allowing you to experience the dancers' discovery in an empathetic way that deepens your engagement and enjoyment. You discover with them at the same moment as they do.

> We are working on finding cushioned support from the air that surrounds us, coupled with a sense of length through the limbs and out into space along gossamer-thin, delicate lines. Suddenly the whole group seems to float above the floor, like gulls on thermals off a summer cliff top. The dancers surprised themselves as they hovered without a shimmer of doubt, the whole group shares the support as if uplifted by the common image. They are all on one leg, high up on tiptoe and they could stay there it seems forever, the air rising up under their ribs and arms to lift them.[10]

Essentially what I am aiming for in any workshop is to bring the dancers 'home' in their bodies. I want them to feel completely at ease, centred, free of anticipation or judgment. It is then that they can then discover new qualities and feel an affirmation of their potential to go further. Everyone needs to be included, respected and treated exactly the same way, with the intention of freeing people from the comparisons or assumptions of their status that only get in the way of dancing, being irrelevant. They need to feel they belong and that they all share this common ground together. I have to find the right way to make people feel comfortable in themselves, with me, with the group, in the space and in the moment. I try to sense this very quickly and respond to my instinct of what might be the best way to achieve it. This could range from intense image-based

improvisations to playful light tasks or to running riot. It depends on the group and what I sense their overall energy is, and where it needs to go to set it on its journey for the workshop.

> One of the children is blowing a bit of fluff across the floor; one of the seniors responds and on hands and knees blows it back. Pretty soon all 13 of us are down, our faces to the floor in a tight circle gently blowing the fluff from face to face, giggling. This became a ritual and transformed into our nightly warm up of throwing an invisible treasure or secret to each other silently before going on stage together.[11]

It's crucial for me to discover where I feel the flow of a workshop needs to go in order to release the potential of the dancers and of the event itself in the best way. It almost feels as if I am searching for the path that is already there. I do have a plan and sometimes follow it, but it's how I introduce things, what pace I go at, what I say, that are directly in response to the group in front of me. Do I need to keep going and push them to pass a threshold within a task in order for them to find the freedom I know they haven't discovered yet? Do I need to change things; do I need to encourage speed or stillness, listening or abandon? Do I need to take them unawares a little as surprise can sometimes bypass doubts and anxieties that are the enemy of finding one's own distinctive dancing voice?

> I am nervous; these are my colleagues in other art forms. I am supposed to be giving them a taste of my working practice. We end up crawling and prowling like lions, meeting each other side by side on all fours and trying with all our might to push the other over. I am surprised by this development and worry as I pursue it that I really have gone down the wrong path. But it brings us together physically without the embarrassment of tentative touching and the exposure of standing up, and it releases the powerful inner drive of each artist there within a very physical and direct non 'dancey' task. The spontaneous laughter that ensued also serves as a welcome release for all of us.[12]

In order to encourage each participant to find and broaden their expressive and qualitative range, I rarely demonstrate but rely on my voice, carefully chosen words and visual images – again in response to what I observe in the group. What words and images will most effectively allow them to find the qualitative state I am after? Some words seem to give the body a clue almost before the brain gets in the way to interpret it. I want to catch the innate intelligence that is in us all, but which seems to get diverted or blocked by the more cerebral approach we have been taught to use. I am usually trying to encourage dancers to stop thought processes that might hinder the body finding its more instinctive response, taking the thought from the forehead and letting it settle further back in the skull. The quality of their engagement is as interesting to me as the resulting movements.

I am watching them but I am losing focus; I can't see; nothing seems clear. Rather it seems held and restricted, tame. I ask them to 'lift the lid off' their dancing for the last couple of minutes of their improvisation and suddenly there is clarity and energy and intention and I could watch them for hours and they could dance for hours.[13]

What I am trying to do in any situation, whether it be teaching, performing, watching or creating a piece, is respond to the present, to be here and now. This is actually exactly what I want of the dancers too, so teacher, audience, maker and dancer ideally need to be in a similar state. This state of being present is one of openness and receptivity in both body and mind, open to the host of possibilities and hyper attentive and sensitive to the present. It is an acute awareness coupled with real ease that promotes a state where one can inhabit the present moment. This receptive place for me is one of infinite openness. This is easier said than done, as anticipating the future or judging the past can so easily fill the dancers' thoughts. To let go of these interferences and trust and surrender to the present gives us the possibility of having true presence and grace. It is this presence, this transformative potential that I find so continually inspiring. Watching participants in workshops when they fully inhabit the dance – or rather the dance fully inhabits them – affirms for me what it is to be alive. We return to that state of connectedness again.

As an artist one is a life-long student and observer, and I want to foster a life-long curiosity in each person I work with. I want to help them be proud of their imagination, own their dancing, broaden their horizons and thus sharpen their perception and awareness of themselves and of the world around them. If dancing helps us to find our feet on the earth then it can also help us to be more aware of the world we inhabit. Dancers who have worked with a respectful, inclusive, creative approach tend to be the most tolerant, open and non-judgemental people I know. They often question and explore givens that others take for granted; they think laterally. They know through dancing what it means to be truly cooperative and collaborative, knowing about listening, leading, following, allowing and making decisions; they know what it means to share. So if we can foster this outlook in all those we work with, couldn't we in our small, local, unspoken way change the world?

Discussion Points

- What is it about Rosemary Lee's working methods and leadership style that allows 'transformative moments' to happen?
- Compare Rosemary Lee's methods of leading dance workshops with Helen Poynor's approach (see Chapter 9).

us who have trained technically in dance at some stage of our career carry more baggage than anyone else. Because we have worked hard and committed years to mastering a particular dance form or style/s we have more investment in what dance is or should be than others. Our training leaves its mark long after we have moved on to other things. It was ten years after I abandoned the ballet training of my youth that I finally kicked the habit of automatically pointing my toes when I danced. Studying a stylised form with a firmly established movement vocabulary and set of aesthetics instils a series of beliefs about what is and isn't part of the form, what is or isn't 'right' and by extension what is or isn't dance. These beliefs take root in our bodies, which are trained to manifest them, and become 'second nature'. Having invested so much of our identity, so much dedication, time and effort to become dancers, it can be very challenging to question these principles, some of which may not even be conscious.

The Myth of a 'Real' Dancer

Is there a way of being able to work more freely, more creatively, more inclusively and still benefit from the discipline, precision and sense of presence that we carry with us from our formal training? Can this serve us in our work with others in a way that does not disempower them, making them feel inadequate or confirming their suspicion that they are not a 'real' dancer?

How can the democratic approach to creativity which is at the core of community arts philosophy and practice be reconciled with the potential elitism of dance as an art form?

Whose Dance Is It Anyway?

If we accept that any body is potentially a dancing body (and without this premise it is not possible to work in community dance), then we need also to accept that any movement has the potential to be a dance movement. Every body has experience of movement (although perhaps less in our sedentary society than previously) from floating in the amniotic fluid before birth, through the development stages of infancy and childhood games, to all the functional and expressive movements of daily life. By working with dancing bodies whose movement range does not comply with an accepted dance vocabulary, dance is created and expressed through an individual movement vocabulary which can be elicited and extended through skilful facilitation.

What makes a movement or series of movements dance? Is it a degree of 'extra-daily'[1] stylisation even if the style is highly personalised? Is it a quality of embodied presence in which the body is 'alive' and 'radiating', manifesting a kinaesthetic awareness of the whole body and of the body in space, opening a channel through which the self finds expression in the body? Does this expression

have to be rhythmic or is it the embodiment of a heightened relationship with time as well as space?

What Is Non-Stylised Dance?

How does non-stylised dance relate to stylised dance training? Is it possible to train in it? How can it be taught? What is its relationship to improvisation? To performance?

How can a trained dancer access ways of thinking about and working with dance which can break down some of the restrictive assumptions that have surrounded dance as an art form? Is it possible to discover ways of working that do not reflect the hierarchical structure of most technique classes with their formal lines and the trained body of the teacher (the 'real dancer') in front of the class as the model by which students judge themselves, a judgement which is reinforced by their critical assessment of their reflection in the mirror?

By contrast, the notion of creative dance is sometimes unfortunately associated with something worthy but undisciplined and unskilled, a form of self-expression in which 'anything goes'.

Non-stylised dance indicates dance in which the movements are not prescribed by a pre-existing technical vocabulary (even one that can be extended and developed) which has to be learnt like the rudiments of a language before one can express oneself fluently or even proficiently. It does not rely on steps that are put together in sequences in order to create dances. Nor does it entail a dance vocabulary based on an 'abstract' aesthetic like ballet or on the body type or physical abilities and preferences of the originator of the form.

The ideal in non-stylised dance is that over time each individual generates their own way (or style, if you like) of moving, which is continually evolving. As a result there is a smaller gap between the person and their movement, because it is not mediated through a pre-existing form. The link between the person moving and the movement expression is direct; their movement reveals rather than conceals who they are, making them more rather than less visible, allowing them to 'shine through'. There are memorable, radiant moments in workshops when a participant becomes fully present in their movement and they can be seen in all their individuality rather than as someone struggling with, or mastering, a particular style. Nevertheless it is also true that since a teacher of non-stylised work is working with a series of physical principles there is still a tendency for a basic style to emerge, precisely because these principles become embodied in the dancers (which is of course the intention), albeit (and this is a crucial difference) embodied in different ways. All stylised forms include a coherent system of physical and aesthetic principles, but these are generally encoded in a learned choreographic vocabulary, which is not the case in non-stylised work.

The physical principles I work with include: skeletal awareness; released joints; the integration of the upper and lower body through the spine, and the integration of the limbs and the torso (both of these support a sense of the interconnection of the whole body and the ability to allow movement to flow freely through the body); a three-dimensional awareness of the body and space; a mobile sense of grounding, a clear but permeable sense of the body's boundaries; and the ability to 'follow' a movement as it evolves and moves through space. These principles are explored through guided physical and creative tasks or scores such as moving between standing and lying, moving at different levels, and pair work including hands-on work in guiding and following. Different teachers of non-stylised practice incorporate different principles into their work. My approach has been significantly influenced by my early training with Anna Halprin at the San Francisco Dancers Workshop and with the Javanese movement artist Suprapto Suryodarmo, to both of whom I am deeply indebted.

Figure 9.1 Helen Poynor (*Annie Pfingst*)

Facilitating Non-Stylised Dance

I aim to set tasks with sufficient structure to enable participants to feel secure enough to explore in their own way without getting drawn into insidious self-criticism. Too little structure can be as anxiety-provoking as too much. I support this exploration by giving as much validation and encouragement as possible to the group and to individuals whilst they are moving. Feedback received whilst moving is more likely to be integrated kinaesthetically than feedback given later, which may be understood conceptually but less easily integrated physically. It is not appropriate to offer 'corrections' early in the process and perhaps is only ever relevant if there is information about the task or about the body which has not been fully understood.

The tasks need to be achievable, open to interpretation and easily engaged with at different levels so both more experienced members of the group and newcomers are stimulated by them. It is helpful to start from familiar movements (I often start with walking), especially if assumptions and movement habits are going to be challenged. I aim for a focussed but light, non-judgmental atmosphere where people don't need to feel they've failed if they misinterpret an instruction. A sense of humour is essential especially at your own expense – but not at that of others.

The atmosphere established in the group is crucial. I encourage participants to get to know one another's names, to work with different partners and cultivate an accepting, non-competitive attitude to one another. There is time for the dancers to share their experiences with each other or with the group. Receptive, non-judgmental listening is encouraged. I remind them how different their bodies are and emphasise that the work is about each person's individual experience rather than about looking or feeling the same. I encourage participants to avoid comparing themselves competitively or detrimentally with one another. I often start a workshop by asking each person what their hopes (or expectations) and fears are. Then at intervals, for example at the beginning of a new session or day, go round the circle and ask people to give a brief 'weather-check' on their current condition physically and, if appropriate, on their feelings and state of mind. After moving I may ask people to notice any reverberations they are left with including sensations, images and feelings.[2] This can serve as a way to integrate the experience of moving and as a bridge to communicating it to others. Inviting participants to draw or write freely, directly out of their experience of moving, using shape, form, colour, language and imagery to reflect their movement without analysis or interpretation, is another way of validating their experience. It may capture a 'flavour' of the movement and provide the ground from which to be able to share it with others. I invite participants to be receptive to and non-judgmental of each other's drawing or writing without superimposing their own interpretation or experience. Oil pastels (infinitely preferable to wax crayons or felt-tips), large drawing pads or rolls of paper, and pens and paper are provided.

Dancing can be a private or a social experience. Some people like to move with their eyes closed and experience themselves moving in their own self-contained universe; for others, closing their eyes can provoke intense anxiety. Some people lose a sense of themselves and their bodies when moving in relation to another, whilst others find it difficult to sustain their own movement without some out-side stimulus, for example a partner or music.

When running a session you need to be able to judge the mood in the room and make an appropriate decision to support it or encourage a change. For exam-ple, if at the beginning of the session people are lying quietly or stretching on the floor you may choose to start the session from there, perhaps putting on some gentle music and encouraging them to develop what they are doing into a creative exploration. On another occasion it may be appropriate to energise the group, waking them up through a structured warm-up or some lively music (the *Buena Vista Social Club* works wonders!). At times it may feel as if you are push-ing against a general sense of inertia. This may mean that people are tired and it would be supportive to introduce something quiet and nurturing (perhaps some hands-on work in pairs), or it may be that there is some underlying issue in the group which needs airing through discussion. This of course requires a flexible attitude to leading. A clear plan is helpful, but you need to be able to adapt it to the circumstances. I find it is always a good idea to have a few extra ideas in reserve. If you don't have a sense of what to do next during a session, perhaps because things are going differently than expected, try not to panic and rush on regardless, but take a moment to breathe, to feel your own body and to see what comes. The moment of not knowing will rarely feel as long to the participants as it does to you! If you need longer give the group a tea-break and take ten minutes to relax or move yourself. Your own level of self-awareness will influ-ence how you lead a group and what can take place within it. Be as honest with yourself as possible about your own responses (although clearly it is not always appropriate to acknowledge these in the group). Admitting that you are nervous may help others to admit their own nervousness and relax. Participants need to feel secure in your holding of the group, but it doesn't necessarily help them to gain self-confidence if they put you up on a pedestal as the 'expert'. (On this note: figure-hugging professional dance clothes can serve to set you apart and be intimidating for participants who may not comfortable with their body image.) It is important to be aware of your own preferences and blind spots. It is human nature that you will resonate more with some people than others. This, combined with your movement and aesthetic preferences, may mean that some participants' movement is harder for you to 'see', and therefore to appreciate and support, than that of others. Try to be open to what the participants have to teach you both about your own assumptions and about new possibilities. The image of setting out on a journey together with an attitude of interested curiosity is a healthy and creative one. It will also stand you in good stead when things don't turn out quite

how you expected and it is easy to feel disappointed or critical of yourself or the group. Your function is to support something to grow, not to inhibit or control it. Like a gardener or a midwife, you need to nurture the emerging movement and creativity of the individuals and the group to facilitate their gaining confidence in themselves, allowing their physical potential and creative expression to blossom to its fullest. Who are you to say red flowers are better than multi-coloured ones?

One way of supporting participants to inhabit their bodies as fully as possible is to prepare your sessions by moving rather than sitting and thinking. The more at home you are in your body, the more it will support them to feel comfortable in theirs. Much, which may not be verbalised or even conscious, is communicated and received through our kinaesthetic sense. Especially in an environment where the body is the primary means of communication the participants, like children, will be particularly sensitised to receiving non-verbal cues. In this respect it is important that you recognise your own comfort zone. You will obviously be more at ease if you are working within it. At the same time there is much you can do to extend your comfort zone by broadening your experience. The more you experience your body in different ways, the more you expose yourself to different experiential working processes, including physical activities that are not stylised dance – for example 5 Rhythms, Halprin work, Feldenkrais, Release, Tai Chi – the richer your work will become, not only through acquiring new skills and ideas but by broadening your experiential knowledge of your body in movement.

The Body in Motion

In order to support a quality of embodiment in movement I endeavour to find ways that stimulate, or offer starting points for movement that are physical rather than conceptual. Translating ideas into movement can produce movements that are superficial or external and leave one feeling alienated rather than 'inside' the movement. One way to start is from the physical structure of the body. There are many simple ways of doing this, for example inviting people to feel their feet on the floor as they walk through space, imagining leaving a trail of footprints behind them. This is more effective in bare feet but only if people are comfortable taking their shoes off and the floor is clean, splinter-free and not too cold. Then work through the body from the feet up, gradually enlivening and releasing each area of the body as the dancers continue to travel through space, until the whole body is moving freely. A basic knowledge of anatomy is helpful, but there is no need to blind people with science. Helping people to experience the interconnections between different areas of their body through a sense of their skeleton and released joints can facilitate whole body awareness and the ability to allow movement to flow freely through the body. People often find it easier to move their arms, which are used expressively in daily life and are associated with dance, than their torso, and experience little sense of connection between the two areas.

The centrality of the spine makes it the obvious starting point to increase aware-ness and movement in the torso. This has the added advantage that, as a result of the sedentary lives many people lead, their backs often benefit greatly from some attention. Simple exercises to release and feel the spine on the floor can be used. Extracts from Anna Halprin's (1979) *Movement Ritual* are useful but there are numerous other sources.[3] Working in pairs, supporting each other through attentive witnessing and gentle touch enhances the experience and establishes a sense of mutual support between participants.

Working actively with the body's structure and continuing the theme of inter-connection between the body parts, I encourage participants to explore the rela-tionship between the foot, ankle, knee and hip joints as they move freely through space. (This can develop out of the simple walking described earlier.) We then focus on the interconnection between the legs and the pelvis and the relation-ship between the pelvis and the earth through the feet. Similarly, the relationship between the pelvis and the spine can be explored with the pelvis serving as the bridge between the upper and lower body. The experience of the spine connecting the pelvis, rib cage and head enlivens the whole torso.

The counterpart of this work with the legs is working with the upper segment of the body connecting hands, arms and shoulder girdle with the neck and head and eventually the upper back and rib cage. These explorations can be repeated many times in different ways until there is a sense of familiarity with and free-dom in the whole body, and participants can feel how a movement in one part of the body subtly reverberates through the whole organism. The emphasis is on encouraging people to experience a three-dimensional sense of themselves in movement. Our visual sense (encouraged by dance studios with mirrors) tends to encourage an external, two-dimensional experience of our body. Combined with the Western cultural tendency to have a relationship with the world which is primarily frontal this means that we often lose a three-dimensional sense of our body in space. One way of counteracting this is to bring awareness into the back and highlight the interconnection between the front and back of the torso, for example between the area between the shoulder blades and the chest, and between the belly and the back of the pelvis.

Non-stylised movement emphasises an experiential knowledge of the body, so it is fundamental to the practice to allow participants to have their own experience and not to be overly directive. Throughout these explorations it is important to support each person at their own level, encouraging those who are tentative and providing more of a challenge for those who are more experienced. Whilst validat-ing an individual's strengths they can also be invited to explore other possibilities; for example, more extroverted dancers can be encouraged to listen to their body's subtle responses and the introverted ones supported to claim more space. Validating each person's different qualities challenges any predominant assumptions in the group about the types of bodies and movements which are acceptable as dance.

Encouraging group members to work with as many different partners as possible broadens their experience as they learn from moving with people who are very different from themselves. Some bodies, for example, express yielding and flow, the qualities of water, whilst others have a strong sense of definition in space, the quality of rock. By witnessing one another and moving together participants can gain an appreciation of each other's qualities and begin to explore new possibilities. See the practical exploration at the end of the chapter.

Towards Performance

How is it possible to move from the process of non-stylised movement described above towards performance? Is it possible to craft a performance that does not rely on learnt sequences of steps?

The concept of 'scoring' is central to my work with performance, both working in the studio and site-specifically. The term 'score' is used by practitioners in a variety of ways, but my own approach is firmly embedded in the RSVP cycles devised by Anna Halprin and her husband Lawrence, an architect and environmental planner. The cycles were originally devised as a way of working collaboratively within the creative process which could be applied to any creative enterprise from choreography to city planning. The letters stand for Resources, Score, 'Valuaction' and Performance.[4] I use scoring as an alternative approach to choreography. There are many different ways of presenting scores: they can be understood as maps of processes, they may be visual incorporating language or they may be a set of simple instructions which are open to interpretation. The purpose of scores in this context is to communicate, to generate creativity and facilitate artistic expression rather than to control others. Scores may be closed (precise) or open, or anywhere along this continuum depending on the intention and the stage of the artistic process. The central feature of the RSVP cycles is that they facilitate a cyclical rather than a linear process. Scores can be used at every stage of the process of creating performance, from initial explorations to generate movement material and themes, to finalising the proposed shape of the performance.

It is preferable to have a significant period of time working with a group before embarking on the process of performance making. This allows time for the group to gain confidence in themselves and the trust necessary to explore new possibilities as well as refining their body awareness and movement skills. During this time resources are also generated for creating scores which could later lead to performance. These resources include movement material and themes, interactions, ideas and the strengths and weaknesses of the group and the individuals within it. One of the beauties of the RSVP cycle is that it encourages you to view potential obstacles as resources. For example, if there is a member of the group who does not fit in easily and perhaps has very different resources from the rest of the group

this non-conformity can be incorporated positively into the performance score. For me the process of creating performance with a group does not start from a preconceived idea but from what I have witnessed as the group has been working together. In other words, the starting point comes from the group's responses to the initial scores that they have been given.

One of the biggest decisions that needs to be addressed is how collaboratively you want to work or how realistic it is to work in a specific situation, and what is your role as a facilitator or director. This needs to be clearly agreed with the group to avoid misunderstanding. Rather than scoring collectively I tend to feed scores back into the group that have been suggested to me by their previous work – for example, images, characters or movement resources that have arisen. Participants can then recognise that the scores being offered have evolved out of their own resources, enabling them to claim a degree of ownership of the piece. The scores guide the evolution of the piece at each stage of its development. It is not a question of creating a score and then just rehearsing it (a more conventional linear process from idea to product), but of reflecting on what has been happening and building on that experience by moving on to explore new resources, create new scores or refine existing ones. Combining a positive evaluation of the process so far with action is the Valuaction phase of the RSVP cycles.

It can be both an exciting and a challenging process for a group to create a performance apparently out of thin air. Admitting that initially you do not know what the performance will be like can generate anxiety, but your confidence in the working process is all that the participants have to rely on. Tolerating the unknown is a necessary part of the creative process, one that any director/chore-ographer needs to be able to handle personally but also needs to be able to 'hold' their performers in, trusting that solutions will come out of the process and sup-porting the performers to find their own solutions.

It is possible that in the move towards performance preconceived ideas about what dance is may arise again, for you as well the group, and the associated anxiety and pressure may trigger a desire to return to recognisable territory. Mapping how a series of familiar scores could build towards performance is a productive way of allaying such fears, giving the group and yourself something to hold on to. These scores may indicate pathways through space, themes, movement activities and qualities, and other resources such as props or music. Different scores within the same performance may be more structured or more open to interpretation. Scores may indicate what an individual or group is doing, when and where they are doing it and the theme and intention or atmosphere of each section as well as the tran-sitions between different phases. A roll of lining paper (cheap and available from any DIY store) and coloured felt tips can be used to map the evolving shape of a performance score. The score, which may develop through a series of variations before it is finalised, serves as a way of communicating decisions that have been made as well as highlighting aspects of the performance which need to be discussed

or finalised. The challenge in the later stages is to keep the process alive rather going through endless repetitions which can become lifeless and lose all sense of embodied presence. If the physical and creative ground work has been done before embarking on the performance element of a project this will serve the group well.

Clearly the balance between structure and spontaneity in any performance score will be affected by many factors, including the group, the situation, and the intention and theme of the performance. It is worth noting that whilst some people are energised by the presence of an audience others may find it challenging to maintain an embodied sense of themselves when they know that they are being watched. The score is the safety net which supports the performers individually and as a group on their journey through the performance – a journey which is of course shared with their audience.

Practical Exploration

The following score is designed to help participants explore the different movement landscapes generated by the movement of various individuals.

1. Get into groups of three. Each group works in a specific area of the room. Have paper/notebooks and pens near you at the edge of the space.
2. One person from each group enters the movement space and begins to move; the intention is not to perform but to follow the movement impulses which arise, allowing them to develop.
3. The other two group members sit in a relaxed but attentive way, aware of their own bodies and breathing, and allow themselves to 'receive' kinaesthetically as well as visually the movement of 'their' mover. Try not to be distracted by the other groups.
4. When they are ready and have a feeling for the movement landscape that is emerging, one of the two witnesses enters the movement space supporting and responding to that landscape. It's not a question of imitating the movements of the first mover or of direct interaction with them but of finding a way of experiencing what it is like to move in this environment. The original mover continues to follow their movement, allowing it to develop even if this means that the movement qualities change.
5. In time the second witness enters, responding as above until the three movers from each group are moving in a shared movement environment that has been 'seeded' by the first mover.
6. When the agreed time is over (I use Tibetan chimes to indicate time) each group allows the movement to find its own completion, returning to stillness. Beware of the temptation to construct a 'tidy' ending. Remain in stillness long enough to recognise the sensations, feelings, atmosphere and images that linger.

7. Without talking take a few moments to write freely out of the experience of moving. The words do not need to be shaped in any formal way and they do not need to explain or describe the experience; allow them instead to flow directly out of it, even if they do not appear to make much sense.

8. Repeat the score (stages 2–7) twice more with a different person's movement 'seeding' the movement landscape each time.

9. When complete the small groups share what each person wrote in respond to the three different movement experiences. Go through the environments in turn, allowing the person who initiated the movement to read first. When everyone has read people may like to share their experiences more freely.

Discussion Points

- What do you understand by the term non-stylised dance?
- What is it that makes a series of movements dance, as opposed to just movement?
- How can a technical training in dance impact on a performer who is practising non-stylised dance?
- Compare Helen Poynor's method of facilitating dance with Rosemary Lee's approach (see Chapter 8).

Notes

1. This term is borrowed from the writing of theatre practitioner Eugenio Barba; for a full explanation of his ideas about 'extra-daily' technique see Barba and Savarese (1991, p. 9). Briefly, it indicates that the use of our bodies in performance is different from their use in daily life. Performers in many of the world's traditions use what Barba refers to as 'extra-daily' techniques. This would apply equally to ballet and classical Indian dance.

2. This reflects Anna Halprin's three level of awareness (Worth and Poynor, 2004, p. 59–60). Anna Halprin is an American choreographer, dancer and teacher whose radical approach over the past 60 years has been a significant influence on dance both as a performance and a community art. I trained with her in the 1980s. She is an enduring influence on my approach; the integration of drawing and writing with movement work is one example of this.

3. Movement Ritual is a fluid sequence of floor movements encouraging flexibility in the spine and fostering in-depth kinaesthetic awareness as it works through the whole body. It can be used as a daily practice, a warm-up/work-out, a physical meditation and a springboard for movement explorations.

 Feldenkrais Awareness Through Movement Lessons® are another good source. There are many registered Feldenkrais practitioners in the United Kingdom.

4. For more detailed information on the RSVP cycles, including practical explorations, see Worth and Poynor (2005, p. 68–74, 111–26, 175–79 and Halprin (1969).

10 Second Time Open

Adam Benjamin

Adam Benjamin is an inspiring practitioner and lecturer who is probably best known for his contribution to integrated dance. As co-founder of CandoCo Dance Company he has played a major role in changing and challenging the nature of the involvement of disabled people in dance.

In this chapter he outlines his own journey as a dance artist, and explores the tensions that exist between accessible practice and professional performance. He also offers some additional food for thought about the defining features of community dance and the skills and qualities needed to deliver the work successfully.

In the eight years since this book was first published, I have been working within Higher Education as a lecturer at Plymouth University. Writing at a time when the arts (again) seem under threat, it is a good moment to look back at some of the developments that have taken place with the companies I worked with and to reconsider some of the implications for community dance.

I began writing the original chapter for *Introduction to Community Dance* in Cape Town whilst choreographing a new work for the Remix Dance Theatre. My first commission[1] with the company had been a few years earlier when they were still struggling to gain recognition. In 2006, shortly after the premier of the new work, the company won the 'Award for Cultural Development' and soon secured arts council funding which afforded them the financial stability to transition from part-time community-based company, into the first full-time, professional integrated dance company in South Africa. In considering their shift from community to professional practice, I reflected back on my own journey as a dance artist in the United Kingdom and asked questions of the role and value of community dance.

I was 27 when I took up a place to study dance and visual art at what was then Middlesex Polytechnic. Graduating in 1990, I started work on my first exhibition as a painter and scrambled to take on dance work in order to buy paint and canvas.

This was how I entered community dance, saying yes to every class I was offered, often busking my way through, learning on the hop and teaching part time at a local college. One of those community classes, co-taught with Celeste Dandeker, was to evolve into CandoCo Dance Company.[2] By 1993 I had given up all hope of a quiet life as a visual artist to become a full-time dancer/maker/teacher/company director – straddling both community outreach and professional performance. At this time the company was already touring the United Kingdom and although we didn't know it, we were about to take off around the world.

Development of CandoCo

CandoCo's early years illustrate the nature of the boundary between community and professional dance, for whilst we started as an open-to-all, 'everybody can dance' class, we quickly began to set ourselves performance and choreographic goals that would earn us the right to perform alongside other mainstream companies. It is worth remembering that in our first few years, the company would be listed in the back of major festival programmes under the title 'Disability Dance'. Fighting for professional and artistic recognition however imposed a new kind of selectivity within the company. Before long we had to scale down our 'community of dancers' so that a smaller group could be maintained and financed on a limited budget. As directors we made decisions in the way that any professional company must. We needed dancers who would fit into a newly defined team, which involved rehearsing, performing and delivering workshops. Touring was an integral part of our first funding agreement, so it needed to be a company small enough to move around the country. This painful process of selection was certainly one of the defining elements that distinguished the CandoCo of 1994 from that of 1992 and marked the company's journey into what is referred to as the 'dance industry' and a world of financial balance sheets and employment responsibilities.

With this shift the ethos changed from 'Everyone can dance' to 'Everyone can dance, but not necessarily in the company'. CandoCo as a professional company moved subtly away from immediate accessibility as we sought to raise levels of performance, whilst at the same time continuing to spread ideas of participation and access to an ever widening audience.[3] CandoCo developed an education programme, as did Remix in South Africa, in order to sustain community links, develop audiences, satisfy funders and build training opportunities for previously excluded members of the dance community. In this way professional dance fosters community dance, which in turn feeds the professional scene.[4] Disability rights was very much on the agenda; the Disability Discrimination Act (DDA), which made discrimination against disabled people unlawful, was only enacted in 1995 and CandoCo was seen as a 'flag ship company' providing a high-profile example of how the arts council/government was responding.

CandoCo radically altered the way disabled people were viewed – not just in dance but on a societal level too, through exposure on stage, in film and through frequent reviews and articles in the national press. The shift to professional touring meant that the education team were able to take integrated dance to communities throughout the Europe and beyond. In an incredibly fertile period between 1994 and 1997 the education work helped launch (amongst others) Blue Eyed Soul, Velcro, StopGap, Independance, Tardis and HandiCapace Tanz Kompanie (Germany). It also influenced a generation of dancers and dance students who have since made their way into significant positions around the world, amongst them, Nicole Richter who reinvigorated the artistic direction at Axis Dance Company in the United States, Louise Katerega and Katie Marsh, Caroline Bowditch (then in Australia), Gerda König in Germany, Katie MacCabe in Cambodia, Vicki Fox in Poland, Susanne Schneider in Switzerland, and Nicola Visser who established Remix in Cape Town. With support from the British Council, CandoCo was able to participate in the world dance community, forging links with countries where inclusion in society, let alone dance, had barely been broached.

Success on such a large scale however does not always promote creativity and by 1997 my choreographic career seemed to falter. In 1998 I left the company and began working, and more importantly researching, with dancers like Russell Maliphant, Kim Itoh, Jordi Cortés, Rick Nodine and Kirstie Simson. I also began to choreograph again for companies such as Vertigo Dance Company, StopGap, Scottish Dance Theatre and in African for Tshwaragano, Remix and Adugna. Throughout this time I maintained strong links in the community. It is this balancing act between community and professional dance that has been at the centre of my practice since my first meeting with Celeste Dandeker in 1990. This was at a time when the field of dance and disability was still in the process of throwing off the therapeutic and the charitable interventions and attitudes of the previous decades.

Dance by Disabled Performers – Some Issues and Debates

If work is shown under the community banner we are not necessarily expecting highly developed individual skills. The choreographer or directors task is to work creatively within limitations. This issue of performance capabilities weaves through the fabric of professional/community dance; the skilled choreographer working in the community will find ways of utilising whatever abilities the individuals on the project possess, certainly pushing and encouraging performance standards and bringing out the best in everyone, but at the same time not making unrealistic demands on individuals and not expecting high-level performance knowledge or skills where they don't exist. The United Kingdom boasts a wonderful array of choreographers who are as adept at making work for the professional stage as they are at making work in community – the likes of Rosemary

Lee, Luca Silvestrini and if we are in need of being reminded of the importance of creativity, a certain Wayne McGregor, one-time dance animateur for Redbridge, now Resident Choreographer of The Royal Ballet.

Challenges for the Choreographer

Choreographing for community requires a particular sensibility about where people are in their lives as well as in their journey as performers. It is, as often as not, about creating the best process and the best performance in which all these different, and differently skilled people can co-exist with a sense of dignity, and a sense of ownership.

Malcolm Black one of the founders of Remix was performing in *Second Time Broken*, the piece I choreographed for the company in 2006. At the time of making, his physical range and focus (as a result of Friedreich's Ataxia) had declined, and this despite his continuing commitment to training. After the first week in the studio it seemed important that we discuss whether he felt able to continue; whether he felt he could bring sufficient resources and energy to this new production. The talk was emotional and crucial for all of us and hinged around just this issue: being able to merit one's presence on stage in a professional setting. Malcolm made it clear that he wished to continue, and with the company's support also clearly expressed, it was then my responsibility to create a piece in which he could coexist with the other dancers on stage. By coexist I mean feel validity in his presence on stage as an artist, without excuse or apology.

The answer of how we might accomplish this came via a chance, overheard conversation in a Kalk Bay café. Local artist Katherine Glenday was creating ceramic vases that could be struck, albeit carefully, to create sound. I had already decided on the title *Second Time Broken*, so the snippet of conversation from the neighbouring table about fragility and sound immediately caught my attention. Introductions made, Katherine invited us to her studio and then, remarkably, agreed to loan us her pots, for which generosity of spirit I am still grateful! We immediately began to break new ground in the studio (sometimes quite literally). The danger of dancing with ceramic vases added a layer of meaning that spoke both to Malcolm's condition but also of something far greater and universal. The work now united us in a common task, a shared question about the risks we choose to take and the precariousness of the human condition.

The sounding of the pots held a particular resonance when struck by Andile Vellem, a deaf dancer, and different significances again when carried by Nicola Visser (who is white) and Mposteng Shuping (who is black). Katherine, whose work usually carries metaphors of fragility and care, was able to witness her pieces in a completely new light. 'Lurched off their pedestals', handled by dancers, on occasion thrown, dropped and toyed with. The vases also became central to the

music created by Neo Muyanga, leading him into an entirely new range of percussive sound. As so often is the case in inclusive work, it is the most fragile link, the most vulnerable spot, which provides the opening to new connections and understandings.

Simply thinking that a company is 'professional' and should therefore be able to handle technical work is to create a potentially disabling environment – or an environment in which only physically strong and technically capable disabled dancers can thrive; when this happens, the dancer who carries the greater impairment is handicapped by the physical language employed by the choreographer. This is most often witnessed in 'one-offs' or first encounters between professional choreographers and inclusive companies. An experienced eye can see the rift opening between dancers with more severe impairment and his or her colleagues – this subtle unravelling of the ensemble reveals a rift of understanding, a lack of listening at the centre of the work.

Impact of Industry

In the early days of CandoCo the company emphasised that the work was not *about* disability, it was about dance and creating a new aesthetic. It is no small irony that one of the most successful pieces from the company in recent years has been *Let's talk about Dis* (2014) directed by Hetain Patel, a piece that tackled disability head on, whilst the company itself is now directed by two non-disabled dancers. In Cape Town Andille Vellem and Mposteng Shuping now work with artistic director Themba Mbuli in Unmute Dance Company which, whilst evidently integrated on disability lines, is less evidently integrated on grounds of colour. Unmute has replaced Remix as the sole professional integrated company in South Africa,[6] whilst Remix continue as a principally education outreach project.

Given that CandoCo was once led by disabled and non-disabled directors and Remix was once integrated along racial as well as physical lines, might it be that there is a tension within the professional context that pulls against integration?

If current trends are anything to go by, it seems that we want our disabled dancers fit and lean and although the sight of highly trained, virtuosic disabled performers *is* thrilling and inspiring, it seems that we may be losing sight of the essentially poetic principles at the heart of inclusivity; the question of how different things – *really* different things – connect. Beauty is an elusive bird and if disabled dancers are only employed because of their athleticism or their passing resemblance to the classical dancer's body, we may yet have to turn to community dance, where the net is cast wider, in order to see how the challenge of difference is really engaged with.

Community dance has been considered, historically, a less sophisticated branch of the art form – certainly not 'high art'. The challenges to our understanding

of aesthetics however is, if anything, greater in community dance than it is elsewhere. It is without doubt here, away from the commercial demands of the industry, that creativity and innovation can take its first uncertain steps, throwing up new possibilities and deeply influencing the lives of people often in difficult and trying circumstances. Culturally our inability to value creativity is evident in the pay scale of those working with pre-school children, possibly one of the most vital and influential stages of education, yet one that consistently fails to attract our best teachers dance or otherwise, because the pay for such work is so unattractive.

When innovative and skilled teachers are able to work with young people throughout their educational experience, we see the results in exceptional dancer/choreographers like Chris Pavia[7] and Hannah Sampson, two artists (with Stop-Gap Dance Company) with Downs Syndrome, who have raised the expectations of all people with learning difficulties through their work with the company; a reminder, if we need one, that most limitations we experience are a result of 'teaching difficulties'.

So what are the qualities and skills that teachers in the community need? 'Increasingly these are professionally trained dancers/teachers', yet their skills must be multiple, they must be dancers first and foremost, but then also educators, communicators, negotiators. They must bring with them the experiences of a life lived, not theorised. They must be 'hands on' and detached at the same time; they need to understand people and the arts, for their interventions are not simply with the academically gifted or the dance trained but with people of all abilities and backgrounds. I think of extraordinary work of Jordi Cortés with Association KIAKAHART in Barcelona, Gladys Agulhas in Johannesburg, Ana Rita Barata in Portugal or Isabel Jones in the United Kingdom, trained dance artists who straddle community and professional worlds.

Community Dance/Professional Dance – Is There a Difference?

Reflecting on 30 years of continued involvement in dance, and watching the ebb and flow of companies and dance organisations, I am more than ever convinced that the real difference between community and professional dance is not one of aesthetics. I have seen work by professional companies which satisfies few aesthetic criteria, and I have seen work by non-professional groups which has held me spellbound. Nor is the difference any longer solely about body type, for there are ample examples of professional companies and choreographers whose work has included widely different bodies, the early work of Michael Clark, DV8, Alain Platel, Jerome Bel and, and whilst it is true that companies like StopGap, Unmute, Axis, Joint Forces and CandoCo maintain a far greater commitment to inclusivity, the balletic mould of the dancer has most definitely been broken.

Today, disabled people are embedded in the UK dance scene in a way unimaginable in the 1970s and 1980s and inclusive companies and groups exist and flourish around the world. Perhaps this is one of the most remarkable cultural shifts that has taken place in recent years and one that has begun to have repercussions throughout dance education and training as disabled people, now visible, exercise their rights. Universities can, when given enough support and encouragement, implement their equal opportunity legislation and actually take disabled students onto their programmes. Plymouth University has demonstrated that this is not only possible, but that all students reap multiple benefits from inclusive education. Opening our educational institutions to the wider community ensures that real learning about community takes place during training, not as a theory but as part of our daily experience.

Defining Features of Community Dance

It may have been a long and very winding road to reach such an obvious conclusion, but it seems that the defining element of community dance is its relevance to local people, to the people who live next door to you – perhaps at this moment unknown. Community dance is made in a neighbourhood and performed by neighbours (some of whom may even be professional dancers). It might be seen in one or two venues around that neighbourhood or borough, and even make the odd excursion further afield, but it rarely tours and does not often place itself on the market shelf (even though some of its members might dream of being there). It harks back to the origins of dance and points us to an ever-pressing question of how we sustain real human communication /community in an ever more digital and solitary world.

Community dance in many ways is dance that knows its *place*. I never once imagined when I trained as a dancer that I would spend so much of my life overseas, nor that I would have the privilege to work in South Africa – a country which, under apartheid, exemplified all that community dance opposes. Strange that a principle, so much to do with 'neighbourhood', should have taken me so far from my own backyard.

It is worth remembering that even 20 years ago there were two no more diverse populations than those of disabled people and professional dancers, poles apart, suspicious and mistrustful of each other's worlds. Now there are disabled people who *are* professional dancers. Once the door has been opened, how far we travel and what connections we make are restricted only by our imagination; when a mind is attuned and informed as to the possibilities that the world holds, the choices and possible journeys even within our own neighbourhood are endless. Community dance reminds us of, and educates us in what it means to be connected and 'in communication' and, at the same time leads us out (from the Latin *educere*) into the wider world.

Notes

1. *Taking Care of Small Things* (2002), *Second Time Broken* (2006)
2. CandoCo was the first professional company for disabled and non-disabled dancers. See Making an Entrance: Theory and Practice for Disabled and Non-disabled Dancers. Routledge (2002).
3. It was the professionalism of CandoCo that caused many dance institutions to reconsider their attitudes to integrated work and consider taking on disabled students. See 'The problem with steps', *Animated* magazine, Autumn 1999.
4. CandoCo began its Foundation Course for disabled dancers in 2005.
5. See In Search of Integrity. *Dance Theatre Journal*, **10**(4), Autumn 1993.
6. Malcolm Black continues to run Remix as an integrated dance in education project, working with groups from mainstream schools and special-needs schools together.
7. See http://www.adambenjamin.co.uk/directory.html.

Part IV
Community Dance Practitioners

Introduction

Part IV focuses on community dance artists:

- What they actually do
- How they acquire their skills
- Routes into the profession and possible career options
- The other people and organisations that they work with

If you have recently become involved in participatory dance work or are considering a career as a community dance artist the following chapters will give you an insight into what these people actually do. You will realise, as you read through this section, that it isn't like other professions which have a clear route from universally recognised initial qualification through to well-defined roles and progression opportunities. There *are* qualifications and there are various career options once you get started, but people rarely follow the same pathways. This is what excites me about belonging to this world. I enjoy the flexible, unpredictable, open-ended nature of the work. My ongoing contact with community groups nourishes me and helps me refine my skills.

I also have a real sense that I can shape my career as an artist. I can choose which work to accept and I can create opportunities to work with individuals and communities where I think I can make a positive contribution. Yes – I imagine emerging practitioners thinking 'It's all right for people like Diane – they've been around for ages so it's going to be easier for them to find work'. This may be so, but my approach now is the same as it has always been: I have an idea for a project and I explore funding opportunities, find participants and create partnerships with people who are interested in working with me. If there is something that inspires and challenges you as an artist, you will find a way of making it happen. As community dance continues to develop into an established profession

I believe there will always be opportunities for practitioners to be proactive in engaging others in the art of dance.

There are specific skills and knowledge which help with this process and these are discussed in Chapter 11 together with leadership behaviour which supports person-centred practice. In the following chapter Sue Akroyd and Anna Leatherdale set out ways that dance artists can acquire these skills and engage in continuing professional development. Chapter 13 will give you an insight into what employers are looking for, and in Chapter 14 I look at the artist's role in building effective relationships with the various people involved.

When you take account of the needs of the different stakeholders it is not surprising that community dance practitioners often act as intermediaries: they are artists, but, as they have connections with a number of different 'worlds', they need mediation skills to help members of these different worlds meet and understand each other. They can be the 'glue' that binds together diverse elements of the same community. Sometimes dance artists on participatory projects help groups by creating links between 'officialdom' and local community issues and aspirations. They can use their knowledge of the health service/arts council/ voluntary sector/local authorities/education/criminal justice system to demystify bureaucracy, translate jargon into everyday language and help communities identify possible sources of funding.

As you read through these chapters think about your own skills and the kind of work you would like to be involved in. Make notes of areas that you find interesting and find out about opportunities for gaining more experience. You don't have to wait for a formal course of training – perhaps, for example, you can find an opportunity to shadow an experienced artist who is working in a context that interests you.

Further Reading

Adams, P. (1998) *Gesundheit*. Healing Arts Press, Rochester.
Cameron, J. (1994) *The Artist's Way: A Course in Discovering and Recovering Your Creative Self*. Pan Macmillan, London.
Delfini, L. (Ed) (2004) Oltre la Scuola … la Community Dance: DES, Bologna.
Lansley, J. & Early, F. (2011) *The Wise Body*. Intellect, Bristol.
Snook, B. (2015) *Dance for Senior Students* 2nd edn. Cengage Learning, Melbourne.
Thompson, N. (2002) *People Skills*. Palgrave Macmillan, Basingstoke.

11 The Dynamic Role of the Community Dance Practitioner

Diane Amans

This chapter explores what it means to be a community dance worker. It includes:

- Case studies showing how different dance artists have become involved in community dance.
- Skills needed to lead participatory dance workshops.
- Leadership behaviour and the way this connects with person-centred practice.
- Personal effectiveness – and making time to 'nourish your artist'.
- Some thoughts on the needs and agendas of the various people and organisations associated with a community dance project.

The accompanying exercise one will help you reflect on your own strengths and identify areas for development. You can follow these up in Chapter 12 where Sue Akroyd and Anna Leatherdale outline a flexible approach to continuing professional development opportunities for community dance practitioners.

> WANTED – an enthusiastic, imaginative, well-organised dance artist with exceptional people skills, boundless energy and the ability to cope under pressure. (Must be flexible and able to work unsocial hours.)

The job vacancies advertised in dance journals and associated websites continually reflect the great variety of work that is being delivered by dance practitioners in community contexts. Community dance practitioners are engaged in a range of different activities: they teach classes, create dance pieces, organise showcase events, liaise with partner organisations, write reports, produce dance resource materials, manage budgets, deliver training, carry out administration tasks and develop new audiences.

Some practitioners are employed full time by a dance agency: others work in community dance on a part-time or freelance basis. Freelance dance artists may spend some of their time in community work and the rest of their time in other aspects of dance work – for example choreographing and performing with a dance company. The following case studies illustrate the working lives of four very different community dance practitioners.

Emma

Emma has been working for two years as a community dance artist. After graduating with a degree in Dance Studies, she took up an apprenticeship with a dance company and now has a full-time permanent post with them.

Emma currently runs 14 sessions a week in a variety of community and education settings. These include youth dance groups, after school dance clubs, over 50s group, classes in a primary school and early years family sessions. The company employs one other community dance artist (part time three days a week) and five freelance dance artists who deliver a variety of community classes.

When she is not leading classes Emma's time is spent doing administrative tasks, attending meetings, planning and coordinating her portfolio of work and preparing for the community dance showcase. She has fortnightly mentoring sessions with the artistic director of the dance company. She is surprised how much of her time is spent on administrative tasks and meetings. She has just been asked to hand her youth dance groups over to freelancers as the company want her to spend time developing projects with the local health and social care team.

Emma's role is defined for her by the dance company she works for. She was recruited to carry out specific duties outlined in a clear job description, although she is encouraged to contribute ideas for new projects. Any changes or developments are discussed at team meetings.

Ashley

Ashley has a portfolio of freelance dance work in Scotland. He developed his passion for dance after being involved in a youth dance project when he was 15. The touring company which led the project inspired Ashley to train in dance at a professional level and he is now keen to provide positive dance experiences for young people. He is concerned about the rather pot luck nature of dance education in schools, which varies considerably according to the skills and interests of the teachers at any given time.

Ashley combines regular weekly sessions in schools, colleges and day centres with choreographing and performing dance pieces with a dance company he founded with two other dancers. Most of his community dance work is passed

on to him by the local authority dance development officer, who keeps a register of freelance artists.

Ashley has considerable autonomy in deciding how he spends his time. He usually finds that there is no shortage of freelance work although sometimes, for example in school holidays, he has several weeks where he has less work (and consequently less income) than he would like.

Lynne

Lynne initially trained as a secondary school modern languages teacher and became involved in community dance after she attended classes in belly dancing. She enjoyed it so much she enrolled on a part-time training course for teaching dance and now runs her own classes.

Three years ago she began with one class in her local community centre and now runs weekly classes in three different venues over a fairly large rural area. She has just been awarded a local authority voluntary arts grant to develop a performance piece for the local community dance showcase event. She has invited a guest choreographer to lead the project and hopes to involve participants from all three groups.

She meets up with other dancers at Forum meetings organised by her local dance agency. She enjoys being part of the performing arts world but is rather self-conscious about the fact that most of the other dancers are much younger and many have dance degrees. Her local dance agency supports her with mentoring sessions and she regularly attends class.

Jerome

Jerome is a choreographer and artistic director of a dance company. In addition to making work and touring with his own company he choreographs work for other companies in the United Kingdom and Europe. Four years ago he was commissioned to create a dance piece for a community dance festival. The dance involved participants from different community groups and included dancers of all ages. Since then Jerome has been involved in other community projects and works on these alongside his own company's work.

He enjoys using his skills as a choreographer in new and different contexts and finds that what he has learned from making dance with community groups is nourishing him as an artist.

These pen pictures illustrate the very different journeys which lead to working in community dance. Lynne had done very little dance until she was in her early forties, whilst Ashley has danced every day since he was a teenager. Many dance artists, like Emma, choose to work in community contexts from the

outset. Others, such as Jerome, take on community work to supplement their 'main passion' – as a performer or choreographer. Most community dance artists find that the experience of working on participatory projects offers unexpected rewards, including the opportunity to develop new skills.

What Skills Does a Community Dance Artist Need?

The 'wanted' advert at the beginning of this chapter is a light-hearted summary of actual comments made by directors of dance agencies (Amans, 2006). Recent interviews with these directors and other managers who commission work from community dance artists revealed that the following are particularly valued:

- Organisation skills.
- People skills.
- Knowledge of contexts.
- Respect for and sensitivity to the contexts in which they work.
- Putting participants at the centre of their practice.
- Demonstration of good practice in teaching.
- Skills as a dancer and choreographer.
- An inclusive approach.
- Awareness of diversity issues.
- Able to manage and balance individual and group needs.
- Ability to evaluate.
- Creativity.
- Enthusiasm.
- Professionalism.

The extent to which the above skills and knowledge are considered to be essential will differ according to the priorities of the organisation employing the artist. The job description below and on the next page was for a post with Green Candle Dance Company in January 2016.

This job description is clearly aimed at recruiting a dance graduate with an extensive range of community experience. It is important to Green Candle that their community practitioner is an *artist* with additional skills. Green Candle has a commitment to 'working in a way which is inclusive and creative' and, like many dance companies involved in community dance work, they have a commitment to work in a person-centred way.[1]

Green Candle Community Dance Artist Job Description

Green Candle Dance Company is seeking a permanent part time Community Dance Artist with significant experience and skills in leading dance with older people with and without physical disabilities or cognitive impairments

and in working with children and young people in mainstream Primary and Secondary Schools, with and without physical and learning disabilities.

The post involves practical teaching, facilitating and choreographing dance with all the above groups, as well as fostering, developing and managing new and existing projects and partnerships. The work will also include related project planning, administration and evaluation.

Candidates were selected by interview, submission of sample project plan and teaching audition. These were the shortlist criteria that Green Candle used to select applicants for interview:

- 2 years' teaching older people in a variety of settings such as Day Care Centres, hospitals …
- 2 years' teaching younger people in a variety of settings such as schools and community settings …
- Professional training to degree level or equivalent
- Additional skills in popular or non-Western dance forms.
- Devising and choreographic skills.
- Commitment to community dance practice and company values.
- Good working knowledge of the sector.
- Leadership skills.
- Aware of child and vulnerable adult protection, equal opportunities, health & safety, safe dance practice.
- Good office skills, including IT.
- Good standard of literacy.
- Self-motivated and able to initiate work.
- Good communicator.
- Good organiser.

Leadership

The following extracts from the People Dancing booklet *Dancing Nation* highlight the impact on the participants of working with a leader who establishes a collaborative relationship with the dancers in the group (FCD, 2001):

Shaun and Roy work in a special way because they don't teach you as a group but as an individual, they let you do your own style – and they suit your abilities to the moves – instead of teaching one move to all the group.

It's not just a teacher–pupil relationship. You go to school and there are teachers who teach you, but Gail and Ian are different, that's why our work is so effective because the atmosphere we work in is so great.

In creating a dance, Wolfgang allows us to express ideas through a piece of music, or through words and improvisation and uses them to contribute to a production. So a production doesn't come solely from him, it comes in many ways from us.

Rosemary Lee, in the introduction to *Dancing Nation*, says of the leaders:

Their belief that participants can dance, are worth listening to and their respect for their students and the art form itself unquestionably have a profound effect on their group. It is what makes an inspiring teacher – someone who believes in you utterly and your potential as a creative individual (**ibid**).

The leadership behaviour of the artist delivering the session determines whether or not the experience of the participants reflects the core values of community dance (see Chapter 1). Ideally the leader will have knowledge and understanding of group dynamics and excellent people skills. John Adair, whose action-centred leadership theories are often used in team development training, stressed the importance of leadership which supports the needs of the task, the group and the individuals in the group. He distinguished between task-oriented and maintenance-oriented leadership actions (Adair, 1998).

Task-oriented functions are concerned with the achievement of goals, seeking and giving information, and successfully completing activities. Maintenance-oriented actions focus on the emotional life of the group, offering support and encouragement and promoting effective relationships. Although members of the group may contribute to task and maintenance functions it is the leader's responsibility to ensure that both sets of actions are carried out and the right balance is achieved between them.

Table 11.1 shows some aspects of community dance artist behaviours which illustrate the different leadership actions:

Table 11.1 Leadership actions

Task-oriented leadership actions	Maintenance-oriented leadership actions
Lead warm-up activities	Help participants communicate ideas
Teach movement phrases	Encourage participation
Teach steps and set routines	Offer support and/or praise
Suggest starting points for choreography	Motivate and inspire
Give feedback after improvisations and suggest additional/alternative movements	Facilitate interaction between group members
Suggest solutions to choreographic problems	Use humour to relieve tension
	Spend time on relationship-building activities
	Allocate time for break/refreshments
	Provide refreshments
	Containment/'holding' a group safely

Another way of looking at leadership behaviour is to consider leader inter-vention and participant autonomy as a continuum. In a group which is very 'leader-centred' the dance practitioner makes the decisions and implements them with little or no opportunity for participants to make choices. At the other end of the spectrum the group has total freedom to control all aspects of the session.

Although many participants in dance projects appreciate some freedom of choice, most want clear leadership and a definite structure to the sessions. In a mixed-ability community dance group it takes ingenuity and flexibility on the part of the practitioner to manage sessions which stimulate and challenge the more confident group members whilst ensuring that those members who prefer to 'play safe' and be told what to do are encouraged to take risks.

Jo Butterworth has developed a model that offers some interesting insights into the relationship between dance artists working as choreographers and the participants with whom they are making dance. Her Didactic-Democratic framework outlines five processes ranging from 'Choreographer as expert/ dancer as instrument' through to 'Choreographer as co-owner/dancer as co-owner'. In the middle there is 'Choreographer as pilot/dancer as contrib-utor'. The model is a useful in helping dance practitioners reflect on their facilitation style.[2]

Artists working on performance projects acknowledge that their leader-ship style changes according to the context in which they were working. For example, in the sessions leading up to a performance the area of freedom of the group is reduced as the leadership style becomes more task-oriented. This leadership behaviour corresponds, unsurprisingly, with situational and contingency theories of leadership (Johnson and Johnson, 1991) (different situations require different leadership styles). The existence of an 'end prod-uct' inevitably means that the leader has to take control and ensure that the group is ready to perform. For a short period the task is all-important and may take more of the leader's time and energy than attending to individual and group needs.

Community Dance – Whose Needs Is It Meeting?

This is a fundamental issue to be considered in any discussion about the role of a community dance practitioner. In person-centred community dance practice it is important to ensure that the needs of the participants are met, but there are other people and agendas involved. Consider the needs of the following:

- The organisation commissioning the work.
- The funding body.
- Host organisation staff such as teachers/support workers.

- Family members of the participants.
- Dance artist leading the project.

Members of each of the above groups have their own needs and priorities, some of which are listed in Table 11.2, together with participants' needs.

These needs are not necessarily incompatible, but occasions will arise where there is conflict. For example, the commissioning organisation may want an 'end product' in the form of a performance, whereas the participants want to enjoy exploring creative ideas and making art without the pressure of a performance. Who decides which needs have priority?

Another example of conflicting needs is where an artist wishes to teach a dance style with carefully choreographed routines and is working with participants who attend the class mainly for social and recreational reasons. They just want to enjoy moving and are not interested in 'getting it right'. How far is it the responsibility of the dance practitioner to promote skills development in order that people are better able to engage with the art form?

In his critique of cultural imperialism in community arts practice Owen Kelly asserts that 'directive professionals' are fulfilling 'their own professional needs' rather than those of the community (Kelly, 1984). Is this true of community dance professionals? To what extent are dance artists *aware* of their needs and the way these are influencing their practice? Sometimes dance practitioners have not considered their own needs and lack the awareness

Table 11.2 Needs and priorities

Needs of participants	Needs of funding body	Needs of commissioning organisation
Access to dance activities	Policy implementation (e.g.	Meet targets
Skills development	social inclusion)	Provide access to dance
Social activity	To be seen to support	Introduce new activities
Making art/being artists	'worthy causes'	To be seen to introduce new
Exercise	To monitor how money is	activities
Sense of achievement	spent	Fulfil requirements of the
New challenges		national curriculum
Needs of dance artist	**Needs of staff in host organisation**	**Needs of family members**
Paid work/job security	A break from usual routine	To know participant is happy
Job satisfaction	To see participants enjoying	and safe
To create work/choreograph	themselves	To have regular respite from
To perform	Professional development	caring
New challenges		To find enjoyable leisure
To help others/feel useful		activity for participant
Sense of achievement		

to realise that they may be allowing those needs to influence their practice. What is important is that all needs are taken into account in the planning and implementation of projects and that dance practitioners have the necessary skills and awareness to work in a collaborative way. They also need skills in assessment, observation and evaluation so that they can be sure the dance sessions are meeting the agreed needs of participants and other appropriate stakeholders.

Personal Effectiveness – and Making Time to 'Nourish Your Artist'

The challenges presented by community dance require artists to have both skills and stamina. It can be exhausting work that needs to be managed efficiently if the dance practitioners are to avoid burnout and retain their enthusiasm for the work. There are some basic skills in organisation and self-management which are essential for both freelance dance practitioners and those who are employed by a dance agency or other community organisation.[3] (See Resources section for tips on making the best use of your time.)

Effective time management and skills in prioritising tasks will mean that dancers are able to fit in time for *themselves* – for reflection, reading, going to

Figure 11.1 Freedom in Dance Salford Elders Project (*Matthew Priestley*)

Exercise 2

Observe the leadership behaviour of a dance artist leading a community group. You could do this as a participant observer but you may find it more useful to watch from the outside and make notes.

- Notice which of the leadership behaviour involves task-oriented actions and how much is maintenance-oriented.
- How does the leader communicate with the group? With verbal directions/suggestions? Is there non-verbal communication? How much does the leader actually speak during the session?
- How does the leader begin and end the session?

Notes

1. The term 'person-centred' is used in a Rogerian sense to emphasise the value of the individual and to promote the development of the individual within the group. See Kirschenbaum and Henderson (1990) for a discussion of person-centred practice.
2. There is a full explanation of the Didactic-Democratic framework in Chapter 12 of Butterworth and Wildschut (2009).
3. See Resources section for time management techniques and tools.

12 Getting to Where You Want to Be

Sue Akroyd and Anna Leatherdale

*In this chapter Sue and Anna focus on the knowledge and skills that dance practition-
ers need to work in community settings and the way in which these can be acquired
and developed. They give an overview of the various training courses and opportunities
available to emerging and established community dance practitioners and outline key
principles and features of continuing professional development for community dance
artists. Whilst this chapter focuses on becoming a practitioner in the United Kingdom,
the case studies in Chapter 15 include references to the career development of dance
artists in a number of other countries.*

The idea of 'becoming' a professional community dance artist is a curious thing.

There's nothing to tell you when you've made it – no finishing line, no
certificate on the wall, no letters after your name, no professional licence. So
how do you – and others – know when you *are* one? In the simplest terms, it's
when you begin to earn a living working in dance in community settings. But
beyond that, what makes you a professional community dance artist? How do
you know when you are ready to do the job? If you want to be one, how do
you go about it?

The answers to these questions are not straightforward.

National Occupational Standards for Dance Leadership (NOS)

In community dance, there are no formal or universally agreed criteria that deter-
mine an individual's 'readiness' to practise as a professional. However, there is
a list of skills and knowledge that the dance sector agrees dance leaders need

during the course of their career. Developed by People Dancing on behalf of the Dance Training and Accreditation Partnership (DTAP), the NOS provide a useful checklist for dance artists so that they can reflect on their practice and consider the range of skills they need to develop in order to be most effective. Whilst an increasing number of course providers and training routes are using the NOS as a benchmark for course content, there is no prescribed route into the profession and few 'must haves' or 'must dos' on the way to becoming a professional practitioner.

In fact, a key characteristic of the community dance profession is the variety of routes people take into it, and the range of people who do it. Individuals come from diverse backgrounds, training and experience, and practise different styles and forms of dance. This is one of its strengths: different people bring different things to the work, which enables the profession as a whole to engage with a wide range of individuals and communities, each with different needs, interests and ambitions. Community dance is an inclusive profession: it values difference and individuality and supports many interpretations of what it is to be a dance artist.

So Can Anyone Be a Professional Community Dance Artist?

Yes and no. Yes, in that you don't have to be any particular age, gender, race, size, shape and so on. Nor do you have to work in a particular dance style or have had a specific type of training. But there are fundamental values and principles that underpin community dance practice and define the community dance artist, regardless of background, training or experience. Community dance artists:

- Share a belief that dance can make a unique and positive contribution to the artistic, creative, educational, social and physical and mental well-being and development of individuals and communities.
- Are committed to enabling access to, and participation in, dance for people of all ages, abilities and backgrounds.
- Possess specialised skills, knowledge and attitudes/qualities (competencies) that make it possible to deliver high-quality, safe, enjoyable dance experiences that meet the creative, learning, physical, psychological and social needs and ambitions of a wide range of participants, in a wide range of settings and contexts.

To be a community dance artist is to hold particular beliefs about the relationship between dance, people, and people dancing, and to possess the skills, knowledge, commitment and motivation to put these beliefs into practice.

And How Does This Come About?

Values can be imparted and nurtured and individual beliefs and attitudes are shaped by an awareness and openness to experiences and environment. But essentially you are either driven by certain beliefs, and committed to pursuing them through your choices and actions, or not. So in some ways, community dance can be seen as a 'calling' or a way of working that 'clicks' with certain people. However, that is not all there is to it – passion and commitment are not enough. Skills and knowledge, the ability to put ideas into practice, to know what to do, when to do it, and to be able to do it effectively – these are crucial aspects of being a professional, and the good news is that these things can be learned, nurtured and developed.

So Where Do I Begin?

Most people's first exposure to dance will be through watching or participating – at school, as a hobby or socially. Your early dance experiences are the beginning of your learning: watching dance gives you a sense of the form and can expose you to different dance styles, techniques and aesthetics. Participating in dance gives you a crucial understanding of what it feels like to dance, how your own body works, learning about making dances, as well as the beginnings of transferable skills such as communication, cooperation, listening, observation and problem-solving.

Your experiences as a participant and a watcher may continue and develop through your personal and professional life, but if your professional goal is to work in community dance, you will need to expand your dance experiences to include some more focussed learning. This could take place in several ways, ranging from formal, mainstream training and education, to self-directed, experiential learning.

Mainstream Education (School, College and University)

Many artists currently working in community dance have not had access to the study of community dance as part of their formal education – for many mature or long-standing practitioners it did not exist as an option. These days, it is possible to study – and gain qualifications in – dance at all educational levels. The study of community dance within mainstream education only really becomes an option beyond secondary school (post–age 16), in further and higher education courses offered at colleges, universities and conservatoires.

Further Education Courses and Qualifications

There are an increasing number of courses and qualifications on offer that can be useful to dancers working in a community context. A range of short courses

About CPD

All our personal and professional experiences offer us the opportunity for learning, but the best CPD is a conscious and systematic approach to maintaining and extending one's professional skills, knowledge and expertise. It means that our learning is planned, rather than *ad hoc* or incidental. Planning our CPD helps us to reach a particular personal or professional goal. We work towards achieving a specific personal or professional outcome, or enhancing an aspect of professional practice.

CPD and You

As a practising professional, you have a responsibility – to yourself and others – to invest in your own learning and actively engage with your own professional development in order to:

- Maintain a baseline level of competence in your professional role.
- Ensure that your knowledge and skills are relevant and up to date.
- Enable your own progression and future employability.

It is important to acknowledge that no one can do everything, or is equally good at all the things they do, and that we all have different strengths and weaknesses. But there is always room for improvement, and as a professional practitioner you should be committed to getting better at what you do. This is where CPD comes in.

CPD is the vehicle that enables you to:

- Focus on your existing competences in your professional role.
- Identify the development you need to improve your performance.
- Reflect on your learning and progression.
- Work towards achieving your future professional ambitions.

The whole process centres on you. It demands self-awareness, rigour, and a considered and developmental approach to learning. It means getting to know yourself personally and professionally, making informed choices about how, when and where your learning takes place, making time for learning, and reflecting regularly on the outcomes of your learning.

Without your investment and engagement, CPD becomes a superficial exercise; *with* your investment and engagement, CPD enables you to take control of your own learning and professional choices.

By putting CPD at the heart of your professional practice, you value and demonstrate a commitment to both your own professional progression and to meeting others' expectations of you as a responsible, capable and committed practitioner.

Development Needs Analysis (DNA)

People Dancing has created a useful tool to help dancers identify and reflect on their CPD needs and find resources to help them fill the gaps. The Development Needs Analysis (DNA) is based on the National Occupational Standards for Dance Leadership (NOS). It's an online tool that enables you to rate your levels of confidence in relation to areas of skills and knowledge identified in the NOS. It also helps you identify what skills and knowledge you need in your current work, which ones you might need in the future and pulls together a list of potential resources including reading lists and course suggestions that you may want to use to help you bridge the gap. A sample copy of the DNA is included in the Resources section.

So How Does CPD Work?

Regardless of what stage you have reached in your career, the cycle of CPD is the same (Figure 12.1).

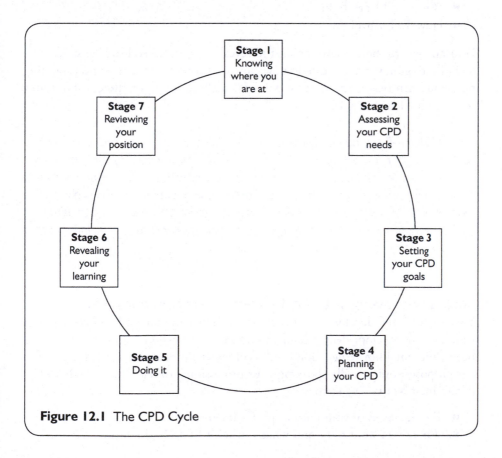

Stage 1
Knowing where you are at

Stage 7
Reviewing your position

Stage 2
Assessing your CPD needs

Stage 6
Revealing your learning

Stage 3
Setting your CPD goals

Stage 5
Doing it

Stage 4
Planning your CPD

Figure 12.1 The CPD Cycle

Stage 1: Knowing Where You Are At

Before you start planning your CPD, you need to have a clear sense of where you are at now. Getting to know yourself in a professional context is crucial to making informed decisions about how to proceed with your CPD: the more information you have about yourself and your needs, the clearer you will be about what to do next. You may want to use the DNA to get you started, or you can ask yourself:

- What skills do I have?
- What is the current breadth and depth of my knowledge and understanding?
- What am I able to do?

Your answers to these questions start to reveal your professional competencies. Now ask yourself:

- How do I like to learn?
- When do I learn best?
- How do I learn best?

Your answers to these questions start to reveal your preferred learning style.

Reflecting on what you can do now, how well you can do it and understanding how you learn best is the starting point for making the right choices about how to proceed with your CPD.

SUGGESTION: If you find it difficult to answer these questions, or you don't feel fully confident in your responses, this in itself will tell you something about where you are at. Self-reflection is a skill (and gets better and easier with practice), but initially you may benefit from some help. Make use of other people around you who know you – a teacher or tutor, your peers or work colleagues. In addition, there are a multitude of self-assessment tools and learning styles questionnaires available on the Internet that will take you through the process step by step.

Stage 2: Assessing Your Professional Development Needs

Your professional development needs are particular to you, and will change over time as you develop, deepen and extend your professional competencies. You need different knowledge, skills and abilities at different times and for different purposes, but broadly speaking your professional development needs will be determined by two key factors:

- The demands of your current professional role.
- Where you want to be and what you want to do in the future.

The Demands of Your Current Professional Role

Sometimes, your professional development needs can be obvious. Starting a new job, or being offered work in an area of practice that is new to you, can reveal obvious gaps in skills and knowledge that need to be addressed.

- It may be a condition of employment that you are able to evidence competence in a specific area of practice (which may or may not be dance-related), or in working with a particular group.
- Some work might require you to undertake particular training, or to be tested, or to have evidence of your competence in order to fulfil a legal requirement of employment.
- Some qualifications – first aid for example – need to be updated regularly. Employers in some contexts are increasingly bound by sector policies that demand that practitioners be suitably developed to a prescribed level. These include the criminal justice sector, health and social care, and any other context where practitioners are working with children, young persons or vulnerable adults.

Throughout your career, the demands of your employment or your employer will continue to guide or even dictate a certain proportion of your CPD needs.

Beyond this, your awareness of what it takes to be an effective practitioner in any given context can be heightened and informed by taking care to keep yourself updated about current trends in what is considered best practice. Learning from experienced practitioners, witnessing their practice, and reading about their work in industry journals, can all be useful ways of revealing your own learning needs.

Animated magazine, the journal of People Dancing, contains articles by, and about, community dance professionals and their work, and is a useful way of keeping abreast of current practice.

Where You Want to Be and What You Want to Do in the Future

Having a clear sense of what you want to do in the future will help you to decide what you need to do now.

It may be that you have a detailed and ambitious career plan mapped out ahead of you, or you may just have an idea that you would like to work in a certain way or explore a new area of practice. Either way, it is likely that achieving this goal will require some additional learning on your part. Taking time to research the demands, expectations or requirements of your future professional role/s and mapping those against your current knowledge, skills and understanding will reveal the competency gap and consequently the learning needs.

Stage 3: Setting Your CPD Goals

This stage is about making an explicit commitment to your learning. Remember that CPD is most effective when you have a systematic and planned approach to learning, so you need to know what you are aiming for and when you have achieved it. A popular mechanism for articulating goals (or objectives) is the acronym SMART, which stands for:

- Specific.
- Measurable.
- Agreed.
- Realistic.
- Timed or time-specific.

If we apply this to setting your learning goals, it works as follows:

- Specific – being clear and definite about what you will achieve:

'I will be able to do a risk assessment for my parents and toddlers group that meets the requirements of the playgroup leader' rather than 'I will be better at risk assessment.'

- Measurable – being able to tell when you have achieved the goal:

'I will know that I can do a group-appropriate risk assessment because the play-group leader will accept my risk assessment as satisfactory.'

- Agreed – shared with/agreed by appropriate others:

'I have the support and agreement of my employer and the playgroup leader in working towards this learning goal to meet the requirements of my professional role.'

- Realistic – achievable given your current position, the learning required and the resources available:

'I have the capacity to learn how to do risk assessment and there are resources available to enable me to achieve this learning whilst fulfilling my other professional responsibilities.'

- Timed – setting a deadline by which the learning goal will be achieved:

'I will be able to independently undertake a risk assessment on the parent and toddler group by the time the new term begins.'

Stage 4: Planning Your CPD

In many ways this is the simplest stage of CPD, but it can also be the most time-consuming and most difficult to manage. This is because it may depend on other people and the availability and cost of appropriate activities.

The main thing to remember is that your choice of CPD activity should be based first and foremost on what you need or want to learn and how you learn best:

1. What you want to or need to achieve/learn
2. Your learning style
3. Resources (time, money, transport, energy)
4. What is available

In other words, work from the inside outwards. What is the point of all that self-reflection and goal setting if you then resort to jumping randomly from one training course to another – just because they happen to be there? This is not only inefficient (and potentially costly), it is also ineffective. In the long term it will not satisfy your needs and won't necessarily move you forward – or at least not in the direction you had hoped!

Of course, you shouldn't deprive yourself of a great opportunity just because it doesn't fit into your learning plan. Generally speaking, you should first decide what you need, and then go out and look for it or make it happen, rather than the reverse.

So What Kind of Things Could I Do?

CPD is often mistakenly presumed to be restricted to formal off-the-job training courses, seminars or workshops. On the contrary, CPD can take many forms and can involve a wide range of activities and processes, depending on your personal and professional needs, your preferred learning style and the particular demands of your employment or working life. So whilst nothing *automatically* counts as CPD, almost anything *could*, and there is a huge range of possibilities, including:

- Learning from experience:
 - Keeping a reflective journal.
 - Self-evaluation.
 - Observing others.
- Independent learning:
 - Research.
 - Reading.
 - Using learning/CPD tools: paper-based, online, audio/video/multimedia.
 - Writing for a professional journal.
 - Attending events, conferences, performances.
- One-to-one learning:
 - Peer appraisal.
 - Mentoring.

- Professional and Career Development Loans (CDLs) are bank loans to pay for courses and training that help with your career or help get you into work. You can use a CDL to fund a variety of vocational (work-related) courses with a wide range of organisations.

To find out more about Career Development Loans visit http://www.direct.gov.uk and search for Career Development Loans (https://www.gov.uk/career-development-loans/overview).

Part of the balancing act between earning and learning is being creative in your approach to how you fund your CPD. Prioritise your CPD needs and identify the best and most cost-effective solutions for them. Consider different ways to harness the 'investment' of others – can you offer something in return for their time or expertise? Can you share the cost of some training by inviting other practitioners to participate?

Not all your CPD will have a direct cash cost, but do be aware of hidden or indirect costs. For example, work-based learning or attending peer-learning groups might not have a fee attached to them, but giving your time does have financial implications: when you are training, you are not earning. This is an important consideration, particularly if you are an independent, freelance, or self-employed artist. In the overall planning of your CPD you need to balance out the demands on your time made by CPD against the need to earn a living.

CPD always uses some resources, be they time, money, energy or headspace. What is important is that you use your available resources appropriately and wisely. It is easy, given the pressures of work and the need to earn a living, to neglect CPD. But its importance to your current work and to your overall career development is considerable. In the longer term, CPD will increase your earning potential, so you should see it as an investment rather than a drain on your resources. Also, if you are a self-employed dance artist CPD activities are tax deductible.

Stage 5: Doing Your CPD

Enjoy your CPD, and take every opportunity to talk with other people about your learning. Whatever way you've chosen to learn – whether on a course, watching a performance, taking part in a class or workshop, talking with or shadowing a colleague, or reading an article – make time to talk with other people (even if it's at the moment when you identify or gain access to the written article). Talking to people will help you begin to reflect on your learning, identify other potential learning opportunities, enable you to connect more deeply to the issue your focusing on, and may even lead to new employment opportunities through the process of networking.

Stage 6: Revealing Your Learning

One of the most difficult things about CPD is identifying, articulating and evidencing the outcomes. The impact of your CPD will not always be immediate, or obvious. At a gathering of members of People Dancing in 2005,[2] experienced practitioners identified the gradual 'emergence' of the impacts of CPD within their practice and their overall confidence and growth on a holistic and long-term basis.

But remember the M for Measurable from your SMART learning goals. It is important for your own sense of progression – and also to others who have a vested interest in your CPD (especially if they have funded it) – to be aware of the learning that has occurred and how it has, or will, impact on your work.

It can be hard when you return to your day-to-day working life to find space and time to think about how to process the things that you have learned. But there are a number of things you can do to clarify and share your learning and integrate it into your work:

- Keep a reflective journal to record what you have done, where and when you did it (in case you want to repeat the experience in the future) and your thoughts and experiences whilst you are doing the activity. Don't just describe what you did – state how it relates to your practice at the moment and how your practice might change because of your engagement in the learning experience.
- Make an action list, noting interesting or useful ideas, and how you might begin to put them into practice.
- Set aside time after the activity (or at regular times during the course of your CPD) to go through your notes and summarise the main points (this could turn into a CPD report later if this is beneficial or required).
- Make time to share your experiences (or knowledge and skills) with others in your organisation or peer group.

Work hard to articulate your learning. It is important to place value on what your CPD has given you and to be able to articulate the value to others. In an unregulated profession, where training, qualifications and experience are not standardised, being able to be clear about what *you* know, have learned, and can do, is even more important.

Ask yourself direct questions, such as:

- What do I know now that I did not know before?
- What can I do now that I could not do before?
- What do I understand more fully?
- What new things can I bring to my practice as a result of this CPD?

More importantly – *answer them!* And not just in your head – write them down, speak them, share them:

- Write them in your reflective journal.
- Share them with a colleague.
- Build them into your curriculum vitae and job applications.
- Find a way to articulate them in your marketing materials, funding applications and project proposals.
- Practise how you will say them to others when discussing your work, seeking employment or in formal appraisals.

Stage 7: Review Your Position – Know Where You Are At

This brings us neatly back to Stage 1 in the CPD cycle – knowing where you are at. Engaging in CPD will – or should – move you forward in terms of your skills, knowledge, abilities and understanding. Your learning changes you and puts you in a new place, so it is important, before you start on your next phase of CPD, to review where you are starting from. Preferred learning styles can also change over time, so it is always important to revisit the self-reflection phase before you embark on a new phase of learning.

Even if you are not planning any CPD, it is never a waste of your time to revisit the key questions as a means of noting and affirming, for yourself and others, where you are at, at any given point in your professional life.

CPD in the Bigger Picture

This chapter makes the case for the value of Continuing Professional Development in terms of your own practice and progression as an existing, or aspiring, professional community dance artist. But the impacts of your engagement in CPD will be felt much more widely – take a look at the list below.

Who Benefits From Your CPD?

- **You**
 Continuing Professional Development:
 - Promotes confidence in your work.
 - Maintains or increases your level of competence.
 - Develops new areas of expertise.
 - Enables you to make links with fellow professionals.
 - Increases your employability and career options.
- **The Public (Your Participants)**
 Your engagement in CPD will enable them to benefit from:
 - Working with a skilled, confident, dance artist
 - Up-to-date ideas and practices

- **Employers**
 Your engagement in CPD will enable them to:
 - Trust in you as a responsible and engaged professional
 - Have confidence in your technical competence and professionalism
- **The Profession**
 As you develop your knowledge and skills, you help to:
 - Increase the shared body of knowledge and expertise.
 - Raise professional standards.
 - Ensure that the profession remains dynamic.
 - Enhance their profession's public image.

Taking a Firmer Stance

The working environment is constantly changing as cultural, educational, legal, social, political, commercial and environmental policies and practices develop. The demands made on professionals and organisations develop equally quickly. Since these changes are inevitable, so is the need for continued learning and development.

Professionalism relies increasingly on an ability to respond quickly to changing conditions and we are all being encouraged to embrace change and foster innovation. No longer can keeping up to date be optional; it is increasingly central to professional and organisational success. The response of many professions to this challenge has been to embrace CPD. Community dance is no exception.

With the growth of community dance, the wide diversity of settings in which dance artists are working and employers' expectations around quality assurance and legal compliance, it has become increasingly important for individual community dance artists to be able to communicate and evidence their professional credentials, and for the profession as a whole to achieve recognition on a par with that of other professions.

That means taking a firmer stance around standards, competence, and professionalism; quality assurance and accountability; and training and professional development.

Leading the way in the UK is the industry's membership organisation and development agency – People Dancing. Since its inception in 1986, People Dancing has represented community dance professionals and their practice, lobbying for greater recognition of community dance and providing support that enables practitioners, their employers and organisations at the local, regional and national level to undertake their work better, with greater satisfaction and with greater benefit to the communities they work for and with.

who teach make up the largest group within the workforce. The workforce needs to be equipped with teaching, entrepreneurial and management skills alongside performance and choreographic skills ... the number of students on higher education programmes has increased by 97 per cent over the last five years. The major focus for these courses is performance. In 2006/07 there were 3,645 dance undergraduates and postgraduates. The number of students in further education and accredited vocational dance/musical theatre training was 6,237; a total of 10,000 are in training in any one year.

(Burns and Harrison, 2009, p. 15)

For me, these statements reveal three important issues. The first is that 'teaching' – which in this context includes participatory dance led by artists in community settings – accounts for the largest slice of available employment in dance. The second is a very clear recognition that to operate as a dance professional in these settings requires a range of skills additional to art form skills. Thirdly, that of the large number of students in dance training, a significant number will go on to work in and through participatory dance practice.

Community and participatory dance has grown steadily and consistently since its establishment in the late 1970s: from a handful of early pioneers to what are now several thousand dance artists, teachers and leaders operating in almost all aspects of modern life.

As the scale and range of contexts in which participatory dance happens has grown and diversified, so have the range and diversity of 'employers'. In this context, I use 'employers' as a flexible term to include commissioners of services and provision as well as employers in the traditional sense of the word. Dance artists now work in a wide range of contexts including theatres, museums, schools, pupil referral units, youth clubs, residential homes, the criminal justice system, hospitals and other healthcare contexts.

As a result they need many different skills to make a living from the artform that they love. As well as being skilled dancers they need good communication skills, research skills, knowledge of legislation, health and safety, assessment and evaluation as well as the ability to identify useful contacts and sources of information and reflect on their practice in order to improve. In addition, there have been calls from employers who want dance artists to be able to articulate their work, demonstrating its value in ways that are relevant and make sense to people in other organisations. It is often the case that employers of dance artists and teachers are not 'dance specialists' themselves.

The picture is rich and complex. This means that individuals need to be clear about what they offer and employers need to be clear about what they're looking for.

National Occupational Standards

People Dancing has been working for many years to support dance leaders to become more articulate about their experience, qualifications and practice.[1] In 2011 People Dancing, together with other organisations, identified the key skills and areas of knowledge that dance leaders need across their career. This list of skills and competencies is set out in the National Occupational Standards (NOS) for Dance Leadership approved by Creative and Cultural Skills (one of the Sector Skills Councils established by the UK Government).

The NOS provide a checklist for dance artists so that they can reflect on their practice and consider the range of skills they need to develop in order to be most effective in their work. They are also a valuable tool for organisations that employ dance leaders to help them ensure that they have the right skills, knowledge and understanding to undertake specific roles.

The term 'dance leaders' is used in this context to describe people who lead dance sessions. Dance leaders go by many names; they might also be called teachers, artists or facilitators but they share a common goal in taking responsibility for individuals or groups who want to dance. Dance leaders may work in a variety of contexts, from schools to prisons or residential care homes. They might be working full time in an institution such as a school but will more likely be working as freelance professionals, or on part-time contracts in a number of different places. The Standards are written for all dance leaders so they are applicable to all dance styles and cultural traditions.

Taking part in dance activities is increasingly popular with participants recognising that dance gives them the opportunity to learn a new activity, remain physically and mentally active, meet new people and develop creative skills. Dance participants range in age from children under one to people in their 90s. Whilst some dance practitioners lead dance sessions across these groups, others specialise – either in relation to the target group of people that they teach, by the dance genre with which they engage people, or the level of creative opportunity offered through their practice.

Finding the right dance practitioner to meet the needs of a specific group is essential if the people participating in the dance activity are to enjoy themselves and experience the highest quality dance practice. By learning about the National Occupational Standards for Dance Leadership employers can begin to identify the range of skills, knowledge and understanding that they should be looking for in the dance artists they engage to lead dance sessions in relation to specific contexts.

What Are National Occupational Standards (NOS)?

NOS are statements of the skills, knowledge and understanding needed in employment. They clearly define the standards of competent performance required for practitioners in a specific sector.

National Occupational Standards for Dance Leadership	Essential for all dance leaders	Desirable for dance leaders
Know and communicate your experience of leading dance to potential customers		
Evaluate and communicate your skills in leading dance	✓	
Identify, research and understand your market	✓	
Identify and communicate with others your personal skill and contextual knowledge of your dance style(s)		✓
Communicate how you carry out creative and compositional skills appropriate to your target market		✓
Communicate your competence and readiness to lead dance with specific groups of people and/or places		✓
Use different media methods to communicate with your target market		✓
Develop working relationships with communities and supporting organisations		
Design programmes of dance work that are appropriate to specific groups and individuals	✓	
Manage expectations of participating individuals, groups, funders and partners	✓	
Build relationships and trust with and within community groups to inspire take up to your session(s)	✓	
Build trust with host organisations and funders		✓
Deliver effective dance leadership and engagement		
Deliver safe and effective dance leading	✓	
Engage and manage groups through your dance leadership in a creative context	✓	
Demonstrate technical skill and knowledge in leading your dance style(s)	✓	
Structure dance for engagement of participants and groups	✓	
Collaborate with other artforms		✓
Work with volunteers, support workers and managers		✓
Evaluate your practice and develop an awareness of achievement in participants		
Evaluate the impact of your dance leading through engagement with your groups and stakeholders	✓	
Communicate the results of evaluating the impact of your dance leading		✓
Develop awareness of achievement in your participants and group	✓	

Reflect on and share evaluation findings to develop own practice and role

Recognise your professional development needs	✓
Research, identify and resource your continuing professional development (CPD)	✓
Reflect on and resource your professional delivery	✓

Figure 13.1: National Occupational Standards for Dance Leadership

The National Occupational Standards for Dance Leadership have created five headings under which the skills, understanding and knowledge required by dance leaders are listed. The headline categories are:

1. Know and communicate your experience of leading dance to potential customers
2. Develop working relationships with communities and supporting organisations
3. Deliver effective dance leadership and engagement
4. Evaluate your practice and develop an awareness of achievement in participants
5. Reflect on and share evaluation findings to develop your own practice and role.

Each of the five categories contains more detailed descriptions of the skills and knowledge that dance leaders need. Dance leaders already have many of these skills and can use the list to identify their strengths. The list can also be used to help identify skills or areas of understanding that they need to acquire if they want to move into new areas of work or simply improve their current practice.

Not all practitioners will need to be proficient in all of the skills outlined in the Standards as the requirement for skills will be largely determined by each practitioner's level of experience and working circumstances. However, having an overview of all the skills outlined in the Standards should help employers identify which skills, knowledge and experience a dance leader might be expected to have to fulfil a specific post.

The National Occupational Standards are a valuable tool for dance employers because they:

- Help employers identify the range of skills that dance leaders may need to have.
- Help employers make informed choices about the selection and recruitment of dance artists.
- Provide employers and dance artists with a common language with which to define and agree expectations in relation to dance delivery.
- Enable employers to identify the areas in which they can provide continuing professional development support for the dance artists they employ.

Additional skills, areas of knowledge and understanding may also be required depending on the circumstances and context of the dance leader's employment. These further learning outcomes could be achieved by the practitioner through engagement in continuing professional development activity (see Chapter 12 for more on CPD).

Conclusion

The chart above lists all the NOS for Dance Leadership and provides a suggestion about which skills all dance leaders should have. This will help dance artists ensure they can offer what employers are looking for and gain an insight into the experience and expertise they may need as their career progresses. In addition dance leaders can learn to see their work from employers' perspectives by taking steps to understand the priorities and agendas of the different organisations and agencies involved in participatory dance practice. Chapter 14, which deals with Partnership Working, suggests ways in which dance artists can be proactive in understanding and connecting with other professions.

Exercise

This chapter suggests using the National Occupational Standards to benchmark your skills against those expected by employers. Using the table above can you identify your strengths and areas for development.

Note

1. You can find the NOS for Dance Leadership at http://bit.ly/29U4syw.

14 Partnership Working
Diane Amans

There are many different examples of joint working – with considerable variation in the size and purpose of partnerships. Some strategic partnerships involve dozens of people working together to tackle an issue that affects a large geographical area. At the other end of the scale smaller partnerships focus on a single community problem or plan a local festival. In this chapter I look at how dance artists have been involved in partnerships and the innovative ways in which they help organisations achieve their objectives. I also discuss some of the challenges and opportunities presented by collaborative working.

> Successful partnerships can achieve goals that individual agencies cannot (Audit Commission, 1998).

As partnership working has become widespread in the United Kingdom, community dance artists have already worked successfully with public authorities such as health and social care, criminal justice, housing and education. Working with different partners is challenging, but it can offer exciting opportunities for dance practitioners, whether they are independent freelancers or part of a dance agency team.

There are formal partnerships, with service level agreements between two or more agencies, and there are more informal arrangements which might involve networking between professionals with similar objectives. Whether the partnerships are formal or informal, the skills needed for effective joint working are very similar, and community dance practitioners often possess these skills.

Formal Partnerships

In formal agreements between dance companies and their local authorities, a dance development worker is sometimes directly employed by the local council and works as part of their cultural development team. In other areas, a local

Figure 14.1 JABADAO Conference 2005 Diane Amans and Penny Greenland (*Linda Neary*)

authority may contribute funding towards a post which is managed by a dance organisation.

There is usually a service level agreement which sets out, in broad terms, the agreed areas of work together with any action points.

Partnerships with local councils can result in benefits for all concerned. Individual artists and dance organisations have access to a wide network of support and advocacy opportunities. The councils have access to skilled dance practitioners who will help them implement their cultural strategies. All partners are able to share information and resources and they may be able to collaborate in joint training/professional development opportunities.

There are various ways in which the dance development posts are line-managed within partnerships. Some dance artists have an office base in a local authority venue and a line manager from a dance company. Others are managed by a cultural services manager with secondary or indirect supervision from an arts development officer. Provided the nature of the relationship is discussed and agreed by all partners the dance artist should have plenty of support. In practice, the success

of any joint working initiatives will depend on effective communication, agreed objectives and good working relationships.

Informal Partnerships

Partnership working on a more informal basis may be associated with something which has a specific time frame. For example, a community health project might involve a regional dance company, freelance dance practitioners together with school teachers, the health promotion team, leisure services, a local business sponsor and community volunteers. For a short period of time they will work in partnership with each other and, although some of the partners might be involved in more formal long-term service agreements, others join them on a more temporary basis. In my experience, it is sometimes the dance artist who acts as a catalyst and brings together different people who might otherwise not have worked together. This is one of the joys of community dance work; it offers an opportunity to create partnerships so that we can do what we want to do. I have often started with an idea and then set about bringing together people who can help me make it happen.

Engaging with Other People's Agendas

Some artists worry that collaborating with other agencies means that the dance work is somehow diminished. Interestingly, this concern is not shared by the young dancers who took part in consultation during 2007 for the North West Youth Dance Regional Development Plan.[1] The research revealed they just accept that dance is linked with other parts of their lives: 'of course it's good for health, yes it helps us understand ourselves and others'. The reality is that the Arts *do* satisfy other agendas. We can see this as an opportunity to develop new relationships and learn to speak other people's languages.

Community dance practitioners need to be able to talk about the benefits of dance in terms of other people's agendas. It doesn't dilute the art form. It doesn't mean that dance is in some way less important – but it could be that some of the partners/stakeholders/other agencies don't realise how important it is. We need to understand *their* priorities and help them understand how dance could become part of their action plan.

If we can explain how what we do connects with Health and Social Care priorities, for example, we are more likely to be approached to run community dance projects in different settings. In fact, we don't have to wait to be approached – we can be proactive in connecting with other people's agendas.

However, some practitioners question why we *should* be proactive in connecting with Health and Social Care agendas. What about community dance

Table 14.1 Comparing different agendas

Health and social care agenda	Community dance agenda
Active older age	Engage people in dance activity because it is
Promote good mental health	life-enhancing and it makes you feel good
Reduce age-related disease	Make new choreography which challenges age
Improve balance and coordination	stereotypes
Reduce social isolation	Build relationships with others by sharing
Challenge stereotypes	pleasurable activities
Root out age discrimination	Create opportunities for self-expression
Treat people as individuals	Celebrate the diversity of each unique
Recognise and manage diversity	individual participant

agendas? This is an understandable point of view. Dance professionals don't want other professions to dictate what they do. It reinforces the notion that dance is something to be used to help other professionals achieve their aims and objectives. But we can do something to change this perception. We can choose to see ourselves as equal partners in collaborative working, which benefits everyone involved. After all, the agendas are not very different. Take the example of Table 14.1, from a 'mature movers' project which connected with the standards in the Department of Health's *National Service Framework: Older People* (Department of Health, 2001).

The agendas are very similar – we just use different language. We need to draw attention to the similarities in our aims and build relationships based on mutual respect. It makes sense to do this if we want to open doors to new work opportunities and stimulating challenges. If we can create alliances with other professions this will strengthen funding bids and bring more resources into community dance. It will also create new opportunities for dance with groups and individuals who currently don't dance.

Case Study 1: Creative Ageing at the Courtyard

The Creative Ageing project was established in 2010 to reduce social isolation for older people through direct access to the arts, with a particular focus on working with those living in care settings. The Courtyard, Herefordshire's Centre for the Arts, has always had collaboration and partnership at the heart of the work it does with older people.

As a very rural county, with a higher than average ageing population, the project had to find ways of working in partnership with established groups and venues to deliver high-quality arts-based activities. In addition to a hugely successful Over 60's choir, there is a range of mentor led artist development programmes including their

most recent Dance Magic Dance project. This involves four local dance artists working in care settings to deliver creative dance activities for people living with dementia and other life limiting conditions. The Courtyard has built a reputation for delivering ambitious projects which have a positive impact on the lives of older people.

Their ethos of partnership and collaborative working runs throughout all the projects, which are a three-way collaboration between artists, the residents/participants, and the care staff. A considerable amount of emphasis is placed on ensuring that everyone involved has plenty of time for reflection and improvement at all stages of the process from the planning right through to delivery.

Project Manager Penny Allen says of the project 'collaboration is at the heart of all of our projects. If we don't take time to respect and understand the expertise each of the partners bring to our projects we are making things much harder for everyone involved!'

The Creative Ageing Project is funded by Reaching Communities Fund and more information about their current projects can be found at www.courtyard.org.uk/A.OP

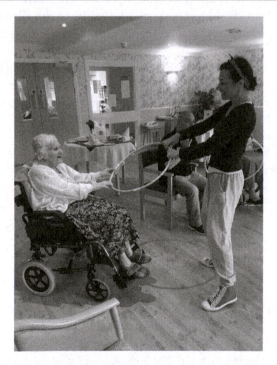

Figure 14.2 Making of Me Project, The Courtyard Marie-Louise Flexen (*Angela Conlan*)

Case Study 2: STRIDE boys and young men dance project

STRIDE is a partnership project with Dance Manchester and Company Chameleon. It began in 2009 and has a focus on engaging young men in dance; it has involved participants in all 10 Greater Manchester districts. The project was set up to challenge stereotypes of both young men in wider society and men in dance. The work is shown in unusual public locations at an annual sited or outdoor performance.

Company Chameleon are the artistic directors of STRIDE and receive a fee from Dance Manchester for their role. A team of freelance artists then receive employment from Dance Manchester and training from Company Chameleon to support their delivery of outreach work. In some years all STRIDE artists have had access to other paid training such as behaviour management and child protection. Artists then deliver outreach activities to young men in schools and community settings (in 46 different locations in 2015).

Participants come together in local groups to make material responding to the Chameleon repertoire taught to artists at the beginning of projects. The boys then have an intensive site development and rehearsal period leading to public performances. These have taken place in the Lowry foyers, Victoria baths, Castle Field urban heritage park, the foyers of the Birmingham Hippodrome, the Great Hall of the Royal Exchange theatre and the Whitworth art gallery.

Initially there was funding from local authorities and Manchester City Council together with some charitable contributions however, over the years, Dance Manchester has continued to subsidize the work from their core funding. Their director, Deb Ashby, explained:

> Funding limitations has meant that the project is only that – a project, not an all year round activity, which is not how I originally imagined it – but it's the reality. The range of outreach we offer as part of the project across ten local authority areas, and the size and the quality of the team we employ to deliver it does not allow resources to stretch to provide year round maintenance. However the consistency of a repeated annual project has had an impact on individuals, some of whom have returned each year; others returning at intervals and some for only one year.

Chapter Three includes anecdotal evidence from the boys about the impact on taking part in STRIDE together with audience comments.

A number of young men who took part have gone on to further dance training and undergraduate study. In 2011 the project was used as a case study in a document which made recommendations to the government on men and mental health (Williams and Kemple, 2011).

How Do We Create Alliances with Other Professions?

Partnership working with other agencies is like working at partnerships in any area of life. It's about building relationships. Whether we're part of a multi-agency initiative to set up a community dance project or getting to know a new circle of friends, the relationship building skills are very similar. They include:

- Finding out what the other people are interested in.
- Learning to speak the same language.
- Identifying things you have in common.

These are the 'people skills' that are necessary in any effective relationships. It is also very useful to find out about the wider contexts in which our partners work – the government's national agendas, present and future funding sources, legislation and local authority priorities. We are more likely to be listened to if we can outline proposed projects in language that connects to other people's agendas. This will help our partners understand our aims and priorities and might lead to unexpected sources of funding or in-kind support.

When I am planning a dance project I have clear ideas about the artistic content. In my mind there is no ambiguity about the aims. It's an arts project. But there's more chance of my getting other partners involved if I can profile other elements of community dance – such as its contribution to arts and health, its impact on social inclusion, its potential for addressing citizenship and diversity issues. Even if I'm not working in collaboration with other professions on this project it's a useful exercise to consider how it *could* connect to other agendas. You never know – I might want to do a follow-up project with this group and I might need partners to get involved.

Partnership Case Study

Here is an example of how a dance project was made possible through totally unexpected resources. I was invited to demonstrate participatory dance methods to members of South Manchester Healthy Living Network. The audience included representatives from Health, Social Care, Housing, Transport, Leisure and Regeneration. Volunteers from the audience took part in a creative dance workshop whilst I described how the various activities linked to falls prevention and healthy ageing. I didn't need to point out that people were having fun and enjoying social interaction as well as creating dance which engaged performers and audience.

After the event I had two phone calls. One was from a housing manager who wanted me to set up similar sessions in a sheltered housing unit, and did I know how he could raise funds for this? The other call was from a leisure services manager who had a budget and a remit for engaging more over 50-year-olds in exercise.

Did I know of any groups who might be interested in participating? I put them in touch with each other and we set up a dance project. We were delighted to work with partners from health, housing and leisure services.

Challenges of Partnership Working

It isn't always this straightforward, however. You sometimes find yourself in partnership relationships where there are tensions because the partners want different outcomes, or there's a shared vision but no one wants to lead on it, or there's no funding and all the partners are too busy to write funding applications. This can be really frustrating if you are a freelance artist who has been invited to put together a proposal, and three meetings later it still doesn't seem to be going anywhere.

This is where the dance practitioner may need to take the initiative in pushing for some decisions because the partnership seems to be just a 'talking shop'. If you're the only one at the meeting who is not on a salary it's in your interest to get things moving. Occasionally I have taken the lead in suggesting that a project is not viable because the partnership does not have the resources to achieve what it has set out to do. I don't think we've anything to lose by taking the initiative in this way. Sometimes a project does not get off the ground, but then I don't have to go to any more unfocused meetings in my own time and I can move on to more promising ventures.

On the other hand, an artist's intervention might nudge people into action. In one memorable meeting between members of a Health Strategic Partnership we really seemed to be going nowhere and I questioned whether it was worth continuing. Suddenly one partner excused himself from the meeting to return minutes later having made a hurried phone call which resulted in a firm funding offer. Then another partner disappeared and returned with match funding. All this happened within twenty minutes of the artist suggesting we call it a day because there was no funding to continue the dance project!

Conclusion

Most dance artists will be involved in joint working at some stage of their career – either as part of a public sector partnership or by contributing to a small-scale community collaboration. Before becoming involved in partnership working it is worth taking the time to clarify what your role will be and checking that all prospective partners have a clear idea of what the partnership hopes to achieve. It may be that there is not a shared vision, but you feel it is worth joining a group anyway because you have the chance to contribute ideas and influence possible outcomes.

The following questions might help you decide whether or not to become involved in a partnership:

- What is the purpose of the partnership?
- What would your role be?
- How much time would be involved?
- Will you be paid for the time?
- What opportunities does it offer you?
- (Artistic/professional/personal development?)

As long as you are realistic about the amount of time you are prepared to allocate, and you feel there is an opportunity for meaningful involvement, there is no reason why it should not be a positive experience.

Certainly community dance artists can offer considerable potential benefits to any collaborative work. Partnership working needs people who can build relationships and that's something we're very good at in community dance. They're the skills we're using every day. Community dance practitioners are creative, resourceful people with leadership skills and experience of communicating with a diverse range of people. As flexible professionals who can 'think outside the box' we can work with other stakeholders to develop joint visions and deliver change.

Exercise and Discussion Points

Find out about regional partnerships in your area – which organisations are working together and what are their objectives? The following have been common topics in the past: health, community safety, social inclusion, regeneration, housing and crime prevention.

Can you think of ways in which dance artists could become involved in helping partnerships deliver their objectives?

Note

1. Research carried out by Deb Barnard as part of Youth Dance Regional Development Plan, 2007.

15 International Dancing Communities

Diane Amans

In researching this chapter I had some interesting and revealing conversations with people from many different countries. Dance artists, community participants, academics and representatives from dance organisations all shared their own unique perspectives on community dance.

I have selected some examples of participatory dance activities in eight countries. Some are very brief snapshots; others are rather longer case studies written by individual practitioners.

There are examples of people dancing in most, if not all, countries in the world. In some countries there is community dance practice similar to that in the United Kingdom, with a dance artist facilitating the sessions and projects. In other countries there are participants dancing together in diverse community settings without necessarily having a community dance artist to lead the activity. Definitions of Community Dance continue to be debated and the examples from different countries illustrate an interesting diversity of approaches to the practice and its defining values.

Japan

The Japan Contemporary Dance Network (JCDN) has been a key organization in the development of community dance practice in Japan. Norikazu Sato, founder of JCDN, describes its aims and activities:

> Japan Contemporary Dance Network (JCDN) was founded in 2001. It is a non-profit-making organization and its network connects society and dance. At first our aim was to spread and develop contemporary dance in Japan

and we held training projects for artists all over the country. In 2004, we visited the UK and encountered community dance. Since then, we spent 3 years in preparation and started our community dance projects in Japan. We organize programs and send dance artists to elementary school and junior high school, making teaching materials for school teachers to lead dance classes. After the tsunami disaster in 2011 JCDN started a new project and, since 2014 has held an annual festival called 'Sanfes'. It is a festival of local traditional performing arts in the tsunami stricken area. In addition, JCDN coordinates and organizes many other community dance projects.

In Japan, the people who are involved in dance could be divided into 2 groups: those who dance and those who watch. For a very long time it's been said only special people do dance and I feel dance has been far away from our society. Community dance could make dance even closer to people and give the idea that anyone and everyone could do or make a dance.

Since 2009, we have organized many community dance projects in Beppu, Kyoto, Shizuoka and Okinawa. Mostly participants are grouped according to their different ages: children, teenagers, old men, mothers and seniors. For each project, there are different artists facilitating the sessions. 3 years ago, we started 'Dance Kingdom Shizuoka' in Shizuoka city. Now there are some community dancers starting to become facilitators and leading groups. In most of the venues visited on the tour people are continuing dancing and there are now community dance festivals in some places. (Amans 2016)

Japanese dance artist Sonoko Chishiro worked for JCDN for five years. In the following case study, she describes how she became involved with community dance.

My Journey to a Community Sonoko Chishiro

I used to be a ballet teacher and my first contact with community dance was when I acted as a translator for Cecilia Macfarlane in 2011. I was deeply inspired by her dance and concept and that is when I became interested in leading dance classes in the community. To learn more about community dance in Japan, I started working for JCDN.

Since JCDN started to organize and spread community dance projects in Japan, it was also their aim to hold a training program for practitioners in the country. So I was sent, from JCDN, to attend the Foundation for Community Dance Summer School in 2012. As my mission was to understand the 'elements' of the school, I simply attended the Introductory Course as a dancer. This FCD Summer School really stimulated me. Dancing, learning and discussing with other dancers and thinking deeply about community

dance were such valuable experiences. Above all, encountering people who have the same aspiration towards dance was a treasure. We were all different ages, nationalities and from diverse dance genres but through dance there were deep communications and it was such a great feeling to share our passion with each other. JCDN wanted Japanese artists to have similar opportunities so they started their own training program for practitioners in 2014.

With Diane Amans and Cecilia Macfarlane as tutors, there were over 60 participants during 2014 and 2015. In 2015, JCDN organised a Community Dance project in a town called Kinosaki. It was a project for a brand new International Art Centre to be available for local people. Luca Silvestrini (Protein Dance) was invited from the United Kingdom to lead the project and I acted as translator. After a three-week residency, our project resulted in a brilliant piece – 'Crossroads'. It was performed in the art centre and had a huge impact in the town. Over 70 non-professional dancers (3–80 years old) performed on stage and all three performances had full audiences. Following this valuable experience there was an increased interest in dance and some of the local participants became eager to keep dancing. They asked me if I could run some dance classes and, finally, I started monthly 'Open Classes' in ballet and contemporary dance with a mixed group of both locals and tourists. (As the open classes are funded by the local airport it is hoped that the dance and the art centre will attract more visitors to Kinosaki.)

Italy

Laura Delfini is a dance practitioner working in schools and in other community settings in Italy. She has been a member of the DES (Italian National Association Dance Education Society) committee since its foundation and here she gives an overview of community dance in Italy.

Generally dance studies in Italy do not have an established and widespread academic status. Community dance, like dance in education a few years previously, has evolved as a result of many different activities: courses, workshops, publications, events and conferences which have been delivered by dance centres, single university departments, individual academics or dance practitioners.

Since its foundation in 2001 the National Association DES has had an important role in Italian dance development. It was founded following a series of five annual meetings named *Educar danzando* (1997–2001), and designed and curated by the Dipartimento di musica e spettacolo of Bologna University together with the Mousiké dance centre. Eugenia Casini Ropa, Dance History Professor at Bologna University until 2009, has been President of DES since its foundation, and is a key figure in the development of an Italian dance culture. DES organises annual conferences and leads projects for practitioners engaged in the educational and community dance fields. It promotes dialogue and the sharing of ideas and practices.

After many conferences focusing on educational dance, DES dedicated its 2004 annual meeting to community dance and, since then, community dance has been more openly discussed, studied and practised. That international meeting was a pivotal event for dance practitioners who began to feel their work belonged or could belong to community dance.

The conference proceedings were collected and published in both Italian and English (Delfini, 2005). Contributions were by authors from a number of different countries: Italy, United Kingdom, France and Finland. By 2004 British community dance was established and its issues had been widely and deeply experienced and discussed, so the sections by Christopher Thomson and by Marion Gough had a powerful effect.

Community Dance Practitioner in Italy – Roles and Definitions

The community dance worker describes himself/herself as an artist-educator with a strong ethic, social and political consciousness; s/he declares that one can (be) mistaken, have second thoughts, get worked up and involved; contact others through speech, listening, observation, feeling; consider it important to know the background of others and compare it with one's own; reconsider and, at times, redesign the symbolics of movement and gesture; use different types of movement techniques and modalities: from those originating in the culture of the Seventies (with special attention to proprioception and to perception of space and of the other dancers) to those more recent (hip-hop, break dance) or consolidated (traditional, social, folk dance); maintain a margin of openness in programming encounters; intervene tactfully; and feel it is one's duty to defend one's work and the group from any pressure dictated by fashion or by stereotyped image of dance held by institutions or financing organizations. (Delfini, 2005, pp. 111–2)

Here is a definition of community dance given by Franca Zagatti in her book *Persone che danzano*:

> ... a practice affirming first of all the right to dance – for everyone. This includes people of all ages and diverse abilities and backgrounds: people enjoying participating together – a balance between individual and collective experiences. (Zagatti, 2012, p. 80, translated by Laura Delfini)

Professional Development

Continuing professional development in Italian community dance includes a range of activities. The *Corso per Danzeducatore** by Mousike dance centre (Bologna) is one of the most important courses in this field. Since 1999 many danzeducatori* have been trained and then extended the activity all over Italy.

Other courses contributing to the development of educational and community dance include:

- *Danza.com*, Associazione Danzarte, Brescia, 2009 and 2013.
- *La Danza va a Scuola*, Choronde Progetto Educativo, Rome, since 2011.
- *Co-dance – abitare corpi abitare luoghi*, Centro Regionale Universitario per la Danza 'Bella Hutter', University of Turin, 2012.
- The course dedicated to 'Danzatori per la comunità', Associazione Filieradarte and Associazione Didee Turin, 2016.
- The educational dance courses led by Elena Viti at Accademia Nazionale di Danza, Rome.
- The courses led by Alessandro Pontremoli at DAMS, University of Turin.
- Various Laban-based short courses led by Laura Delfini in different Italian towns.

The Resources section includes case studies of Italian community dance projects led by Laura Delfini, Theodor Rawyler, Luca Silvestrini and Franca Zagatti. These case studies are examples of the way four very different dance artists are influencing participatory dance practice in Italy. Since the beginning of the twenty-first century there have been some exciting developments leading to a new 'era', characterised by the birth and development of the educational and the community dance practitioner. There is also an increasing number of publications and an emerging language which facilitates dialogue between community dance artists and practitioners. Community dance is constantly developing and finding an identity or rather recognizing and accepting different identities.

Finland

Kai Lehikoinen, a lecturer at the University of the Arts Helsinki, gives an overview of Community Dance in Finland.

Dancers and dance teachers in Finland have engaged groups and communities in and through dance at least since the early twentieth century. It could be proposed that community engagement was included in small scale as part of women's gymnastics and free dance already in the 1920s and 1930s.[1] Community engagement has been part of the outreach work done by a number of dance artists and groups since 1960s.

The concept of community dance was first introduced in Finland through the Theatre Academy Helsinki's continuing education programme in 1998. The 15-credit course was led by Kirsi Heimonen who locates community dance within the 1970s British democratic art movement.[2] The course also had a contribution by Christopher Thomson who was then engaged with

community dance projects at London Contemporary Dance School in the United Kingdom.[3] Thus, community dance in Finland was linked to the British community dance movement from early on. The British approach was appreciated as a useful foundation due to its use of practice-based reflection as a means to develop its methods.[4]

More recently, community dance has been taught not only in short courses but also as part of degree programmes in Dance, Choreography and Dance Education.[5] At the University of the Arts Helsinki, a community arts approach was integrated in an artist-as-developer – specialisation programme pilot (2014–15). The pilot was informed by research on artistic interventions in organisations.[6] The pilot, which included also other art forms besides dance, yielded an anthology on 13 autobiographical reports on artistic interventions in various contexts.[7]

In recent years, several dance artists have engaged in extensive community dance projects in various contexts such as health, welfare, care, architecture, design, politics and so on.[8] Today, an active network of professionals in community dance is brought together by a registered association Yhteisö tanssii ry. The association was set up in 1999 to foster ideological values of community dance, provide peer support, and maintain discussions on ethics of communal engagement and the role of the community artist.[9] The association has been organising a biannual Community Dance Festival under the artistic leadership of Marjo Hämäläinen in Tampere since 2010. The association also awards the two-year Community Dance Artist of the Year award.[10]

Since 2004, the regional dance centre network in Finland has had a significant role in creating community dance activities. Currently there are six regional dance centres that aim to enhance prerequisites for dance, increase job openings for dance artists and broaden cultural activities nationally. In addition to producing new dance works, many of the regional dance centres provide dance-based services of well-being.[11] Some of such services – dance in elderly care and with asylum seekers, for example – are currently researched in a recently launched ArtsEqual Research Initiative.[12]

Some pracademics have also challenged the concept of community dance in Finland. In her recent doctoral thesis, choreographer Kirsi Törmi found 'community' an overly simplistic concept when addressed from inside a group of participants. Those who participated in her project at a recycling centre appeared first and foremost as individuals rather than a community with a shared interest. In such context, the concept of community appeared as overly generalising and also externally governing. That is why Törmi prefers to talk about process-oriented and participatory work.[13]

Drawing from an Australian context, dancer and choreographer Raisa Foster prefers to talk about 'dance animateuring' rather than community dance. Dance animateruing refers to a contemporary performance maker and a researcher who can embody multiple social positions.[14] Foster has revised the concept by introducing dance animateuring as an artistic-pedagogical method. Further, she regards the educational and artistic dimensions of the holistic approach as equally valuable.[15] She perceives dance animateuring as arts education but with a critical distinction: it is not fixed to any existing art forms or techniques but on movement improvisation.[16] To protect her community dance approach and to keep it precise, Foster has registered its name, the Tanssi-innostaminen® method. That way only trained dance animateurs have a right to use the name in their work.[17]

Australia

Dance artist Katrina Rank describes her work and gives her view of community dance practice in Australia.

Australia is vast. With a population of just above 24 million and a land mass of approximately 8 million km^2, we'd have 3.1 people per square kilometre, if we spread everyone out evenly across the country. However, as almost two-thirds of our population lives in and around our big cities, access to the benefits of dance outside the big cities is a challenge. The cost and time in setting up and running regional and rural programmes is diabolical. The usual way of dealing with this is by accessing philanthropy and funding that is directed at outreach operations. Many of our dance companies have instigated a range of community dance experiences for people living outside our cities. Some look like education but have wider ramifications in terms of arts and dance development. For example, the Australian Ballet's *Out There* programme takes dance workshops to schools in metropolitan, regional and rural Australia. Other programmes aim to build resilience and authentic, respectful relationships with indigenous communities, such as the work by Bangarra Dance Theatre's *Rekindling Project*, Phuntional's suite of programmes (*Calling the Shots, Stories from Beneath the Vale, Cycles to Circles, The Yumpla Project* and the *Chit Chat Programme*) in Mildura and projects such as Tracks Dance Company's *Hidden Meaning*. This is a project that explores 'the importance of design and costume to the deeper understanding of culturally specific dance' in the Northern Territory.[18]

Our land is comprised of six states and two territories. Diverse community dance activity can be seen in all of them as projects, classes, community cultural development or a combination of these approaches. To gain a full picture of the dance ecology, I recommend looking at Ausdance's website. Ausdance

is the peak body for dance in Australia and has branches in most states and territories. Whilst they don't deliver all programmes to everyone, they do advocate and promote the arts sector and provide information for the inquisitive.

Like many developed nations, Australia has an increasing aging population with a total life expectancy of 81.8 years. Sustaining good health, preventing disease, managing conditions and maintaining quality of life will be important for us all in the decades to come. As there are dwindling numbers of people who once populated Dance Halls, there is a noticeable gap in seniors' dance programmes. What does the generation brought up on disco or clubbing do as they reach their 60s, 70s, 80s and 90s? Where is their dance? What are their stories? How do we recognise, value and celebrate these individuals who have accrued skills, knowledge, experience and some fascinating tales and opinions? How do we see THEM, and not the stereotype, and encourage their creativity and artistry? This is the space to which I am drawn.

I am a community dance artist. I've worked in the field since 1996 but it is only quite recently that I have embraced dance for older people. In 2013 I founded Fine Lines, a community dance experiment, designed for dancers who were nearing and past 50, wishing to create a space where mature dancers could come together to form a community, share weekly class and make work. We now have approximately 25 dancers, though rarely at the same time. They come from many different dance backgrounds. We have produced and performed in a number of works including *Anatomy of Disgust (live dance theatre work)* and *Mean Feat (community dance film project)*. We have a number of works in progress including *Wallflowers (live dance theatre work)* and *Wild Thing (site-specific work)*.

I also belong to a network of independent dancers who teach dance classes for people with Parkinson's. I find it a completely joyous experience to teach these classes. To be able to share that joy with others is a great privilege and a key driver for me in all my community dance efforts. Like the programme in Bassano del Grappa, Italy, I hope to open similar classes for older people with and without Parkinson's, providing a creative space and place in which participants become dancers and artists, not patients or clients.

There has never been a better time to be a community dance artist in Australia. Whilst we may be light on funding and spread thin over distance and resources, we are rich in cameraderie and hope. Today I see Australian community dance artists working to address the BIG issues – issues of inequality, and lack of representation, of untold histories and invisible stories. These are big issues of big import – all changing the world doggedly and incrementally, as part of a creative movement. I think we can achieve almost anything if we have vision, courage, determination, humour and good friends to encourage us.

United States

In the above case study, Katrina Rank mentions her dance classes with people who have Parkinson's. The New York–based Mark Morris Dance Group developed Dance for PD® work at the beginning of the twenty-first century in collaboration with the Brooklyn Parkinson Group. Led by programme director David Levanthal the Dance for PD® training has extended to other countries including Australia, Canada and the United Kingdom.

Another example of community dance work in the United States is Kairos Alive! – an intergenerational dance company based in Minnesota. It was founded in 1999 and includes performers whose ages span four generations. In 2001 they developed a programme for older adults: The Dancing Heart – Vital Elders Moving in Community™. In describing her approach to the work the founder and artistic director of Kairos Alive!, Maria Dubois Genné, says:

> … As an artist I have the opportunity to facilitate self-discovery and empower individuals and communities by creating meaningful and even profound art through dance based in a collaborative engagement model of participatory art-making. Dance and music changes the dynamics of relationships between people of all ages and cultures – heightening social interactions and transforming boundaries – such as those between care professionals and patients, to ones of peers creating and discovering together. (Genné 2016)

These are just two examples of the very diverse range of community dance work taking place in the United States.

China – Square Dancing (Guangchang wu)

Here is an interesting example of community dance that is a feature of everyday life in China. Guangchang wu literally means 'public square dance'. In most areas of the country groups of people gather together in parks or public squares in the evening or early morning and dance to the accompaniment of Western popular music, folk dance classics and Chinese pop songs. The dancers, who are mostly older women, all face the same direction and follow a leader; the more experienced people occupy the front rows and the beginners or less confident participants are at the back. Most routines are fairly straightforward but some are more complex. The dances are a fusion of disco moves, social dance steps and Tibetan, Uyghur and Dai folk dances. Participants enjoy the health benefits of regular dancing and many dancers feel the Guangchang wu sessions offer opportunities for social interaction, helping dispel feelings of loneliness.

Guangchang wu has been so popular that the large groups and loud music has resulted in complaints from local residents. In 2015 the General Administration of Sport and Ministry of Culture decided to introduce national standards to regulate square dancing – with 12 authorised routines and permissible times and volume. Eventually the routines were not compulsory – the government

said they should be considered as suggestions – and there continues to be discussion about whether it is possible to regulate an activity with millions of participants.

Qianni Wang, a researcher from the Chinese University of Hong Kong, interviewed many participants and concluded:

> The dance is more than a fitness fad. It is a confluence of rights regarding the use of space, aesthetic values, cultural politics and, as such, it provides a rich 'cultural text' to aid in the understanding of contemporary China.
>
> (Wang, 2015)

India

Anusha Subramanyam is a dance artist with a wide experience of community dance and, in Autumn 2012, she worked with the Foundation for Community Dance to edit an edition of the professional journal *Animated*, with a focus on Dance in India. Here are her introductory comments:

> Dance has always been used, as in the United Kingdom, in the areas of health, education and wider social contexts.
>
> Community dance is included historically in the large umbrella term of tribal, folk and social dances. The Ministry of Tribal Welfare supports many initiatives in the regions, in addition religious festivals offer opportunities to geographic communities to perform together and celebrate through dance. In urban areas social dances are performed on different New Years of various communities throughout India.
>
> In the multi-layered, multi-complex diverse and vast variety of dances it is not only the government that supports dance, but it is people who wish to dance and celebrate life through dance. (FCD 2012)

This edition of *Animated* included information about some fascinating dance projects such as Sangeeta Isvaran's work with street children, sex workers and other marginalised communities. She is a choreographer, performer, researcher and social activist who has worked in many different countries creating opportunities for self-expression through performing arts. She is very interested in the part that empathy plays in conflict resolution and her research into living art traditions constantly informs her dance practice.

New Zealand

In 2015 the University of Otago, Dunedin, hosted 'Moving Communities', a three-day community dance conference. There were presentations and discussions about different aspects of community dance:

- Diverse Dancing Communities.
- Community Dance Practice and Place.
- Contested Spaces of Community Dance.
- Community Dance and Well-being.
- Community Dance and Artistic Performance.
- Community Dance Education.
- Valuing Process in Community Dance.

Much of this content is similar to that found at UK Community Dance events but there were some interesting differences – particularly in the area of 'Artistic Performance'. I have discussed this further in Chapter 19: Challenges and Tension Lines.

As part of the 2015 conference there was a reunion between the 10 recipients of the Caroline Plummer Fellowship in Community Dance. This is an annual six-month fellowship offered to local and international dance practitioners, teachers and researchers. It honours Caroline Plummer, who died in 2003 after completing a bachelor of art in anthropology and a diploma for graduates in dance. Caroline had a vision for community dance and this fellowship, introduced in 2003, is one of a number of fellowships offered by the University of Otago in Dunedin.

The fellowship recipients were also keynote speakers at the conference. Barbara Snook, a dance academic working at the University of Auckland, researches and teaches in the areas of community dance and dance education. She presented a case study about her fellowship project, which took place in 2008. Here is a summary of her 'Circle of Life' project.

I worked with the cancer community to facilitate a 10-week dance project with 17 participants. They were mainly contacted through the cancer society and were at various stages of treatment or were strongly associated with someone going through treatment. I had recently lost my partner and my daughter to cancer so this provided me with a particular connection with the participants, who were four men and thirteen women aged from late 40s to 82.

Community dance is an evolving field that is particularly accessible to people who have limitations imposed by cancer. There is an emphasis on experiential learning which has broad educational aims in terms of facilitating social interaction and assisting people to be at ease with themselves within a group (Matarasso, 1998). The value of community dance with cancer patients is the potential that dance has to appeal to those who are old, sick, isolated and less fit. The focus on dance as a meaningful, creative and social outlet, rather than just being a physical pursuit, is one of the reasons why community dance in this instance was such a valuable activity. The participants wanted to be there despite their physical fragility. There was a sense of connection between the people. Attendance was something that did not come easily and some participants only continued with great perseverance. One participant commented, 'You certainly

find strength you just never knew you possessed' and this indicates some of the ways that taking part was more or less easy, but always worthwhile.

Irene stated:

> People had different energies different weeks. If I had a chemotherapy session that week, I had to drag myself there sometimes. A couple of times I nearly got there and I nearly turned for home. But I thought, I'm nearer there than home, I'll keep going.

The participants, whose bodies had been invaded by cancer, experienced a heightened need to express their feelings and emotions through movement. Most people were not dancers in a traditional sense and overcame the associations they had brought with them about the meaning of dance. For example, Mary arrived and announced herself and her mother as 'two dumpy Irish women'. Os, a male performer, took a long time to grasp the concept that the quality of his dance technique was unimportant and struggled to throw off old associations of dance. Irene's comments reflect a general feeling at the start,

> I was afraid of making a total ass of myself if I am totally frank. Because I thought, I can't move like these people can move. Goodness me they are going to think, 'what is that lady doing here?'

However, in time all the group got over their reservations and described the sense of safety that was engendered by the community dance project.

Each week I led the group to develop gestures and motifs that expressed simple ideas relating to the richness of the participants' lives or their sense of identity. The participants themselves provided the movement and the simplicity of the movement vocabulary ensured that each individual was able to fully participate. Dance and somatic knowledge in this project were used as tools to allow expression of feelings, thoughts and emotions. The gestures had a universality, which meant that they did not need to be explained. The embodied expression of symbolic gestures repeated week after week, eventually led to the increased capacity to make sense of personal situations. One of the group exercises was to create a tableau from an individual experience. First, each member of the group reflected on a significant personal experience. They then shared in small groups with one experience being selected to re-enact in a frozen tableau.

Peggy took responsibility for choreographing her experience of viewing Halley's comet on a dark night in the country with her late husband. Each week she remembered her choreography slightly differently but she directed the members of her group with the enthusiasm of someone who had taken complete ownership of 'her movement'. Peggy has died since the project

and as a group member mused on Peggy's passing during the focus group session sometime later, she expressed that although she felt she knew little about Peggy on one level, she felt she knew her deeply because of sharing her special movements over and over again. She stated:

> That scene was so vivid to her, we had to get it right. What it did for me was that I realised you could remember the character and beauty of people you hardly knew. I felt so connected. … You knew Peggy's character and her wackiness and zest for life … she was so completely alive inside herself. Nobody had told her that she was old.

The movements became symbolic of hope in what Sue Wooton (The 2008 Burns Fellow) identified as:

> A common experience of bewilderment, helplessness and paralysis when one is faced with one's own mortality or that of loved ones.

It was as though mortality was confronted by the dance. Rachel stated:

> Those gestures we made somehow defy death. It doesn't resolve it, it doesn't take it away, but somehow something beautiful is made out of the experience.

Having cancer assisted the participants in developing a somatic awareness of their bodies, which in turn allowed them to utilize that awareness when expressing what could not be expressed in words. They moved from a situation of self-judgement to one where they could begin to see the beauty of what others might see in their performance. Participants were able to embody their emotional and spiritual feelings and give them expression without any fear of judgement. Gradually the gestures became filled with meaning although this was not the case at the start. Irene described how the gestures became a private ritual of release:

> The dance for me was about letting the cancer go. Essentially at the beginning it wasn't. But then we did movements and would raise our hands. That was my cancer coming out of my fingertips and flying away. I used it as therapy. The rocking became, yes this is subsiding, you're going to be better. Peace. Each gesture we did had a meaning.

Although the process and sense of community that grew throughout the ten weeks was at the heart of the project, participants were able to choose to take their work to a performance level and ended up performing twice at the Dunedin Public Art Gallery and once at Bellamy's Gallery in Macandrew Bay.

The dance performance was envisaged as a celebration and the bond and support that had been built during the process was particularly evident in the performance. This was discussed during the focus group. Os was able to communicate how he

finally resolved his initial issues about not being able to perform the dance perfectly. There was something about the group process that was able to overcome the inhibitions of even the most intensely self-conscious member. Mary explains:

> With music you are prepared to give it a go, but with dance, you are not prepared to dance in front of people …. I'll dance by myself, but that group made it safe. This was so conscious and you were allowing people to look. There were artists there who were looking.

Irene's comments were shared by the group:

> I thought, I've got so much out of these weeks I've got to see it through, and Elaine felt the same. And once we were out there doing it, it felt totally lifted. It was natural actually, wasn't it Os? It was just wonderful.

Rachel summed it up when she stated, 'Wasn't the dance [performance] one of those things that allowed us to say how wonderful we were?'

Following a Circle of Life performance in the Art Gallery, a lone woman stood in the space. I went up to her and asked if she was alright. She replied 'Something amazing has happened in this space and I want to remain in the energy for as long as I can'.

Movement is at the core of all human experience. Body and mind, emotion and intellect are inseparable. The gestures that these dancers developed together were the embodied expression of their shared experiences. The importance of the performance following the community dance experience was spoken about in terms of a bonus or an optional extra, yet it was something that all participants chose to do. The final performance denoted a reversal in the self-image of the Circle of Life dancers, who moved from seeing themselves as suffering to persons who were able to communicate something of worth and integrity.

Canada

Norma Sue Fisher-Stitt, a dance professor from Toronto gives her perspective on community dance in Canada.

> There is currently no established national organisation or network in Canada that is the equivalent of 'People Dancing: The Foundation for Community Dance' located in the United Kingdom, but there are many dance artists and leaders positioned across the country who are engaged in various forms of community dance practice. Perhaps because we do not yet have a single unifying organisation, a clear definition of what we mean by community dance is not easily determined. However, there is a common underlying concept that philosophically unites many Canadian projects: a commitment to social justice. In the forefront,

the five-year ASC! Research Project on art for social change (ASC!) in Canada, headed by director Judith Marcuse, is an ambitious and ground breaking initiative that might well provide the impetus to establish an enduring Canada-wide network. A national gathering is scheduled for the fall of 2017.

Listing all the projects and people who are engaged in community dance practices in Canada is impossible in this brief report. Therefore, with apologies to all those whom I fail to mention, I have elected to provide a few examples of work currently underway via snapshots of selected projects taking place in Vancouver and Toronto.

Through the Vancouver Board of Parks and Recreation, there are nine community-engaged dance projects offered in various community centres. The values of inclusion, access and diversity are shared by all the projects: participants have access to the activities at minimal or no cost. No one is to be excluded and the emphasis is on process rather than on polished final products. The populations involved in these projects are diverse, including a mixed ability 'All Bodies Dance' group; a 'Dancing the Parenting' project whose mandate is to explore making dances with children under five years of age; and several groups of senior dancers, including 'Ageless Dancers' and the 'Moberly Senior Dancers' which originated as a culturally diverse knitting group.

In Toronto, similar to the Vancouver examples above, community dance projects share a commitment to offering dance opportunities to those too frequently excluded from these experiences. 'Dancing with Parkinson's' (DWP) was established by Sarah Robichaud in 2008 and now offers classes in several locations in and outside Toronto. Canada's National Ballet School has also made space available for Parkinson's dance classes in their facilities, with students in their Teacher Training Program being encouraged to develop skills as community dance practitioners. In 2015, a course in Community Dance Education was launched at York University in Toronto, providing upper level undergraduate students with the opportunity to lead dance classes in community settings. Several students in the course, seeking to extend their personal teaching experience beyond children and adolescents, decided to work with seniors. The quotes below offer examples of the impact the community placements had on the students:

Carla

Before I started this course, whenever I heard someone say community dance I initially thought of younger kids taking recreational classes within a community centre. In this course I have learned that is not what community dance is. It is actually about building, creating, and welcoming communities into the dance world, no matter the age or skill level of the individuals.

Molly

I became aware that community dance consists of bringing together diverse populations of people to dance, regardless of their age, cultural background, race, training, cognitive or physical ability etc. I enjoy the idea that community dance is a new way to reinstate dance as a significant part of our world and a way to unify our communities.

There also are a number of independent dance artists in Toronto who are engaged in projects that employ dance as a means through which to break down cultural and societal barriers. One such project, titled 'Dance Together,' emerged in response to the Syrian Refugee Crisis, and relates to Molly's idea of community dance offering a means through which to bring disparate communities and people together. The impact and role played by the 'Dance Together' project is eloquently described by one recent refugee:

These people are brave. But it is very difficult, and because of past experiences people coming here may think that those hosting them will offer food, housing, practical things, but not a lot of love, not a lot of energy. And for their part, people coming here think 'I will work, I will study, I will care for my children' but not 'I will dance, I will play music' – and that is for two reasons. One, it is so difficult, they know people back home are dying and two, they are sad themselves and removed from the life force of art.

Finally, the inclusion of diverse bodies is the focus of another Toronto dance artist who describes herself as an educator and activist who strives to make 'art that is meaningful … with movers of varied abilities.' In addition to leading 'integrated ability' classes to a range of ages and populations, she is currently developing a sensorial movement event titled 'Flying Hearts'. She describes this as a project which 'is redefining how all bodies can see and experience dance as a community that shares a love of dance with each other'.

Interest in, and commitment to, community dance practice in Canada is steadily growing; I am optimistic that in the years ahead we will see continued growth, increased opportunities for professional development, and the emergence of a robust network of community dance leaders/practitioners.

Conclusion

These positive predictions for the future of community dance in Canada are echoed in numerous places internationally. The above examples have offered a brief glimpse into some of the participatory dance activities in eight very different countries. In many respects they reflect the defining values and principles of community dance outlined in Chapter 1, although there is considerable diversity in

the characteristics of the practice. Practitioners and academics, in the United Kingdom and internationally, will continue to debate issues around definitions of community dance but the examples in this chapter 'uphold the ideal that dance is about a communion amongst participants' (Houston, S. in Chapter 2).

Discussion and Exercise

To what extent do you think the examples of international community dance described above reflect the qualities and core values of community dance that are outlined in Chapters 1 and 2?

Can you find examples of community dance in countries which are not mentioned in this chapter? (The People Dancing website has examples in past issues of *Animated* magazine.)

Notes

1. Makkonen Anne, personal communication 16.5.2016.
2. Heimonen 2009, 28, fn. 40.
3. Yhteiso Tanssii ry 2016a.
4. Kuusisto Sanna, personal communication 15.4.2016.
5. Here, I am referring to the Upper Secondary Vocational Degree of the Dancer at the North Karelia College Outokumpu in Eastern Finland as well as the degree programmes in Dance, Choreography and Dance Education in the Theatre Academy at the University of the Arts Helsinki.
6. See Heinsius and Lehikoinen 2013.
7. See Lehikoinen et al 2016.
8. Hanna Brotherus, Kirsi Heimonen and Pia Lindy to name but a few.
9. Yhteiso Tanssii ry 2016b.
10. Former recipients of the award have been dance artists Mirja Tukiainen (2009), Paivi Aura (2010), Pia Lindy (2012) and Titta Court 2014).
11. Tanssin aluekeskusverkosto 2014.
12. ArtsEqual 2016.
13. Tormi 2016, 84–85.
14. Foster 2015, see also Foster 2012.
15. Foster 2015, 8.
16. Foster 2012.
17. Foster 2015.
18. (http://tracksdance.com.au/hidden-meaning) Australia.

Part V
Community Dance Delivery

Introduction

In this final part of the book I deal with the practical aspects of planning, delivering and evaluating our practice. I set out to share what I have learned and offer some guidelines and samples of resources. If you are new to community dance you may find it useful to use these as starting points, which is exactly what they are. I hope you will continuously reflect on your practice and that of others as you develop your own leadership style and your own approach to planning and recording your work. I suggest you seek out opportunities for observing other artists at work and discussing your own projects with others. This will help with reflective practice – and, as you gain experience, you will feel able to depart from your session plan when you sense that something different would better meet the needs of the group.

In Part III Rosemary Lee describes how she starts with a plan but is constantly noticing and reading feedback from the participants and checking in with herself – her observations and feelings about the session. She talks about responding to the present, being in the here and now. Similarly, Helen Poynor highlights the importance of self-awareness and being open to what we can learn from participants (see Chapter 9). Both these artists are *reflexive practitioners*. They combine sensitivity to the needs of the participants, awareness of their own needs and the ability to respond in the moment.

Think about your own practice and your experience of being a participant in someone else's session. Are you a reflexive practitioner? Have you experienced dance leaders who seem to be engaging in an ongoing process of reflection? What was it like to be a participant in their group? At the end of most chapters there are exercises or discussion points. I suggest you read through them, select those which particularly interest you and discuss them with colleagues. Tutors responsible for community dance studies may wish to use these as a focus for classroom discussion or written assignment.

Further Reading

Amans, D. (2013) *Age and Dancing*. Palgrave Macmillan, Basingstoke.

Blom, L. A. and Tarin Chaplin, L. (1989) *The Intimate Act of Choreography*. Dance Books, London.

Dunphy, K. and Scott, J. (2003) *Freedom to Move: Movement and Dance for People with Intellectual Disabilities*. Maclennan & Petty, Sydney.

Gough, M. (1993) *In Touch with Dance*. Whitethorn, Lancaster.

Langford, S. and Mayo, S. (2001) *Sharing the Experience: How to Set Up and Run Arts Projects Linking Young and Older People*. Magic Me, London.

Lerman, L. (1984) *Teaching Dance to Senior Adults*. Thomas, Illinois.

Lynch Fraser, D. (1991) *Playdancing: Discovering and Developing Creativity in Young Children*. Dance Horizons, Pennington.

Macfarlane, C. and Pethybridge, R. (2016) *Any Age, Any Body, Any Dance*. People Dancing, Leicester.

Matarasso, F. (1997) *Use or Ornament: The Social Impact of Participation in the Arts*. Comedia, London.

Smith-Autard, J. M. (1994) *The Art of Dance in Education*. A&C Black, London.

Tufnell, M. and Crickmay, C. (1993) *Body, Space, Image*. Dance Books, Hampshire.

Tufnell, M. and Crickmay, C. (2004) *A Widening Field: Journeys in Body and Imagination*. Dance Books, Hampshire.

16 Planning a Session
Diane Amans

This chapter will help dance artists consider the practical aspects of leading community dance sessions. It is aimed primarily at those who are new to the profession, but experienced community dance workers may find the material useful in helping them reflect on their methods of planning and delivering sessions. The prompt questions will help the reader to clarify aims and objectives and select activities that will achieve these. The chapter also includes practical advice on timing, writing a session plan, risk assessment, use of resources, group management and methods of documenting the impact on participants.

Before You Begin

The following questions are a useful starting point for any intervention – whether it is a one-off taster session, a regular weekly programme or a month-long residency, the questions that need to be asked are:

Who? Where? When? What? Why? How?

Who? Find out as much as you can about the participants. Who will you be working with? Is it an established group or a group formed especially for this project? Have they chosen to take part or has someone else made that decision? What are their interests/expectations/needs? Who says so? How many people will you be working with and what are their ages? What is known about their previous experience of dance?

What do you know about participants' health and movement ability? Sometimes you may be briefed by other people (for instance in schools and hospitals). In other contexts it will be up to you to find out what you need to know to keep people safe and plan an appropriate session. Many adults will happily chat about their health. Take particular note of any medical conditions

and check up on contra-indicated activities. (NB: Think about confidentiality and data protection when you record this information.)

If you are working with children, young people or vulnerable adults what are the duty of care issues?[1] Who is the carer?

Who else will be in the session? If you are working with other artists, coleaders or support workers, are your respective roles clear? Will there be teachers/parents/carers in the room? Do you want them to join in or watch?

Where? What is the venue like? Do you have any choice of room? Look at floor surface, ventilation, whether there are any fixed hazards like pillars or cupboards with sharp corners. If your session is for a seated group, do the chairs provide support? Is there plenty of room for free activity? Is the room a thoroughfare for other people? What happens in the space before your session? (For instance, will the floor need sweeping if it's been used for dinner?) What are the arrangements for tea/coffee making? How do you access the space?

Do you need to find out who holds the key? Who else will be working nearby? Will they disturb you or ask you to turn the music down?

When? What happens just before/after your session? How long will the session last? Do you have any say over when the session takes place and how long it lasts? Do you have a particular deadline for being out of the space?

What? What will you include in your session? Have you taken account of previous evaluations/feedback? If this is a newly formed group how will you 'break the ice'? What activities will you use to warm the group up? What is the main focus of the dance activity? Has this already been decided or will it be negotiated with the group? If you are working towards a performance, who decides on the theme? Do you need any props or other resources? Will you be using music?

Why? Why have you chosen these activities and how are they linked to your aims and objectives for the session? How were these decided?

How? How will you know if you've achieved your aims? What indicators will you use to determine success? Have you thought about how you will evaluate the session? How will you document the work? (Do you just need a record for your own use or will you be expected to produce a report?)

Finally, *how* do you find out the answers to these questions? If it is the first session or a one-off workshop you need as much information as possible beforehand. Whenever possible try to arrange a briefing meeting with the organisation who

has commissioned the work and even meet the participants if this can be arranged. Prepare for the meeting by making a checklist of the questions you need to ask.

Some questions will not be answered until you begin the first dance session. If this first session is planned carefully it can be a useful opportunity to assess the participants and check out the approach that will best match the skills and interests of the group.

Writing a Session Plan

If you are delivering a session for a school or college there will be a standard format for lesson planning. This is likely to include a scheme of work and session plans which take account of the different needs of individual learners. Some dance organisations also provide a standard *pro forma* for their dance artists to complete, whilst others leave practitioners to devise their own systems. Community dance work which does not involve conforming to a prescribed formula leaves dance artists free to write the session plan in their own style. It is a matter of personal choice and you may find it useful to experiment till you find a system that works for you. Some artists just have brief handwritten notes in a small notebook; others prefer to type plans which they keep in a loose-leaf file together with other documentation, such as meeting notes and risk assessments.

I find it helpful to use colour to highlight different elements in session plans. For example, if resources, such as music and props, are highlighted or written in colour it is easy to check and make sure nothing is forgotten. Coaching points/ reminders about safety issues could be a different colour which will make them stand out as you glance at your notes. It is also worth paying attention to how much time you estimate each activity will take. If you find you have five minutes remaining and you are only halfway through your hour-long plan you need to know where the time went. Did the session start late? Did you spend too long talking about the dance before you began moving? Was the plan realistic or had you included too many activities? In the above example the plan includes the estimated start time for each activity with the actual times written on the plan. This helps with planning future sessions.

An experienced practitioner does not need to continue to write notes out in full particularly if the activities are tried and tested 'old favourites'. Many artists find a shorthand version of the plan is sufficient. The actual process of writing out a session plan – however you choose to do it – is a significant part of any preparation. If the plan is well thought through the dance artist may find that the session flows naturally without frequent reference to the written notes. On the other hand, if something unexpected happens or your mind 'goes blank', it can be most reassuring to have a well-structured plan with you.

Alternative Approaches to Session Planning

The approach I've described so far is only one way of preparing to lead community dance work. Some highly effective and inspiring practitioners do not plan their classes in this way. Ruth Spencer is an independent dance artist working with many different community groups. She records all her work in a spiral-bound notebook and prefers to create a diagram as she plans her session. Look at her plan in Figure 16.1 and see if you can follow Ruth's thinking.

Risk Assessment

Assessing risk is an element of duty of care and is part of any planning process. It needs to take account of all aspects of the session – the environment, the activities, the people involved and any equipment or resources which are used. Risk assessment means thinking ahead and identifying anything which might cause an accident or injury to people involved in the session. A dance session is not going to be completely free from risk, but dance artists can identify possible hazards and take steps to control these.

It is important to document risk assessment procedures and retain these records. Some organisations expect you to use their risk assessment methods and forms; others assume you will take any necessary precautions. In any case it is

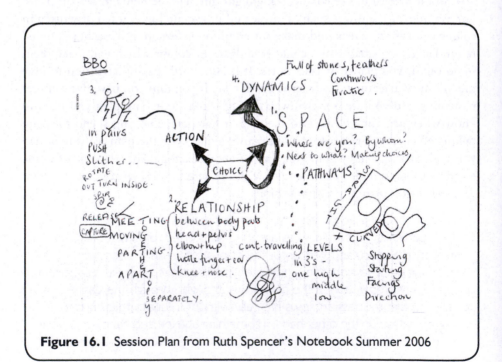

Figure 16.1 Session Plan from Ruth Spencer's Notebook Summer 2006

worth having your own system and taking the trouble to file your notes. The Resources section includes examples of risk assessment forms taken from community dance projects.

Music and Accompaniment

Choice of music – and whether or not to use music at all – is a personal matter. If you like to include accompaniment in your sessions there is a huge variety of sounds to choose from. Experienced community dance artists usually have a wide range of recorded music and participants sometimes appreciate the chance to bring a piece of music that they particularly enjoy. As you listen to music you will find your own way of categorising the different types and the movement possibilities suggested by the sounds. It may be that you prefer to work without sound or with voice and other sounds that you can make with the group – experiment and see what works for you.

Percussion instruments and other live music can add an exciting quality – if you work with improvisation you could invite a musician who will improvise along with the dancers. Participants who have difficulties with hearing may find live music preferable to recorded music (which can cause problems with some hearing aids). Live musicians can add a very special quality to a dance session. Make sure they have directions to the venue and a briefing about what you expect of them. Check out their access needs and what they need in terms of space, time for set-up and so on. Naturally there is a cost to be considered, but I have always either found funding for a musician or, in some cases, found that the host organisation has a member of staff who plays an instrument. On one memorable occasion, in hospital, a therapy assistant brought in his violin to accompany a gentle duet as I led a session with very frail older people.

If recorded or downloaded music is to be included in the dance sessions whose equipment will be used? If you are using your own, is it appropriate for the space? Do you need access to mains power? If so where are the electric sockets? Will you need an extension lead? Will this need to be taped down to ensure it is not a hazard? Some organisations require visiting artists to have any electronic machines checked by an electrician to ensure they comply with health and safety standards.[2] If you will be using equipment provided by the host organisation have you allowed time for familiarising yourself with their machines? Have you checked out music copyright and performing rights laws if you are using recorded music?

Props and Materials

There are numerous commercially produced props to support dance work[3] – for example, scarves, parachutes, ribbon sticks, feathers, lengths of fabric and masks. If you enjoy craft work you can easily make your own versions of these. Ordinary

everyday objects such as chairs, hats, balls and walking sticks also offer exciting possibilities. If you have the chance to block out light you can create a totally different atmosphere with torches, battery LED tea lights, lasers or glow sticks. There are some practical considerations when using props in dance sessions. Apart from making sure you have sufficient props for all participants you need to check to ensure they do not present a health and safety risk. Some percussion instruments are not suitable for use with children; scarves can cause an accident on a slippery floor; parachutes are best used in rooms with high ceilings and unbreakable light fittings. When working in health settings it is important to consult relevant staff, as there will be policy guidelines relating to materials that can be used with people who are unwell.

Personal Preparation

This may take any number of different forms. Some dance artists like to go into the space and spend time moving and preparing their body and mind for the session ahead. Others like to quietly organise their music and props and read through the session plan. It may be that you have little time for personal preparation, but at least take the time to focus yourself, think through the aims of the session and be available to greet your group.

People Management

Being able to engage with people, build relationships and 'hold' a group is essential in leading participatory dance sessions. There are a number of strategies that help us 'connect' with other people and encourage them to engage in activities in their own individual way. Some of these are very simple and, whilst they may seem too obvious to mention, it is surprising how often they are forgotten.

- Greet each participant individually (smile, eye contact, touch where appropriate).
- Make sure you arrive in good time so you are available if someone needs to ask you anything/let you know about an injury etc.
- Use people's names and help them learn each other's names.
- Time spent on an icebreaker (such as a name game) will pay dividends later on when you want them to do partner and group work.
- Incorporate some interactive warm-up activities which have a social element as well as serving as a physical warm-up.
- An activity in a circle – such as a parachute game or a circle dance – is often useful in helping a group 'gel'.
- Be sensitive to situations where there are participants who are new/different/just don't seem to be very popular with other members of the group.

You can manage this effectively if you are careful how partners and groups are selected. Move people around and be prepared to partner someone who needs extra help.

In addition to the participants in a community dance session there are sometimes co-leaders, support workers and diverse other people who may have a reason for being in the space where the activity takes place. In planning a session the dance artist needs to consider how these people will be managed. Co-leaders and other artists should have a copy of the session plan and a clear understanding of their roles in the session.

You may encounter the occasional support worker who decides to become an additional co-leader. If a staff member's well-intentioned 'helper behaviour' is too interventionist the dance practitioner needs to manage the situation so that the participants are not denied opportunities for personal growth and self-expression. This is not easy – particularly in organisations where the prevailing culture is to be fairly directive and to limit opportunities for individuals to make decisions.

One solution is to enlist help with documenting the impact on participants. I have found it very useful to prepare an observation checklist for support staff to complete as an 'outside eye' whilst I am working with a group. This serves a number of purposes; I acquire some valuable evidence to help me with evaluation; the support worker has a meaningful role; and I retain control of the nature and frequency of any interventions.

Methods of Evaluation

The results of evaluation help with planning future sessions, and the selection of appropriate evaluation methods is an important part of the planning process. Time will need to be allocated for feedback discussions, written questionnaires or any other activity involving participants. It may be necessary to devise evaluation tools which are less word-dependent if the participants are not able to use language easily. Chapter 17 considers evaluation in more detail and includes examples of different methods of gathering evidence and documenting evaluation.

Conclusion

Careful and thorough planning will usually help practitioners deliver effective participatory dance in community settings – provided that the dance artist is flexible enough to adapt the plan, or abandon it altogether if necessary. The key aspect here is to remain 'present' and aware of what is happening. It is more important to notice reactions and feedback from participants than to stick rigidly to a timetable of activities. From time to time even very skilled and experienced artists find that a session just does not work very well. It may be, after evaluating

the session, that the cause of the problem becomes clear; but occasionally there just doesn't seem to be any explanation when things go wrong. On these occasions I usually talk it through with another practitioner and, if I still can't work out what happened, I just accept that it was disappointing and try to forget it. I aim for high standards, but I have learned not to punish myself if I do not always achieve them. Planning is very important, but it does not guarantee that every session will be an unqualified success.

Exercise

Imagine you have been asked to lead an introductory dance session for one of the following groups. Write a session plan and make notes on any action you would take before this session.

- An after-school dance club for 15 Key Stage 2 children.
- A youth dance group.
- An adult community group (mostly women) who have been meeting for an exercise class and have decided they want to do something more creative.
- A group of adults with learning disabilities who attend a community centre to take part in a range of activities.
- Residents in a home for older people. This will be a taster session and about 12 participants are expected.

Notes

1. See Chapter 6 for more discussion on duty of care.
2. Most public organisations have a health and safety policy that requires all portable electrical appliances to be tested. **Portable appliance testing** (commonly known as '**PAT**') is the name of a process in the United Kingdom, the Republic of Ireland, New Zealand and Australia by which electrical appliances are routinely checked for safety.
3. JABADAO and Rompa are just two companies that produce excellent catalogues. See Resources section for contact details.

17 Meaningful Measurement
Diane Amans

Evaluation is working out the value of something – 'making judgements, based on evidence, about the value and quality of a project' (Woolf, 2004). As community dance artists we are expected to understand the impact of our work on the participants and to be able to demonstrate the extent to which aims and objectives have been achieved. The evaluation process also has the potential to contribute to an artist's own professional development and can be an important part of developing skills as a reflective practitioner. The challenge is to find reliable ways of gathering evidence of quality and meaningful methods of evaluating it.

> *Evaluation is about calculating worth. Its difficulty arises from the essentially relative nature of worth. ... Evaluation is not, despite being widely used in this way, shorthand for 'How did we do?' though answering that question is a step along the way. (Matarasso, 1996)*

The dance worker leading a project is often responsible for determining its value and reporting on the outcomes. This chapter discusses the ways in which dance artists engage in critical reflection and examines the validity of evaluation processes.

Why Do We Evaluate?
1. So we can be better practitioners?
2. So we can use evaluation in our planning?
3. So we can check out the extent to which we have achieved our objectives?
4. To measure ourselves against quality standards/targets?
5. To demonstrate to funders and other stakeholders that we're delivering what we said we'd deliver?
6. To get evidence for more funding?

These are all valid reasons for evaluating, but it is likely that some have a higher priority depending on the context of the work and the viewpoint of the various

stakeholders. It is important to be clear about *why* we are evaluating so we can decide on the evaluation methodology. Arts Council England (ACE) asks artists for information about proposed evaluation methods before they award grants for projects. In their guidelines on evaluation ACE outlines the benefits to artists of evaluating their work.

- Evaluation helps with planning, as it makes you think about what you're aiming to do, how you will do it and how you will know if you've succeeded.
- Ongoing feedback keeps you on track and helps to avoid disasters.
- Evaluation helps you to adapt and change as your project continues.
- Evaluation is a good way of dealing with 'quality assurance' – you keep an eye on things to make sure quality is maintained.
- Evaluation helps prove the value of what you are doing.
- Evaluation records your contribution to the field you are working in.
- Your evaluation can help others working in the same field.
- Information you collect can also be used for reporting back to those with an interest in the project (e.g. participants, funders) and telling others about what you've done.
- The evidence you collect can support future applications.

(Arts Council England, 2016)

Evaluation is part of our professional practice – the process of evaluation helps artists engage in the debate about what constitutes good practice. But who decides what is good practice and what criteria are being used?

Who Makes the Judgements?

If the artist leading the project is also responsible for making judgements about its value, it requires considerable detachment and objectivity to ensure that the evaluation process is well balanced.

The practical example given here illustrates what can happen when an artist does not realise the extent to which he is influencing the feedback he is receiving. He may genuinely believe that he has evaluated the project in a thorough and professional way. There were many positive aspects of the work, but there were also areas which could have been better. The artist missed an opportunity for some valuable feedback.

Practical Example

The dance artist gathered his group together for feedback at the end of their week-long community dance project. He asked each individual if they wanted to say anything. When someone made a positive comment the artist's encouraging non-verbal responses invited further contributions. When

someone made a negative comment or no comment at all he acknowledged it briefly and moved quickly on to the next person. This was an integrated group with a non-disabled workshop leader facilitating the discussion. Some of the disabled dancers were not able to communicate verbally and their support worker was out of the room making telephone calls (she had asked if she was needed at this point and the artist had said 'no').

One of the disabled participants later remarked to a friend – 'I don't think he's really interested in us as individuals – just as a vehicle for making him look good'. She did not feel able to voice this view publicly as she felt that the artist did not want to hear negative comments.

The artist wrote a positive evaluation report quoting the excellent feedback from participants. The host organisation invited him back for the next year's project.

It is the responsibility of dance artists to make sure that the work is evaluated effectively, but this does not necessarily mean that they are the only ones who make these important value judgements. Everyone involved in a community dance project should have an opportunity to contribute to the evaluation process. This includes participants, support workers, other partners and members of the audience. They all have their own values which will influence how they define quality – one person's high-quality project can be seen, by someone else, to be a waste of resources. This subjectivity is an inevitable factor in evaluating arts activities, but, as Matarasso argues, it need not devalue or invalidate the process. We need to devise evaluation procedures which 'take account of the legitimate subjectivity of different stakeholders'.

Sometimes stakeholders do not have a clear idea of what outcomes are possible or appropriate. This can often be the case when dance is a new activity with a community group and the dance artist is expected to suggest project goals. Despite the fact that aims and objectives focus on intended benefits for those who take part, it is not always possible to involve potential participants in the planning stages of a project. However the project is set up, the challenge for the dance artist is to make sure that methods of evaluation are flexible, inclusive and accessible. There will need to be effective strategies for encouraging feedback and it may be useful to involve other people in the evaluation.

Some community projects have external evaluators who can provide excellent additional evidence. The questions asked by someone who is not very close to a project offer interesting food for thought. Naturally there are resource implications here; an external evaluator has to be funded. This is why it is important to think about evaluation *before* a project begins. A framework needs to be agreed with all stakeholders and, if an external evaluator is necessary, then the fee can be costed in at the beginning.

What Are We Evaluating?
1. The impact on participants?
2. The extent to which we achieve our objectives?
3. The artistic content in the work?
4. The skills of the artist?
5. The final performance?
6. The processes involved in creating work?

Good practice in evaluation means being clear and *specific* about what is being evaluated – however, some aspects of community dance are easier to measure than others. We need to find a way to measure those aspects of our work that we, and the participants, find significant. But who decides what is significant? It may be that the participants think one thing is significant and the facilitators or funders find something else significant. Whose significant aspect is the one that counts?

There are no easy answers here but, if the evaluation is to be meaningful, there needs to be agreement about what outcomes are going to be measured. Meaningful measurement involves getting the right fit between what we want to measure and the methods we use to measure it. The indicators have to be thought through beforehand, together with ways of measuring progress towards the agreed outcomes. There is no point claiming that participants in a dance and health project demonstrate a greater confidence in movement if we have no record of what 'less confident' looked like. Evaluation involves comparison; we need to have something to measure against.

Meaningful Measurement
In 2014 I began some research into Meaningful Measurement. I interviewed a range of experienced community dance practitioners to find out about their approach to evaluation. Many of them highlighted a tension between funders and managers wanting numbers/statistical evidence of impact and dance artists looking for a greater understanding of the creative process and participants' experience.

Fergus Early from Green Candle Dance Company said:

> Basically, I feel we evaluate and collect stats till they come out of our ears. Mostly it is because some of our funders (particularly the council) demand the stats, though they are not so interested in the qualitative stuff. The NHS and aligned parties want data that looks scientifically credible and we want to know how to make what we do as good as possible (and of course to impress our funders …). (Amans, 2014)

A number of dance artists expressed their frustration with an emphasis on quantitative evaluation methods but the issue here is not about quantitative versus

qualitative methods.[1] Both can be valid ways of evaluating practice – what is important is that we are clear about *what* we want to measure and that there is a shared understanding of quality between artists and commissioners. In her Artworks research paper on facilitating quality impacts Rachel Blanche points out that '… robust constructive communication between partners is the key to creating the conditions needed for quality work' (Blanche, 2014).

Methods of Evaluation

There are many ways of collecting evidence to help evaluate community dance projects – interviews, questionnaires, film, feedback discussions, photography, diaries, tape recordings, observation, 'graffiti walls' and final performances.

The dance artists and other creative arts practitioners on one hospital project decided to write a blog.[2] They write up their workshops and everyone else on the team can share good practice, comment on each other's work and support one another. They ask each other's advice and share ideas and ways of working. The artists also have to complete monitoring information online and they have a template form for submitting monitoring information. In this example the blog captures both quantitative and qualitative data.

The project manager said:

- The blog is great as photos, quotes and videos can all be added instantly as part of the post.
- It's a private blog to protect the identities of the patients and this also enables us to use it as a place where we can be entirely open and honest about the work with one another.
- The overall idea is that the blog will be edited and condensed at the end of the project into an illustrated narrative to enable us to use it for presentation purposes.
- They started off thinking about measuring well-being of patients, but the standard well-being questionnaires (for example the Warwick-Edinburgh Mental Wellbeing Scale)[3] are rather lengthy and not entirely relevant for hospital patients, so the artists use postcards to gather in written feedback from participants. The questions on the postcard are simple and open ended – such as 'what did you think about today?' – as they can't give the patients lengthy questionnaires and this also fits in with the national NHS friends and family test.

In choosing the appropriate methods for evidencing and documenting the work the evaluators need to consider, amongst other things, whether the methods are accessible and user-friendly for all the participants. These judgements require evaluators to have the necessary awareness and skills to ensure an inclusive approach. For example, if the participants don't use words to communicate, dance artists

need to find other ways to check whether their own understanding about a project's value reflects the experience of the participants? As part of my research into Meaningful Measurement I asked dance artists what they look for to help them decide whether a session or project has been a success. Here are a few of their comments:

- Levels of engagement, concentration and focus. Has it kept their attention? Has it invited them to invest something of themselves?
- I look at their body language and facial expressions.
- I hope to hear laughter.
- I show them photos of the dance session and watch their reactions
- … another obvious one is if they come back again!!

Several practitioners said that film is a very effective way of capturing impact, provided it is discreetly and sensitively done. It can document evidence and be part of the evaluation process as participants view what they have done and discuss it.

Making Judgements

How do we actually work out the value of community dance work? How much information or involvement do we need and what criteria are we using to make judgements about value? Are we going to look at aesthetics or the extent to which people are engaged in dance? Are we going to judge the quality of the relationships or look for evidence of participant enjoyment?

Clearly these questions cannot be answered without reference to the aims and objectives of the project – but the questions have to be asked before the work begins. If we don't think it through and cost it in before the project starts we may severely restrict our options when it comes to selecting methodology.

Personally I use a range of different methods to collect evidence and document projects. The following example illustrates how these are used in evaluation.

As project coordinator I had overall responsibility for evaluating this project, but there were many people whose judgements were incorporated into the evaluation process. I had regular discussions with the other artists on the project and took account of participants' responses as I planned each new session. Some of the most valuable feedback came from people who were not directly involved on a daily basis but had a link with the project. Parents, costume makers, photographers, providers of refreshments and transport, guest artists – all made interesting and thought-provoking comments which fed into the evaluation. I noted down comments I overheard when visitors were watching the end of rehearsals. I stored up the little observations like 'I was really surprised when my husband joined in – he only went to drop the children off'.

At My Age – An Intergenerational Dance Project

At My Age was a dance film project which explored intergenerational relationships and perceptions of youth and ageing. Over 30 children, young people and older adults worked with choreographers and a film artist to create a short video.

Aims of the Project

- To promote better mutual understanding between people of different generations.
- To challenge stereotypes of youth and ageing.
- To increase skills and creativity of participants.
- To extend access and participation in community dance.

Impact of the Project

The impact of the project was documented using a range of methods.

Project Log for Participants' Comments and Drawings

This was an A3 sketch pad which was prominently displayed during each dance session with the invitation: 'Please make comments/words/pictures in this book'. Most participants contributed to the log and sometimes parents sent in pictures that the children had made when they went home and talked about what they had been doing (see Figure 17.1).

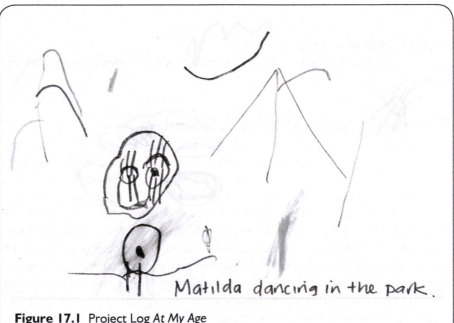

Figure 17.1 Project Log At My Age

The project log also included photographs and feedback from members of the audience who came to the video screening.

Photographs
A photographer attended four out of the seven days and the photographs were a useful focus for discussion.

Video
A video artist filmed the dance workshops and this visual record helped participants to contribute to an evaluation of the work in progress. The feedback discussions were also filmed, giving an opportunity for the project coordinator to reflect on participants' comments after each session.

Questionnaires
Participants were invited to complete simple questionnaires. If the participants were too young to read, an adult asked the questions and recorded the responses to the following questions: What did you enjoy? What did you not enjoy? How did it make you feel? What did it make you think about?

Feedback Discussions
Throughout the project there were informal discussions with small groups and individuals.

Project Coordinator's Log
This contained session plans with observations and reflections during and after sessions.

External Evaluator as 'Critical Friend'
In my work as a community dance artist I try to involve an 'outside eye' whenever possible. This may be a member of staff, if I am working in a health and social care setting, or it may be an arts worker. Often I bring in an external evaluator. I feel this adds rigour to the evaluation process – and it keeps me on my toes. It's an invaluable source of professional development for an artist. In addition to discussing evidence for evaluation there's nothing quite like being asked to justify decisions and talking through alternatives with an experienced practitioner. On one memorable project the external evaluator gave me some very useful feedback about my communication style. I was working with deaf and hard of hearing young people and I had adapted my methods to keep verbal prompts to a minimum. I learned some basic sign language so that I could lead the introductions and initiate simple activities. I also involved signers to help with more complex

communication. What I hadn't realised, until I read the gentle feedback from the external evaluator, was that my well-intentioned communication methods contained a significant flaw. I continued to use my habitual arm gestures – often fairly exuberant – thus introducing the visual equivalent of considerable 'background noise'. The rest of the evaluation report related to the impact on participants and was extremely favourable, but most memorable for me was the comment about arm gestures. This feedback was an unexpected 'gift' to help me evaluate my practice.

Self-Evaluation

As artists involved in participatory dance activities with different community groups we have plenty of scope for personal development if we are open to receiving feedback. Alongside an evaluation of the dance activity we have an opportunity to evaluate our own practice and raise awareness of our strengths and any areas for further development. We will only receive this essential feedback, though, if we establish relationships based on trust and openness – where participants, colleagues and observers feel comfortable in sharing value judgements which may not always be easy to hear. We need feedback if we are going to understand the impact of our behaviour on others. The Johari Window[4] (Figure 17.2) is a useful model to illustrate how feedback can help increase our self-awareness.

	Known to self	Not known to self
Known to others	Open area	Blind area
Not known to others	Hidden area	Unknown area

Figure 17.2 The Johari Window

In evaluating community dance projects we have an opportunity to increase the size of our open area by inviting others to give us 'feedback presents'. If we have a good level of self-awareness and understand our own values and behaviour we are more likely to be able to be able to make objective value judgements about others.

Conclusion

The questions and issues discussed in this chapter illustrate the complex nature of measuring quality and value. Evaluation is too important to be left to the end of a project. Although the last-minute questionnaire is still a feature of some community dance activities, it has limited worth if this is the only method used to evaluate the work. As dance artists we have an important role to play in measuring the value of what we do and promoting a shared understanding of that value.

We can do this by:

- Seeking out alternative, creative ways to make measurement meaningful.
- Articulating our measurement – what we are looking for and how we justify our evidence.
- Suggesting aims and success criteria when projects are first set up.

If we are proactive in these ways then we will help to promote a shared understanding between artists, employers and commissioners

Discussion Points

- What is the difference between documentation and evaluation?
- Think about a recent experience of evaluation in dance – either as a participant or as a dance practitioner. Would you say this was meaningful measurement?

Notes

1. Quantitative methods of collecting evaluation data usually produce numbers and answers to questions relating to what, who and when. Qualitative methods capture information about how and why people behave in certain ways. Evaluators often use a combination of quantitative and qualitative techniques – a 'mixed method' approach to evaluation.
2. Air Arts: Engage are creative arts practitioners who worked on hospital projects at Derby Royal Hospital and London Rd Community Hospital in Derby.
3. The Warwick-Edinburgh Mental Wellbeing Scale (WEMWBS) consists of positively worded statements about mental well-being and is sometimes incorporated into evaluation strategies to measure the impact of arts projects on health and wellbeing.
4. The Johari Window is a tool for understanding and developing self-awareness. Further information can be found at http://www.businessballs.com/.

18 Project Coordination
Diane Amans

If you are a community dance artist who also acts as project coordinator you will find that this chapter gives a comprehensive overview of your responsibilities in managing the work. There is a checklist with prompt questions and details of two actual projects showing the very different ways in which practitioners develop projects from an initial idea through to delivery and evaluation. The chapter includes:

- *Writing a proposal and developing the project.*
- *Costing and managing budgets.*
- *Publicity.*
- *Risk management and duty of care.*
- *Administration and record keeping.*
- *Partnership working.*
- *Documentation and report writing.*
- *Managing endings.*

Delivering community dance involves far more than writing session plans and carrying out evaluations. The project coordinator has to manage all aspects of the work from the beginning through to writing a final report. Sometimes practitioners take on both roles – they are dance artist and coordinator. In other cases, for instance when artists are working for a dance company, they may have a line manager who acts as project coordinator.

The following questions will usually have to be answered before any dance project takes place, though in some cases the questions have been dealt with before the project coordinator becomes involved. Even so, it is important to be clear about your 'ideal situation' so that if you are involved from the beginning you know what you are aiming for and where you are prepared to compromise. If the project structure has already been established it may still be possible (or necessary) to suggest changes. This checklist will focus your planning and signpost you to sources of help.

Project Coordinator Checklist

- **Aims** What is the purpose of the project? Who decides? Are you working for an organisation which has set clear aims for the project or will you need to suggest aims? Perhaps the project is your idea and you have aims in mind. Why have you chosen these?

- **Participants** Who will take part in the project? How many? Is there an existing group? If so, what are their interests? How active are they? Do you have any say in who takes part? What criteria will you use to decide on the make-up of the group?

- **Schedule** How many sessions? How long is each session? What time of day is best? If it is a health/social care/residential setting, check for clashes with established activities (such as bingo) or community visitors such as hairdresser or chiropodist.

- **Venue** Have you a choice? What type of floor/furniture/ventilation? Can you get into the venue before the start time? What happens just before/just after the session? Will this impact on your work? Are there facilities for refreshments?

- **Content** It may be that the project aims determine the dance form, but, if that is not the case, what type of dance would be most appropriate? How will you decide what to do/where to start? Will the participants prefer set dances or improvisation? Will there be icebreaker activities? What is the best way to warm up the group?

- **People management** As project coordinator you will need effective people skills to manage interactions with a wide range of people. You are responsible for ensuring that everyone directly involved in the project is clear about roles and understands what will take place in the sessions. If you are not actually leading the dance sessions, how will you liaise with the lead artist? How much support does he/she need? Who else is involved? Who are the partners you will be working with? Have you established clear lines of communication? The people skills that are important here are the ability to build relationships, listen effectively and be able to adapt your communication style to suit various situations.

- **Equal opportunities/inclusion** Does the planned project take account of the different needs of those involved? Have you taken steps to make sure you are not excluding any potential participants without good reason? Will you accept all comers? Are there any issues relating to access/diversity/inclusion? Sometimes we can unwittingly exclude people by the way we recruit participants for a project. Think about how people find out about your activities and have a look at the makeup of your group. Does it reflect the diversity of the local population? Perhaps it doesn't, and you have made well-considered decisions about targeting a particular section

of the community. Check the dates to make sure there are no clashes with key faith festivals or other important events. Make sure that you are aware of any considerations relating to dress, food and drink. The Shap Calendar of Religious Festivals has information about key dates for different world religions – see contact details in the Resources section.

- **Publicity** Are you responsible for this? If so how will you publicise the project? Do you need to make any presentations? Is there a budget for leaflets, e-flyers or adverts in newspapers? Is information written in clear, jargon-free language? Will you be using images? If so, do you have consent to use them?

- **Duty of care** What do you need to do to take care of the people on the project? Will you carry out a Health and Safety questionnaire? Who will take responsibility for this? Will it be done before the project or at the first session? Where will the information be stored? Have you done a risk assessment on venue and activities? Have you discussed existing controls and precautions with all staff involved? It may be that the host organisation has carried out a risk assessment on the venue, but you still need to look at possible hazards in the context of dance sessions. Will you be working with children, young people or vulnerable adults? If so you will need to consider **safeguarding** issues. As project coordinator you have a duty of care to participants, staff, yourself and the general public. The Resources section has sample Health and Safety questionnaires and Risk Assessments, and Chapter 6 has further information on duty of care issues.

- **Insurance** Does the project have adequate insurance cover? Have you seen artists' certificates of insurance? Does the venue have public liability insurance cover?

- **Resources/music/materials** Do you need to buy/borrow any resources? Will you be using music? If so do you need a licence? (See Resources section for information on music copyright.) If your sound system needs a mains power lead you may need to check whether the venue requires it to be PAT tested by their health and safety staff.[1]

- **Liaison with partners** How will you report on the project? Do you need to have meetings with host organisation/arts officers/funders/anyone else? Have you allowed time for this and costed it into the budget?

- **Documentation** As with all other aspects of the project, documentation needs to be considered at the planning stage because there are resource implications. Part of your role is to discuss this with your partners and suggest appropriate methods of documentation to suit the budget. If you decide to involve photography or film you will need to organise consent forms (see Resources section for an example consent form). If the documentation is to be shared with participants it needs to be in a format which is accessible for them. On the other hand, if it is to accompany an evaluation report

to demonstrate that the aims have been achieved, it will need to bring the project alive for funders and others who may not have witnessed it. You may decide to involve a visual artist to make paintings or drawings of your project. Bisakha Sarker (Figure 18.1), a dancer working in a wide range of community contexts, often involves artist Noelle Williamson who paints as participants respond to Bisakha's dance ideas. The paintings in Figure 18.2 were made during a dance session in a hospital waiting room. Bisakha used the paintings in her illustrated report of the project. There was no problem with gaining consent as patients cannot be identified in the paintings – and works of art have been created in the process. (Many patients came back to see the paintings when they were finished.)

- **Monitoring** What records will you be keeping? How will information be collected? Who needs to receive monitoring information? Where will you store the information? Many organisations which fund projects ask for information about participants – such as gender, ethnicity, age, postcode, and whether there are any disabled people involved. It is worth knowing as early as possible which details are needed for a final report.

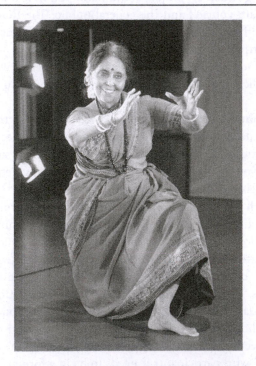

Figure 18.1 Bisakha Sarker (*Simon Richardson*)

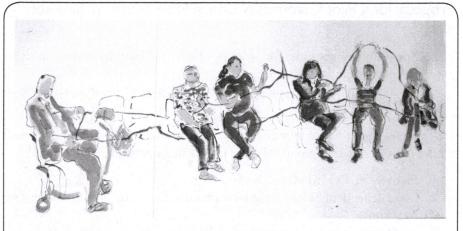

Figure 18.2 Patients at the Royal Liverpool Hospital. Painting by Noelle Williamson

- **Evaluation** What will you be evaluating and what methods will you be using? Will there be an external evaluator? Have you costed this into your budget? Chapter 17 looks in some detail at evaluation methods.
- **Celebration/final session** Is this definitely the end or might there be a follow-up project at some future date? Whatever the circumstances, the challenge for the project coordinator is to find a way to make the last day special and end on a positive note.[2]
- **Mentoring/support for you** Do you need any specific help/advice? Will you need support? Have you created opportunities to discuss the practice with a mentor? Do you think this is important? Have you costed it into the budget?

Case Study 1: Project with Older People

In this first case study the artist leading the dance sessions was also the project coordinator. Amanda Rosario, a dance artist, was approached by Tamesbridge local authority arts officer James Sheikh, who wanted to set up a pilot community dance programme for older people in the borough. James was keen to promote arts and health programmes and was very proactive in developing partnerships with health, social care, charities and voluntary agencies. Amanda had recently completed a training course in leading dance activities with older people.

After an initial meeting Amanda prepared the following proposal and presented it to a meeting of the local Active Communities Group who were interested in funding the venture.

Proposal for a Pilot Community Dance Programme in Tamesbridge
Aims

1. To create opportunities for older people in Tamesbridge to join in dance activities regardless of ability
2. To document and evaluate benefit to participants with particular reference to the impact on health

It is proposed that this community dance project be delivered in 3 × 6 week blocks to three different groups of older people in Tamesbridge. For example:

1. Fit over-50s living independently
2. More dependent older people who attend a day centre but still live in their own homes
3. residents in sheltered housing or similar

The project will include 18 dance sessions for up to 45 local people. The sessions will be facilitated by a lead artist and a co-leader, both of whom have attended training courses in leading dance with older people. Sessions will include warm-ups, breathing exercises, relaxation and a range of dance activities. The objectives of each session will be to improve mobility and strength and to offer opportunities for individuals to express themselves creatively through dance. At the end of the dance sessions there will be light refreshments; artist and co-leader will take responsibility for organising these and facilitating the social interaction between participants.

The programme will include a range of activities and dance styles and the evaluation methods will incorporate feedback discussion and the completion of simple well-being questionnaires to monitor the impact on participants.

An illustrated evaluation report will be provided within two weeks of the end of the project.

In her presentation Amanda showed a brief film of dance work with older adults and described some ideas for recruiting participants – running taster sessions in day centres, circulating leaflets and fliers to GP surgeries, supermarkets, churches, bingo halls and so on.

The members of the partnership were impressed with Amanda's presentation and they offered to provide assistance with marketing and other support where possible. They agreed a budget and requested that the project be launched with three taster sessions in the town hall as part of the Falls Prevention Awareness Day which was due to take place in a month's time. Weekly sessions would begin two weeks after the taster sessions.

Costing and Managing Budgets
The costing for the project included fees for artists and co-leaders, costs of materials, publicity, photography and refreshments. Amanda also included a fee for

coordinating and managing the project and charged for time to produce an illustrated evaluation report. Venue hire was supplied as in-kind support by the Active Communities Group.

Amanda was responsible for managing the budget, which came from a local authority grant. The fee, in two instalments, was paid direct to the artist who trades under the name 'Xoros Dance'. All costs, including the co-leader's fee, were paid from the Xoros Dance account.[3] In costing the project Amanda allowed for the development time which took place before the work was even agreed:

One month to go till the project begins – the artist coordinator has so far spent 14 hours on the project:

Initial phone call with Arts Office and 10 minutes writing notes	0 hr 30min
Preparation for proposal	2 hr
Presentation to Active Communities Group (inc. travel)	2 hr 30min
Development work – recruiting a co-leader, visits to venues, liaison with Health and Social Care staff	7 hr
Preparation and circulation of publicity material, writing copy for newsletter	2 hr

Publicity

The project was publicised via leaflets, e-flyers, announcements in the local press and posters on community notice boards. Amanda provided copy for all the publicity material; the arts officer and other members of the Active Communities Group took responsibility for circulating information amongst sheltered housing associations and other organisations which provide services for older people. At the Falls Awareness Day people were encouraged to take part in or watch the taster sessions and everyone attending received information about the forthcoming dance sessions.

Risk Assessment

Amanda carried out a risk assessment at the town hall and the three proposed venues: Sheltered Housing Complex, Day Centre and Leisure Centre. One of the proposed venues (a residents' lounge) had very limited space, large heavy chairs and a glass-fronted display cabinet. Amanda felt the room was not really suitable for a dance session, but the warden was very keen to motivate her rather frail residents to take part in some form of exercise. The artist agreed to run six chair-based dance sessions for a maximum of ten residents and the warden agreed to move the display cabinet into a different lounge.

At the taster sessions the falls prevention team took responsibility for asking each participant if there were any health issues that the artist needed to be aware of. Amanda delivered a very gentle session and whenever there were activities that

were not chair-based – for example partner work – she divided the group into smaller groups which she and the co-leader could safely manage. The remaining participants watched until it was their turn.

Before the six-weekly project began at the three venues, all participants completed a health and safety questionnaire and signed to say they agreed to inform the artist of any issue affecting their ability to take part safely in the session. In the event there were a few extra people enrolling on the first day at each venue. The artist and co-leader went through the questionnaire with them before the session starts. At one of the venues there was a woman who had a number of health problems, and had recently been diagnosed with cancer. Amanda was happy for the woman to watch the session, but asked her to get her doctor's advice before taking part.[4] The woman took a copy of the questionnaire and her doctor countersigned it.

Administration and Record Keeping

Administration for the project included liaison with key partners, completion of forms for the finance division to release funding, sending a letter of contract to the co-leader and photographer, collecting details of participants (names addresses and monitoring information such as postcodes and ethnicity) and keeping a register of attendance. This was all carried out by Amanda who also recorded her risk assessment and the steps she had taken to reduce risk.

There also needed to be signed consent forms for the photographs which were taken during the fourth week of the project. The artist prepared the forms, which were signed during the refreshment break at the end of the sessions.

Partnership Working

During the course of the project Amanda had communication with the following people:

- Co-leader.
- Arts Officer.
- Active Communities Group (nine members).
- Falls Prevention Team (four members).
- Warden and assistant warden at sheltered housing.
- Day Centre Manager.
- Leisure Centre Manager.
- Caretakers and cleaners at two of the venues (four in total).
- 48 participants (including taster days and weekly sessions).
- Support staff to assist with refreshments (six in total, five of whom joined in the sessions).
- Photographer.

So, in addition to the participants, there were 78 other people involved in this short project. As coordinator Amanda was responsible for making sure that individual needs and wishes were recognised and that everyone involved was satisfied.

Documentation and Report Writing

Amanda documented session plans and the evaluation which was completed in a short meeting with the co-leader after every session. Any comments by staff and participants were recorded in the project diary together with the results of feedback discussions which took place during refreshment breaks every week. There was a demand, from participants, for the sessions to be continued and the arts officer agreed to explore possible sources of future funding.

The illustrated project report was written during the week following the last sessions. It was a 10-page document detailing the background to the project, list of aims, evaluation of the sessions in each venue, comments by participants, final conclusions and recommendations for the future. Photographs were included in the main body of the report with additional photographs in an appendix.

Amanda was only asked to provide two copies of the report, but she decided to produce ten copies – one for the arts officer and one each for members of the Active Communities Group. She did this because it was likely to be used as an advocacy document to promote the work and all members of the group had shown considerable interest during the project.

Managing Endings

Although it was hoped that the sessions could be started again at a future date, the original pilot project in each venue lasted only six sessions. Amanda made the last sessions special by introducing a celebratory circle dance and giving an opportunity for everyone to request their favourite dance activities from the project. She and the co-leader also brought cakes and fresh fruit kebabs to share with the group. Whilst participants clearly appreciated the efforts to create a special atmosphere, they expressed disappointment and frustration because the classes were ending after such a short time.

Case Study 2: Intergenerational Performance Project

Marco was commissioned to create a site-specific dance piece to be performed by cross-generational community performers at a July street festival. He decided to act as artistic director and project coordinator and invited a guest choreographer to create the dance piece.

The arts organisation which commissioned the work asked for a dance that challenged stereotypes and celebrated diversity. The project began in May when Marco brought together a new group of dancers from widely different backgrounds. He drew on his various contacts in the community and found 10 dancers aged 7 years to 82 years who were prepared to take part in something new. One of the dancers was a performing arts student and three of the children attended Saturday dance classes. The adults in the group had never performed for an audience.

Marco organised an intensive rehearsal week during the school half-term holidays and then seven evening rehearsals once a week. The intensive week took place in the dance studio of a college and the weekly rehearsals were held at a hotel close to the site of the summer festival. The week before the performance there was a dress rehearsal on site. The choreographer, Bernie, worked closely with both Marco and the participants, incorporating their ideas into a witty 12-minute dance which delighted the performers and everyone who watched it.

On the day of the street festival the group performed three times to large audiences who gathered in the town square close to the shopping centre. They had changing facilities in the upstairs room of a local bar and between performances they returned there to relax and eat lunch. During these rest times each performer was interviewed about their experiences on the project and their comments recorded using a digital camera. This was done as part of the project documentation organised by Marco.

Project Coordination

This was a complex project to organise – the coordinator's tasks included:

- Recruiting participants and arranging for their transport to and from rehearsals.
- Carrying out risk assessments on venues.
- Liaison with participants, parents, choreographer, festival organisers, support worker, publicity staff, costume maker, video artist, photographer.
- Sourcing costumes and props.
- Ensuring the safety and comfort of participants.
- Ensuring security of props and participants' possessions during performance.
- Booking space for rehearsals.
- Securing signed consent forms for photographs and video use.
- Ongoing reviews with choreographer, including choice of music and costumes.
- Ongoing reviews with participants.
- Providing copy for publicity.
- Managing the budget.
- Documenting the project and writing an evaluation report.

Marco attended most of the rehearsals and took advantage of opportunities to chat with the performers and their parents. This meant that he was aware of ongoing feedback about the project and was able to deal promptly with any queries and concerns. Bernie was free to focus on the choreography as she knew Marco shared responsibility for taking care of the individual and group needs.

Marco compiled an evaluation report using feedback from performers, parents, choreographer, audience members, festival staff and other artists who attended the festival. He illustrated the report with photographs taken by the photographer he had invited to attend the dress rehearsal. The report was sent to the arts organisation which commissioned the dance.

Challenges – Dealing with the Unexpected

Marco is an experienced project coordinator who plans his work well but, like most projects, this one presented a few challenges. These were mostly relating to risk management and duty of care. First of all there were safeguarding considerations, as the participants included children and young people under 18 years old. Marco met with parents before the first session and it was agreed that a parent or other carer would accompany the children at all times. Just before the third rehearsal a seven-year-old girl was dropped off at the front door of the hotel by a parent who returned to collect her two hours later. Another parent, who did accompany the child to rehearsals, was happy for her daughter to go unaccompanied to the public toilets in the hotel foyer. On both these occasions Marco had to deal with different expectations and boundaries with regard to duty of care. As project coordinator he had to insist that people complied with the safeguarding measures he had put in place.

Another duty of care challenge occurred in relation to managing the pace of rehearsals. The adults, some of whom were aged over 60, needed a slower pace and more frequent rest periods than the children. However, they did not always like to admit they were feeling tired, and Bernie, who led the rehearsals, assumed everyone was comfortable if they did not say anything to the contrary. After the first two rehearsals Marco insisted that there were more frequent breaks during which people rested, discussed costumes, made an entry in the diary or worked in pairs to talk through their duets. Several of the older adults mentioned that they were glad the practical sessions now included a chance to 'catch their breath'. They had all been struggling a little but had not wanted to be the one to ask for a break – despite the fact that Bernie had made it very clear she was happy to stop when anyone felt they needed to. In reviewing the rehearsals with Marco, Bernie said this was a valuable lesson for her. In future intergenerational projects she will take particular care to think of ways in which the different energy levels might be managed.

On the day of the performance Marco was disappointed that there was very little technical support from the festival organisers – despite the fact that they had promised two members of staff. In the event there were insufficient stewards and Marco was thankful that he had brought along his friend, Sam, who was able to move props on and off stage, look after performers' valuables and carry out various other last minute tasks.

Marco thought he had considered every possible hazard when he carried out the risk assessment for the project. He had not predicted that members of the public might show their appreciation by throwing coins at the performers! Fortunately no-one was injured and, together with Sam, he was able to intervene promptly.

The End of the Project

After the final performance the group gathered for a drink in the changing room, where Marco gave Bernie a thankyou gift and each of the participants a celebration card containing photographs which had been taken at the dress rehearsal. They were all invited to come together in September and view a film of the performance. All but two of the performers attended this informal gathering, which took place in the dance studio where they had previously rehearsed.

Lessons Learned

Both of these case studies are examples of successful projects which were well managed by experienced practitioners. However, in evaluating their work both Amanda and Marco identified areas where they could improve their practice.

Amanda now takes particular care not to raise any unrealistic expectations about projects continuing beyond the initial pilot period. Although she had told participants that it was a six-week project, she also mentioned that the Arts Officer was seeking further funding and it was hoped the sessions could continue. If a similar situation arose in the future she has decided to 'play down' the possibility of sessions carrying on. She also considered ways of helping the Active Communities Group find funding, as the Arts Officer moved to another local authority shortly after the end of the project.

The main lesson that Marco learned was to recruit an additional 'pair of hands' for the performance day: someone who knows the dance piece and is available to carry out errands at short notice. Although he did have a number of people in his team – parents, choreographer and the costume maker – he and Sam found it exhausting to deal with the technical support as well as making sure the performers were in the right place. In future he will make sure he has funding to hire dedicated technical support for his project – regardless of whether the organisation hosting the event say that staff are available.

Conclusion

These two case studies offer a flavour of the very different types of work that are managed by community dance artists. In both these examples the projects were initiated by external agencies, but there are plenty of opportunities for practitioners who want to develop their own proposals. If you have an idea for a project you could approach a dance organisation, your local authority arts officer or any appropriate community partnership. Alternatively, you could create your own project and apply for funding from one of the grant awarding bodies that fund community groups.[5]

Exercise

Think about a dance project that you would like to run. Come up with a project outline describing the project. This would include aims, target group, duration, venue etc. Really let your imagination go and devise your dream project.

- How would you go about setting up this project?
- Who could you approach to fund it?
- Write a proposal with a timetable of activities.
- Produce a costing for the project.
- Identify key tasks and who would be responsible for carrying out these tasks.
- Produce a draft flyer to market the project.
- Identify any issues which need clarification.

Notes

1. Portable appliance testing (commonly known as 'PAT') is the name of a process in the United Kingdom, the Republic of Ireland, New Zealand and Australia by which electrical appliances are routinely checked for safety.
2. The Resources section contains ideas for creating celebrations and special occasions.
3. The artist set up the dance company in order to be eligible for a wider range of funding. It has a management group of four and all cheques are countersigned by one of the named signatories.
4. Exercise is contraindicated for some forms of cancer.
5. Contact your local community and voluntary services group for information about funding opportunities; details from http://www.ncvo-vol.org.uk/.

19 Challenges and Tension Lines

Diane Amans

In this book I have explored some of the challenges and tension lines associated with community dance practice. There is the ongoing debate about terminology: should there be a separate term for community dance and, if we use the term, what exactly do we mean by it? Sara Houston argues that, provided 'there is identification with the ideals for which community dance stands', then the term 'community dance' is valid.

Inevitably there are different perceptions of what is meant by 'community dance' in different countries. In New Zealand, for example, the 2015 'Moving Communities' conference on community dance, included presentations by performance artists. There were some interesting discussions about whether performance art – which engages people as audience members rather than participants – could be considered to be community dance. The process-oriented values listed in Chapter 1 include a 'focus on participants' and 'collaborative relationships'; these are not usually features of performance art. However the same list of values also includes 'opportunities for positive experiences' and 'celebration of diversity' and performance art often includes these.

Several contributors to this book mention the distinction between 'community' and 'professional' dance, with its implicit hierarchy of aesthetics and performance standards. For example, Adam Benjamin talks about 'accomplished performers' and 'higher levels of excellence' when he describes how CandoCo developed into a professional company. Benjamin acknowledges that, although the company had moved away from 'immediate accessibility', it would, hopefully, go on to 'spread ideas of participation and involvement to an ever-widening audience'.

Rosemary Lee also refers to these labels ('professional', 'non-professional' and 'community') and explains that she tries to ignore such divisions as they influence the way the audience views the performance. Regardless of context, Lee wants all

her work 'to be considered critically as art' and doesn't want people to look at it with 'different eyes'. The challenge for community choreographers is to present dance performance in such a way as to avoid perpetuating divisions between a community/professional aesthetic.

In reading about Lee's working practice I reflected on another tension line in community dance – the extent and nature of interventions by the dance artist. As community dance practitioners we *are* interventionist, and some chapters in this book give an insight into the kind of interventions dance artists make. Lee thinks carefully about the way she works with a group and talks of 'treading a line between responding to the participant and responding to my artistic imperatives'. Similarly, Helen Poynor talks of tuning in to the mood of the group before deciding on an intervention – whether to support a quiet, gentle exploration or to initiate something more energetic. These are examples of flexible practitioners who are ready to adapt their plans in response to feedback from the group. Poynor highlights the importance of self-awareness: if practitioners have an awareness of their own 'preferences and blind spots' they are more likely to support individuals to engage in dance in a way which is meaningful for them.

How do people gain the skills to work in this way? Can we train people to have self-awareness? As Sue Akroyd points out, skills can be nurtured and developed throughout one's career as a community dance artist. Self-awareness skills, as described by Poynor and Lee, encompass observation skills, noticing one's own behaviours and impulses, and checking that one is 'reading' other people accurately. These skills can certainly be learned and practised; ideally, they will be combined with a fundamental interest in other people and a commitment to support them in achieving their potential as dancers.

Louise Katerega's story illustrates how she helped someone achieve his potential – again by thinking carefully about her own interventions. She raises some interesting issues about power relationships in participatory dance practice. Community dance artists have considerable power to influence not only the content of the sessions' activities but also the extent to which people feel able to make connections with the dance, and with other dancers. The way practitioners use their power – in other words their leadership behaviours – will determine whether or not a community dance project reflects the core values outlined in Chapter 1.

One of these core values is inclusive practice, and Katerega and Benjamin both describe their roles in relation to integrated performance projects which involve disabled and non-disabled dancers. Benjamin talks of the choreographer creating the best situation in which 'all these diverse people can thrive'. He encourages high standards whilst making sure he doesn't make unrealistic demands of performers. Katerega reveals how she supported integrated practice by withdrawing and taking a 'back seat' with a group who were accustomed to her leadership.

This made it easier for a disabled choreographer to work effectively with the group without ambiguities surrounding who was directing the piece.

Benjamin and Katerega have many years of varied experience in community dance. The late Alan Martin, a relative newcomer to the profession, had a very different route into the dance world. As a participant and a workshop leader he described his experiences from the perspective of a disabled man and challenged practitioners to think about planning inclusive activities in *all* their sessions. This doesn't mean we have to simplify everything in case it presents a barrier – we just need to have open structures and flexible delivery methods, rather than hastily adding on an 'accessible' activity if a disabled dancer turns up. Disability equality legislation requires us to be able to make 'reasonable adjustments'[1] – this is something that community dance artists are doing every day. We don't do it because the law says we should, but because it's consistent with our defining values.

These values and principles are shaped by contact with other practitioners, professional development activities and our openness to new experiences. They are the 'glue' that binds together a very diverse profession. As long as we have dialogue with other practitioners, and carry on debating our practice, we will continue to evolve a shared ownership of our professional standards and a broad agreement about what we mean by 'good practice'.

For me, the 'community voices' in Chapter 3 highlight some of the elements which characterise community dance:

- Accessible opportunities for people to engage in dance in a way which is meaningful for them.
- Celebration of diversity.
- The experience of feeling valued.
- Magical, 'transformative' moments.

I expect many practitioners can identify with the so-called 'transformative moments'. I wonder how many artists can also relate to the challenge of recreating these moments for an audience: supporting dancers to perform in the embodied way they did during the making process. Live performance can be a thrilling experience for the dancers and the audience. At the other end of the tension line it can be full of stress and anxiety, thus making it an inappropriate experience for some performers.

There are many ways of celebrating achievement and sharing work with others; performing to a live audience is only one of them. A resourceful practitioner will be able to consult with the group and find a way which best meets their needs.

Community dance is a complex activity and dance artists need to be able to tune in to the needs of individual participants and the demands of partners in other sectors. It is also important to retain the focus on dance as an art form; sometimes this can be difficult when different stakeholders are focusing on different

outcomes. In Chapter 17, I discuss some of the tensions between funders and managers who want statistical evidence of impact and dance artists whose focus is on the creative process and participants' experience.

Finally, as we continue to grow and develop community dance work, it is important that we make opportunities for nourishing ourselves as artists. This is just as important as continuing to update our skills. I hope that this book will have provided food for thought and some practical guidance. The Resources section, which follows, signposts you to further sources of information and support.

Note

1. This refers to the UK Disability Discrimination Act 1995 which was replaced by the Equality Act 2010 (apart from in Northern Ireland where the original Act is still in force). The Commission for Equality and Human Rights website has information on this: http://www.equalityhumanrights.com/.

 In the late twentieth and early twenty-first century, several countries passed laws aimed at reducing discrimination against people with disabilities. Further information is available from www.un.org/esa/socdev/enable/disovlf.html.

Resources

People Dancing

What Is People Dancing?
People Dancing is 'the foundation for community dance.' It is the UK development organisation and membership body for anyone involved in creating opportunities for people to experience and participate in dance. Its membership reaches more than 4,500 dance professionals worldwide.

What Is People Dancing's Core Belief?
That dance can change lives and transform communities. It can do this by:

- Contributing positively to people's health and well-being, resilience and social relationships
- Adding value to broader social, creative and learning agendas.

What Is Its Vision?
A world where dance is a part of everyone's life.

What Is Its Mission?
To make dance important to all individuals, communities and society by promoting excellent dance practice.

How Does It Go About This?
People Dancing works with and on behalf of artists, organisations and teachers involved in leading, delivering or supporting community and participatory dance.

What Areas or Issues Does People Dancing Focus On?

People Dancing's leadership of the community dance network acts as a driving force for the sector, providing a platform for exchange, critical debate and peer learning. This exposes its members and partners to diverse dance practices and new contacts.

By helping to expand professional horizons, profile and professional identity, People Dancing is an invaluable resource for anyone working in community dance. It also creates opportunities for people to take part in dance activities.

People Dancing delivers through three interlinked programmes:

- Developing Practice
- Developing Participation
- Providing Member Services.

Following a collaborative and dynamic approach to organisational development, People Dancing adds value to the community dance sector, supporting artists and organisations to do what they do better. It helps bind them together, offering a national vision and stategic overview.

For further information about People Dancing go to: www.communitydance.org.uk

Duty of Care Quiz Answers – Chapter 6, Exercise 1

1. You have a duty of care to:
 - the people who come to your activity session
 - anyone you work with (colleagues, support workers),
 - anyone you employ
 - yourself
2. A vulnerable adult is a person who is, or may be, in need of community care services because of mental disability, age or illness, and who is, or who may be, unable to take care of themselves or unable to protect themselves against significant harm or exploitation.
3. No – artists are advised that they should not act in loco parentis or work with children, young people or vulnerable adults without the appropriate teachers, youth workers carers or other legally responsible staff present.
4. Risk assessment is a technique for preventing accidents and ill health by helping people to think about what could go wrong and ways to prevent problems. Some structures for risk assessment and action are included in the Resources section.
5. Insurance is a complex area and you should satisfy yourself that you have adequate cover for your work. Most organisations expect freelance practitioners to hold public liability cover and will ask to see a copy of your certificate of insurance. Public liability insurance covers a legal claim being made by someone other than an employee for accidental injury or damage caused by defect in the premises or equipment which it is your (or your employer's) responsibility to maintain. If you are working for an organisation which has its own building (for example a school) you are likely to be covered by their insurance. If you are hiring a building it is likely that the letting body will want you to use your own public liability insurance.
6. A DBS check is a criminal records check processed through the Disclosure and Barring Service. It helps employers and voluntary organisations make safer recruitment decisions for positions that involve regular contact

with children, young people and vulnerable adults. The DBS replaces the Criminal Records Bureau (CRB) and Independent Safeguarding Authority (ISA). www.gov.uk/government/organisations/disclosure-and-barring-service

7. In youth work practice the ratio of legally responsible adults to children/ young people tends to be 1:8 regardless of age. The Arts Council recommends that a minimum of two people with legal responsibility are present at all times and that children under 8 are supervised all the time.

Case Study Exercises and Discussion Points

CASE STUDY ONE

A parent approaches you on behalf of a group of families with home-schooled children. They would like you to run dance sessions for them for a trial period of 8 sessions. The parent asks you the following questions:

- How many children should be in the group?
- Would it be feasible to have an age range of 5 to 11 years?
- What would be the ideal length of time for the sessions?
- How much would you charge?

How would you respond to the parent? Are there any questions you would want to ask before deciding whether to accept the work?

CASE STUDY TWO

You have been asked to run a weekend intergenerational dance workshop as part of a local community festival. There will be around 25 participants with ages ranging from 4 years to 73 years. You will have at least 6 people helping you – two other dance artists, two parents and at least three volunteers. You are preparing to meet with the organisers of the event.

- What information do you need in order to plan the dance sessions?
- What safeguarding issues do you need to consider?
- This seems to be a generous staffing ratio – can you think of any challenges you might encounter?

CASE STUDY THREE

During a seated dance session for frail older people, the 'helper behaviour' of the support workers causes you something of a problem. They offer loud verbal prompts and sometimes physically move people's limbs to encourage them to

move in the 'right' way. This well-intentioned behavior is a little confusing for some participants as there appear to be several leaders. Also you have been trying to lead with the minimum of verbal prompts to engender a 'failure-free' approach where people did not worry about 'getting it wrong'.

- How would you handle this situation?
- If you have chance to speak with support workers before the next project begins how would you brief them? Ideally, what would you like them to do to support the session?

CASE STUDY FOUR

You have started to lead dance sessions with a newly formed youth club group. The youth club leader would like them to perform at a dance showcase in 12 weeks' time. They are mostly 13–15 year old teenage girls and you want to create opportunities for them to express themselves – to make the dances they want to make. However, it soon becomes clear that they want to dress and perform like the dancers they see on pop music videos.

Some of the group attend a local dance school and they have been showing the other girls the routines they have learned for their auditions. These routines include dance moves which are sexually suggestive and the other members of your group are keen to learn them.

- How would you feel and what would you do?
- Would you go along with their wishes or encourage them to try to develop new movement vocabulary?
- What are the issues here?

DNA – Development Needs Analysis Tool

Extracts from the People Dancing – Development Needs Analysis (this has been reproduced with the kind permission of People Dancing)

Rate yourself on the skills, knowledge and experience listed below and remember you don't need to be able to do all of these things at all points throughout your career as a community dance artist.

How confident would you say you are in relation to the following statements?
How important is this activity to your current role?
How important do you think this activity will be in the future to your practice?

WRITING

- Using written communication skills to describe your practice and its effects on others
- Preparing funding applications for appropriate funding streams/sources
- Writing a pitch for work
- Writing a CV
- Writing press releases, publicity material, programme notes, flyers etc.
- Writing the terms of reference for a community project with a number of partners
- Writing role descriptions for volunteers, support workers or assistants
- Writing proposals that set out ideas for joint collaboration
- Assisting in the preparation of a marketing plan
- Documenting projects and maintaining records

COMMUNICATION

- Using verbal communication skills to describe your practice and its effects on others
- Articulating your current values, knowledge, skills and experience
- Establishing clear lines of communication
- Finding different ways of communicating effectively with different members of a team
- Communicating with people if problems arise – being honest about mistakes you make
- Communicating in an inclusive and effective manner to set up and manage expectations of individuals, groups and stakeholders
- Making formal or informal presentations about your work
- Communicating effectively with people in your classes, workshops or performance group
- Using body language and non-verbal communication effectively
- Communicating effectively with those involved in technical production
- Making formal or informal presentations to dance participants or others

SKILLS DEVELOPMENT

- Using negotiating skills effectively
- Designing a dance programme that uses your skills and experience to meet the needs of the group, the setting and the intents and purpose of the programme
- Applying time management skills
- Creating lesson/session plans with clear aims and objectives
- Developing and applying effective teaching or leading strategies
- Establishing ground rules for equality, respects and safety of participants and yourself in your dance sessions
- Designing accessible programmes of work
- Applying effective compositional or choreographic skills
- Applying technical skills and knowledge when leading your dance style(s)
- Learning new/emerging technique relating to your dance genre
- Creating budgets
- Managing finances
- Managing group dynamics

HEALTH AND SAFETY

- Understanding how to develop and deliver effective warm ups and cool downs in relation to your practice

- Knowing how to research the anatomical limitations of individuals' physical differences
- Giving advice on hydration, nutrition and clothing to dance participants
- Understanding the safety issues facing lone workers
- Developing a health and safety policy in relation to your practice
- Structuring sessions for safe and effective delivery to participants that ensures their well-being
- Ensuring the environment is safe for the participants in the activity you are leading
- Conducting a risk assessment
- Giving advice on safe practice to participants
- Delivering basic first aid

LEGISLATION

- Understanding legal compliance, permissions and insurance relating to your practice
- Understanding national or regional policies that affect your practice
- Complying with data protection legislation
- Understanding copyright regulations and/or licensing
- Understanding safeguarding requirements in relation to children, young people and/or vulnerable adults
- Knowing how to protect your intellectual property
- Being aware of and knowing how to monitor the relevant legal, regulatory, ethical and social requirements and their impact on your area of work
- Understanding the policies and legislation relevant to a partnership
- Understanding health and safety legislation as it pertains to your work
- Understanding contracts

RESOURCES

- Identifying and making contact with local artists and arts support agencies
- Identifying the resources required for a project or dance session
- Knowing where to find and how to engage community volunteers
- Using new media – websites, social networks, Twitter
- Sharing lesson/session plans and ideas
- Identifying key information that needs to be shared between partners
- Understanding organisational hierarchies

RESEARCH

- Knowing where to find reliable background information about your dance genre

- Knowing where to find reliable information about the sorts of groups that you're working with (e.g. elders)
- Researching and taking part in continuing professional development opportunities
- Identifying trends and opportunities within your specialism(s) as well as other areas of the arts that may affect the demands for or impact on particular projects
- Researching supporting material for applications to funding bodies
- Identifying where appropriate funding can be sought
- Knowing how to access newsletters and journals
- Identifying existing local art and/or education provision
- Researching the market needs that can be met by your practice

REFLECTION, ASSESSMENT AND EVALUATION

- Objectively observing other practitioners' arts sessions
- Using creative, engaging and accessible evaluation methods to see if you are meeting the lesson/session aims and objectives you identified
- Taking part in an appraisal or self-appraisal
- Inviting people in to observe your lessons/sessions and getting feedback
- Learning to analyse your strengths, weaknesses, opportunities and threats (SWOT)
- Taking part in regular informal meetings/discussions with other practitioners
- Providing and supporting reflective opportunities for participants
- Assessing your current levels of competence and establish where areas of personal development are needed
- Keeping a reflective journal

Inclusive Practice – Interview with Caroline Bowditch

Caroline Bowditch is a performer and choreographer who is renowned for making work which challenges and delights audiences. In 2014 she created *Falling in Love with Frida* which won the Herald Angel award at the Edinburgh Fringe.

The following is an extract from an email conversation between Diane Amans and Caroline Bowditch in 2007 followed by a more recent exchange in 2016.

DA What do you understand by 'inclusive practice'?

CB I think inclusive practice is one of those things that we all strive for but have real difficulty in achieving, for very good reason. I think it is the idea that we are able to offer classes or sessions that are so open in their structure and delivery that they are accessible to everyone – from beginners to people with loads of experience, for people of all abilities and backgrounds. And that these are the classes that every participant leaves feeling they've thoroughly enjoyed, been challenged by and have had their expectations fulfilled. There are some community practitioners that come closer to achieving this than others.

 I think there are two main points that come to my mind when thinking about delivering in an inclusive way:

 1. The practitioner runs the risk of losing the specificity of a session because they feel it has to be somehow made more general or simplified so that as many people as possible can participate.
 2. Workshop session leaders, unless they have an on-going relationship with participants, are less likely to really push people that they feel may be struggling in the class for fear of offending them in some way – this happens frequently to disabled participants.

DA Should community dance classes be open to everyone?

CB This is a hard question to answer but I suppose I would say yes and no. There are advantages and disadvantages on both sides. I also think that not all community classes are open to everyone even when they state they are, due

to many of the points I mentioned above. People also self-select – they go where they feel comfortable. I think this is not only about who is delivering the class but also about the attitudes of others who attend the class.

The advantages of all classes being open to everyone is that people have unlimited choice – everyone has the option to try everything or at least what they are interested in. I know, as a disabled dancer, how frustrating it is to read that such and such a class is only open to a specific group of people and in the past many of my options have been limited due to inaccessible spaces or inflexible attitudes of session leaders – although this happens more in professional settings rather community classes it must be said.

2016 Follow Up

CB On re-reading our original conversation I think some of it still applies but I have been introduced, and have been teaching, a new technique that applies the principles of Universal Design techniques used in design and buildings, to dance.

The Principles of Universal Design[1] in dance and performance were pioneered by Jürg Koch at the University of Washington, Seattle. Instead of a disability specific approach of 'adapting' movement to suit individuals, this approach allows everyone in the class to work with the same principles and use them in a way that works for them and allows them to push themselves.

I use these with every group I teach from professional dancers through to community groups and it has cemented my belief that dance can be accessible and inclusive to every body in the room if the teacher/facilitator is able to articulate and focus on the aims and purpose of the exercise.

Caroline Bowditch photo (*Kenny Bean, courtesy of Scottish Dance*)

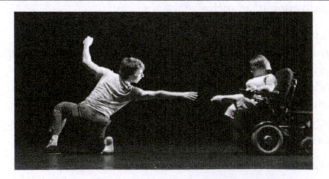

Caroline Bowditch (*Kenny Bean, courtesy of Scottish Dance*)

[1] See http://en.wikipedia.org/wiki/universal_design (accessed 5.6.2016)

Rubicon Dance: The Experience of a Dance Apprentice

I have been attending Rubicon dance as a participant for the last 8 years and volunteering with the Saturday children's sessions for the last 5 years; these Saturday sessions involve creative dance with children ages 3–11 years. Experiencing this setting taught me so much about community dance and allowed me to start developing dance leadership skills, which in the autumn term of 2011 led to my starting my first class with Rubicon as a freelance dance leader for 4–6 year olds in the Riverfront, Newport. I also added in volunteering with the Thursday disability classes; a session for adults with high support needs and 'Choices' dance group for adults with disabilities.

This background with Rubicon meant that when the opportunity to apply for the apprenticeship came up, I was very certain that it was exactly what I wanted to do – I already knew Rubicon and their work and was already deeply committed to their ethos. I feel so lucky to have gained the opportunity to spend a whole year learning and developing with an organisation that I am so enthusiastic about.

My apprenticeship started at the beginning of term in January and takes place three days a week. The always rather daunting experience of starting a new job was made so much easier by support from all the Rubicon staff and the encouragement to take things at my own pace as I settled in. The collaborative approach to designing my timetable was also very helpful; it allowed me to build on my strengths and interests but also encouraged me to reach outside my comfort zone in a supported way. Through Rubicon I also enrolled in an evening course to gain an initial teaching qualification in Preparing to Teach in the Lifelong Learning Sector.

My programme for the first term consisted of shadowing and participating in a wide variety of classes from the community programmes in Cardiff and Newport as well as the centre programme at Rubicon. My timetable consisted of sessions in a day-care centre in Ely with children aged between two and four, parent and toddler classes, three different sessions for adults with disabilities – the

three classes have varying support needs so provide a good breadth of experience, classes for people over 60, classes in school curriculum time with year one children, after-school dance for children in years 1 and 2, a boys only dance class and an integrated class with children from a special needs primary and a mainstream primary. I also continued with my voluntary classes on Saturday mornings. Over the whole first term of my apprenticeship I have shadowed and participated in 161 classes as well as continuing with my freelance class for 4-6 year olds.

My timetable also has scheduled time each week with my mentors Tracey Brown and Paul Davies. This has been invaluable to be able to analyse and reflect on everything I have been observing and learning as well as having an opportunity to learn background information about the different settings and client groups I have been working with. In this way I have been able to build up a really balanced picture by combining practical experience and observation with supported reflective learning.

The different dance leaders that I have been shadowing have all been so supportive in so many ways, right from giving me lifts to new locations the first time and making sure I knew how to find my way around, to answering my endless queries and questions and spending time giving me feedback. I have found it hugely inspiring to learn from so many different dance leaders who are all enthusiastic, committed and highly skilled. Shadowing a number of different dance leaders and being able to see a variety of different leading styles has also been very helpful.

As my reflective log for the first few weeks of term shows, initially I felt like there was a huge amount of new stuff to take in, I had so many questions about the different settings, some of which I had never been in before such as the day care and school settings. As I was already familiar with Rubicon and their ways of working through my years of volunteering, it was particularly enlightening to experience the wide variety of settings and see the same ethos of client led dance leadership applied in so many different ways.

As the term progressed and I became more familiar with the different settings I was able to focus my attention on observing and building up my understanding of the different dance and movement content that the leaders used in each setting; again, having the opportunity to question and reflect on sessions with my mentors and with the dance leaders has been invaluable in combining the practical participation of these sessions with theory.

Towards the end of term I started on my leadership practice. I really appreciated that I was encouraged to lead the timing of when to start this part of my apprenticeship. Starting to lead sessions can feel quite daunting but the way that it was introduced was really supportive and made the experience an encouraging and exciting one.

I started with very short sections in the smaller classes that I felt most confident in and built up to doing slightly longer sections in larger sessions. Receiving

detailed feedback on my first sections of leadership really gave me a confidence boost and felt a great incentive to take on more. Completing my Preparing to Teach in the Lifelong Learning Sector qualification has also been an achievement this term; I found it to be very intense but a really useful and enjoyable experience that ties in very strongly with all the practical leading I am experiencing and observing.

During the term I also spent some time work shadowing and observing in various settings, and I spent a day in the Ely Children's centre and a day with a year one class in Rhydpennau primary school; both of these experiences really helped me get a sense of the behavioural expectations of those settings as well as gain a deeper understanding of the abilities of these age groups.

Overall, I have had an amazing experience this term. I feel I have learnt and developed so much and am excited by what I feel I have achieved. I look forward to this continuing in the new term ahead.

Esther KilBride
Apprentice Report 2012

Esther KilBride Rubicon apprenticeship timetable – spring term 2012

	Monday	Tuesday	Wednesday	Thursday	Friday	Saturday
9.00–9.15		Ely Day care 1st Session				
9.15–9.30						
9.30–9.45		Ely Day care 2nd Session		Adults with high support needs		
9.45–10.00			Travel time			
10.00–10.15		Ely Parent and toddler class				4–5 yrs class at Rubicon
10.15–10.30						
10.30–10.45			Stow Park, Newport, 60+ session	Choices dance group – Adults with disabilities		
10.45–11.00						3 yrs class at Rubicon
11.00–11.15		Travel time				
11.15–11.30						
11.30–11.45						9–11 yrs class at Rubicon
11.45–12.00			Travel time and lunch			
12.00–12.15		lunch				
12.15–12.30				Staff meeting		
12.30–12.45						

(Continued)

Time						
12.45–13.00				Travel time		
13.00–13.15		Meet with Paul				
13.15–13.30			R/pennau School Curriculum time, yr 1 1st session			
13.30–13.45				Hollies integrated class		
13.45–14.00		Adults with disabilities session at Rubicon				
14.00–14.15						
14.15–14.30						
14.30–14.45			R/pennau School Curriculum time, yr 1 2nd session	Travel time		
14.45–15.00						
15.00–15.15						
15.15–15.30				Meet with Tracey		
15.30–15.45			R/pennau after school club dance yrs 2 and 3			
15.45–16.00						
16.00–16.15	4–6 yrs class Riverfront, Newport, freelance session					
16.15–16.30						
16.30–16.45				Boys dance at Rubicon		
16.45–17.00						
17.00–17.15	Travel time					
17.15–17.30						
17.30–17.45						
17.45–18.00						
18.00–18.15	Contemporary class at Rubicon	PTLLS course At WEA centre, coopers yard in town.				
18.15–18.30						
18.30–18.45						
18.45–19.00						
19.00–19.15						
19.15–19.30						
19.30–19.45						
19.45–20.00	Jazz class at Rubicon					
20.00–20.15						
20.15–20.30						
20.30–20.45						
20.45–21.00						

Rubicon Dance: What Makes an Outstanding Dance Session?

What makes an outstanding dance leader/session delivered by Rubicon?

The following list is a summary of feedback from dance leaders, head teachers, deputy heads, class teachers and day centre managers.

Dance Leader Essentials

- To aim to fully engage/re-engage all participants within a session
- To have strong session management skills with a range of groups
- To have the ability to give groups ownership of their own work/ideas
- To be able to step back and allow people to make their own choice within a session
- To be able to challenge people's natural energy and physicality
- To be able to adapt throughout the session/responding to individual and group needs
- To reinforce current level of skill and show participants the opportunity to progress
- To have the right energy levels for each group – some sessions need a higher level of physical energy
- To be motivational and inspirational
- Dance leaders tone of voice is crucial – contrast of voice essential to engage and re engage groups of all ages/abilities
- To know how to support individuals within a group
- To be able to alter session plans at the drop of a hat and respond to what is needed/ability to pick up on any tensions within a session in a safe and professional way
- To have a professional attitude with high/realistic expectations, well communicated in an encouraging way for every group

Dance Session Essentials

- To allow people of all ages and abilities to be the very best they can be within a Rubicon dance session
- Age/ability-appropriate sessions so that groups are motivated to use their own imaginations and also give them confidence in their own ideas
- The development of participant creativity and self expression is key to every session
- Clear aims and objectives for every session
- Clear instruction of tasks set in a session and clarity of movement from the dance leader whilst demonstrating
- Material that is satisfying, challenging, and relevant
- Well-paced session containing contrasting elements of togetherness and opportunity of individual and paired work, performance and observation/evaluation/reflection

Project Coordinator Checklist

(See Chapter 18 for further discussion on project coordination.)

- **Aims**: Who decides these? Are you working for an organisation that has set clear aims for the project or will you need to suggest aims?
- **Publicity**: Are you responsible for this? If so, how will you market the project? Do you need to make any presentations? Will you put up posters, send e-leaflets or advertise via websites?
- **Schedule**: How many sessions? How long per session? What time of day is best? (Check for clashes with hairdresser/chiropody visits if working in sheltered housing or care homes.)
- **Participants**: How many? What are their interests? How fit are they?
- **Venue**: Have you a choice? What type of floor/furniture/ventilation? Are there facilities for refreshments? Who will provide these? Can you get into the venue before the start time?
- **Content**: What type of dance would be most appropriate? How will you decide what to do/where to start?
- **People management**: Who will lead and support on the sessions? If you are not leading on it, how will you liaise with the lead artist? How much support does he/she need? Have you established clear lines of communication? What role would you like support workers to play? Will you get the chance to brief them?
- **Risk assessment**: Have you done a risk assessment on venue and activities? Have you discussed existing controls and precautions with all staff involved?
- **Equal opportunities/inclusion**: Are there any issues relating to access/diversity/inclusion? Will you accept all comers? How will you decide on staff? Is written information clear and easy to understand? Have you thought about how to communicate with people who do not read?
- **Duty of care**: What do you need to do to take care of the people on the project?
- **Insurance**: Does the project have adequate insurance cover?

- **Consent form**: Will you be taking photographs/video? Who will organise the consent forms? Where will they be stored?
- **Administration**: Have you allowed time for this?
- **Resources/music/materials**: Do you need to buy/borrow any resources? Do you need a licence?
- **Celebration/final session**: Is this definitely the end, or might the funders come up with more money for another project? How will this be handled? Can you strike the right balance and end the project on a positive note? Check that your celebration does not clash with any key festivals for people of different faiths.
- **Liaison with partners**: How will you report on the project? Do you need to have meetings with host organisation/warden/arts officers/funders? Have you allowed time for this and costed it into the budget?
- **Monitoring**: What records will you be keeping? How will information be collected? Who needs to receive monitoring information?
- **Evaluation**: What will you be evaluating and what methods will you be using? Will you be using an external evaluator? Have you costed this in your budget?
- **Documentation**: Will you be providing a summary document? Will you be documenting the project in other ways? (Photographs, video, chronicler report, project diary?) Do you need to book a photographer?
- **Mentoring/support for you**: Do you need any specific help/advice? Have you created opportunities to discuss the practice with other practitioners? Do you think this is important? Have you costed it into the budget?

Planning and Recording Dance Sessions

Here are some brief guidelines that I gave to practitioners on a community project. Each dance artist kept a logbook and the contents were used as an aid for reflection, evaluation and planning. It was also a useful focus for discussion during mentoring sessions.

Practitioner Logbook

You are invited to use this book to record your planning notes and a short diary account of each session. For each entry please record:

- Date and times
- Venue
- Number of participants
- Any assisting staff/relatives/others
- What activities took place
- Participant responses
- Any problems or difficulties
- What worked particularly well
- Self-development notes – anything you did for the first time, any area you feel more (or less) confident, things to try differently, any other developments in your practice
- Any action points

It is good practice to keep notes of anything significant which occurs in the dance session. If you have a particularly successful activity – make a note of what you did and how you did it.

If you have any incident or concern about any of the participants note down the details and any action you took. (NB Think about confidentiality – keep the information secure and use initials instead of names if you are recording sensitive information.)

This briefing sheet was pasted on the inside cover of an A5 notebook but practitioners may prefer to make notes on their tablet or phone. It doesn't matter what format is used as long as there is some form of record keeping.

Diane's Top Tips for Community Dance Artists

- Learn and use people's names.
- Allow time for icebreakers and name games – even when participants know each other.
- Check that you don't talk too much when trying to engage people in dance.
- Think about how you might make each of your activities easier or more challenging.
- Practise careful observation – we receive non-verbal feedback all the time. We need to become skilled at noticing it and checking out that we are reading the feedback correctly.
- Encourage people to give you feedback – see it as a gift.
- Collaborate with other artists – including those from other art forms. This will nourish your creativity and help prevent burnout.
- Make time for yourself to dance – whether it's in class or at home with the furniture pushed back.
- Go and see a wide variety of dance performances.
- If you haven't already done so, create a separate dance bag or box which stays packed with a range of music and props – a sort of emergency pack in case you have to lead a session at short notice.
- Always have a variety of music with you for when you sense the need to change the energy in the room.
- Be clear about what you can offer. Think about your skills and competencies – what are you qualified for and capable of doing?.
- Be proactive – make your ideas happen!

Time Management – Some Tips for Making the Best Use of Your Time

Make a 'to-do' list for your day and prioritise your tasks.

Start with a high-priority task – even if you don't complete all of it.

Avoid putting off tasks that you find unpleasant or difficult.

They often turn out not to be as bad as you thought they were going to be. It might help to break them down into sections and treat yourself when you have completed a section.

Make time for tasks which are important.

Block off time in your diary and protect this time for its designated purpose.

Make time for you – to do the things you've always said you'd do if you only had the time.

Again, allocate time in your diary – and plan how you will spend this time. Protect this time, it is just as important as time for tasks.

Resist the temptation to spend time on non-urgent or trivial activities – unless that is how you have planned to spend your time.

Notice when you are engaging in displacement activities like rearranging the furniture, clearing out the top drawer, making unnecessary phone calls. If this is how you like to relax, allocate time for these activities and discipline yourself to stick to the task you had planned to do.

Organise your communication systems to suit your needs wherever possible

Switch your phone off if you need to focus on an important task. Plan time for people to reach you and for dealing with emails.

Give yourself permission to say 'no'.

You don't have to please others or agree to take on another activity just because someone has asked you to.

Slow down and look at how you are spending your time. How could you make more time and reduce your stress?

Presentation Skills: Guidelines for Making an Effective Presentation

Prepare
Whether you are presenting to a large group or just describing your work to an individual think about what you want to say and structure it into a logical order.

Structure
Make notes and then condense these onto prompt cards/handouts/PowerPoint slides. (Even if you don't use the prompt cards you will remember your structure if you have written it down.)

Rehearse
Practise talking through your main points (in the car, in front of the bedroom mirror, to the cat!). You'll be more confident if you've talked it through a few times.

Relax
Practise relaxing and check your posture and facial expression for tension (it's really useful to see a video of yourself in these kinds of situations – you soon realise where your tension is).

During a Presentation
- Smile
- Make eye contact
- Modulate your voice more than usual (though not too much)

- Pitch your voice to the person at the back
- Pause at key points or visual aids
- Take less time than you said you would
- Use attention joggers (saying someone's name, change pace, have a short discussion)
- Get feedback from someone you trust

Suggestions for Music

Selecting music to use in participatory dance work is a matter of personal choice and experienced practitioners usually compile their own eclectic mix of music that works for them. If you have the opportunity (and funding) to involve live music in your sessions this can create a special atmosphere. It is important to have a range of sounds that can be used to support different styles and themes – it is also important to use music which you personally find inspiring. Participants are often happy to share their music choices and some will suggest music which makes them want to move.

In 2015 People Dancing invited some dance artists to produce playlists for dance practitioners. You can find these curated playlists at https://peopledancingmusic. wordpress.com

- Dance for Early Years Playlist Liz Clark
- Contemporary Dance Playlist Lindsay Jenkins
- Dance for Parkinson's Playlist Halifax Dance for Fun Group
- Dance with Older People Playlist Amy Redwood
- South Asian Styles Playlist Anusha Subramanyam
- Lindyhop Playlist Mike 'Jumpin' Jones
- Argentine Tango Playlist Dr. Ute Scholl
- Creative Dance Playlist Miriam Early
- Bollywood Playlist Laura Menghini
- Diane Amans Dance Playlist Diane Amans

The following music is a varied selection that I have used with groups of all ages in different community settings. There are some old favourites and a few you may not have heard before. Hopefully you will find something useful here:

Odissea: Rondo Veneziano
Quidam: Cirque du Soleil (Zydeko, Carrousel and Steel Dream)
The Shocking Miss Emerald: Caro Emerald
Drowning by Numbers and *The Piano:* Michael Nyman
Images: Jean Michel Jarre
La Revolte des Enfants: Rene Aubry (Passagers du Vent)

Chan Chan: Buena Vista Social Club
Vacilon Que Rico Vacilon: Ruben Gonzalez
Strictly Come Dancing TV Theme: Laurie Holloway Orchestra
La Cumparsita: Laurie Holloway Orchestra
Love Shack: Glee Cast
Shall We Dance?: Randy Spendlove
Hullighan's Jig: Gordon Pattullo's Ceilidh Band
Me Gustas Tu: Manu Chao
Dark Island: Mike Oldfield
Je Cherche: Tarmac
1902: The Mels – John Leventhal
The Grind: Pet Shop Boys
Bahamut: Hazmat Modine
La Viguela: Gotan Project
The Waves: Ludvico Einaudi
Un Samedi sur la Terre: Pascale Comelade
Songs from Liquid Days: Philip Glass
Yes Sir, I Can Boogie: Baccara
The Entertainer: Scott Joplin
When I'm Cleaning Windows: George Formby

Information on Use of Sound Recordings in Dance Work

Music Copyright
You are advised to check out music copyright and performing rights where you are intending to use recorded music. There are a number of issues which need to be considered; most countries have their own laws dealing with copyright. In the UK and you can find out further information from:

Phonographic Performance Limited (PPL) www.ppluk.com
The PPL deals with licence applications for the broadcasting and playing of recorded music in public. As a dance practitioner you give them details such as the number of sessions you lead and the average attendance. Your annual tariff is calculated based on these figures.
 PPL Tel +44 (0)20 7534 1000

Performing Right Society for Music (PRS) www.prsformusic.com
PRS for Music licenses organisations to play or perform copyright music. They licence a variety of premises where music is performed, such as concert halls and radio and television stations. The fees collected are distributed to its members (such as composers, lyricists and publishers) and to affiliated societies overseas.
PRS Tel +44 (0)20 7580 5544

Educational Recording Agency www.era.org.uk
The ERA deals with licences for educational establishments at all levels of education. Schools, colleges and other educational organisations need an ERA licence for teachers and students using material from broadcasts.
ERA Tel +44 (0)20 7837 3222

If you are not sure about whether you need a licence the above websites have comprehensive details and each organisation has a helpline for telephone queries.

Risk Assessment

Cheshire Dance	Date of Risk Assessment: Time of Risk Assessment: Weather Conditions: Date of Activity:	Venue / Activity:

Likelihood	Score	Severity		Risk Score Definitions
Very Unlikely	1	Minor Injury – No Treatment	1–6	Low Risk
Quite Unlikely	2	Minor Injury – First Aid	7–10	Medium Risk (Acceptable in some circumstances – implement measures where possible)
Possible	3	Minor Injury – Hospital Visit	11–16	High Risk (Acceptable in certain circumstances – implement measures where possible)
Quite Likely	4	Major Injury – Emergency call	17–25	High Risk (Unacceptable – implement measures or cancel activity)
Highly Likely	5	Major Injury / Death		

Hazard	Affected Persons & How Affected	Likelihood	Severity	Risk Score	Mitigating Measures	Responsible Officer	Revised Likelihood	Revised Severity	Revised Risk Score

FREEDOM IN DANCE RISK ASSESSMENT – MATURE MOVERS	CREATIVE DANCE SESSION IN SHELTERED HOUSING LOUNGE
	Participants are all aged between 72 and 94 years – many are frail

Creative movement exercises designed to promote mobility and reduce falls.

Existing controls:

- Most activities take place with participants seated.
- Workshop leaders have received training from Freedom in Dance.
- Participants read guidelines for exercise and sign that they agree to advise leaders of any health condition which might affect their ability to exercise.
- Participants are regularly reminded not to do any movement which feels uncomfortable.
- Handbags and walking sticks are stored safely under seats or out of the way so people won't trip.

Activities	Hazards	Risk rating			Precautions to be taken	Additional information for leaders
		Low	Med	High		
Rolling large ball	Leaning too far, getting out of chair to retrieve ball	✓			Leaders be ready to retrieve ball if participants can't reach	Location of warden call button to be determined prior to session beginning.
Foot exercises (toe taps heel lifts, leg raises)	Too many repetitions could result in fatigue or angina	✓			Remind participants to take a rest when they need one	Observe participants carefully for signs of fatigue and be prepared to reduce actual activity time by introducing pauses for listening to music / discussion.
Shoulder and upper arm exercises	Too many repetitions could result in fatigue or angina	✓			Activity to be stopped if any participant appears fatigued	
Tapping balloon	If standing** participants might attempt to kick balloon and overbalance	✓*	✓**		*If any participants are standing ensure co-leaders are next to them	
Blowing feathers	Leaning too far, getting out of chair to retrieve feather	✓			Be ready to retrieve feather if participants can't reach	
Circle dance	Losing balance / Falling		✓		Special attention to be paid as participants get up and return to seats	

Assessor:

Date:

Health and Safety Questionnaires

You can find free downloadable PAR-Q (Physical activity readiness) questionnaires online. You may want to design your own; the main thing is that you get information about people's health status and <u>record</u> what steps you take to keep them safe.

Here is an example of a questionnaire used with Mature Movers.

Guidelines for Dance Exercise

The Mature Movers programme includes dance activities designed to improve balance, strength and flexibility. It may also increase circulation and lessen or prevent the effects of heart disease.

If you have not taken part in exercise for a while you are advised to speak to your doctor who will check for any condition which may make certain forms of exercise unwise. Please read the following guidelines and advise your dance leader of any health condition or medication which may affect your ability to exercise.

1. Don't exercise if you are tired, unwell or have just eaten.
2. Wear loose clothing and soft soled shoes.
3. At no time should an exercise or activity cause pain. If it does, stop immediately and advise the dance leader.
4. It is not unusual to feel a bit stiff and tired after the first few sessions. If this continues speak to your doctor.

Please complete the following and give it to your dance leader.

Please tell us if you have experienced any of the following: (Please tick either yes or no for each condition)

	Yes	No
❏ Osteoporosis	☐	☐
❏ Coronary thrombosis	☐	☐
❏ Stroke	☐	☐
❏ Cancer	☐	☐
❏ Falls	☐	☐
❏ Recent viral infection	☐	☐
❏ High / low blood pressure	☐	☐
❏ Asthma / other chest condition	☐	☐
❏ Other (please give details)		

I have read the guidelines for dance exercise and agree to advise the dance leader of any changes in my health condition which may affect my ability to exercise.

Signed Date
PRINT NAME ...
Witness signature Date
PRINT NAME ... © Diane Amans 2015

PARTICIPANT REGISTRATION FORM
SEPTEMBER 2015–SEPTEMBER 2016
THIS FORM MUST BE COMPLETED AND HANDED BACK TO YOUR DANCE LEADER

Name of Activity _____ Time _____ Venue _____

Participant FULL name	Home telephone no
Address	Participant's mobile number (Parents' no if under 16)
Postcode	
Email address (parents for under 16 yrs)	Emergency contact tel. no
Date of birth:	Where did you hear about this class ?
Male/Female	
Any medical conditions/allergies (including medication)	Any access needs
If under 16 name of person collecting:	

Cheshire Dance has to provide details showing the diversity of its membership, e.g. for grant applications and to its core funders. To help us provide accurate information, please tick the appropriate boxes.

Ethnic Group:

☐ White British
☐ White Irish
☐ Any Other White background (please state)
...

☐ White and Black Caribbean
☐ White and Black African
☐ White and Asian
☐ Any Other Mixed background (please state)
...

☐ Chinese

☐ Asian or Asian British Indian
☐ Asian or British Pakistani
☐ Asian or Asian British Bangladeshi
☐ Any other Asian background (please state)
...

☐ Black or Black British Caribbean
☐ Black or Black British African
☐ Any other Black background (please state)
...

☐ Any other ethnic background (please state)
...

244

Sexuality:		**Religion or Belief:**		
☐ Bisexual	☐ Gay	☐ Buddhist	☐ Catholic	☐ Church of England
☐ Heterosexual		☐ Hindu	☐ Jewish	☐ Muslim
☐ Lesbian	☐ Prefer not to say	☐ Protestant	☐ Sikh	☐ None
☐ Other (please state)		☐ Other (please state)		
.............................		☐ Prefer not to say		

Photographs and Video

I consent/do not consent to my image (delete where appropriate) obtained through photography or film work being used for 4 years following the date of signing, in any of the following ways:

- ✓ Cheshire Dance/Cheshire Dance partners publications, exhibitions, display, website, Facebook/Twitter
- ✓ As part of any press release that could appear in a local newspaper
- ✓ For public screening/broadcast (film only)
- ✓ For other participants to purchase

Signed (Parent/Guardian)_____ Date _____

Please Print Name _____

Laughing Knees Dance Company

Consent Form: Photographs and Video Film

Images from dance projects may be used in Laughing Knees publicity material and to illustrate journals and conference presentations during the period from July 2016–July 2019.*

Please complete the following consent form.

I agree to Laughing Knees Dance Company keeping these images and my contact details and understand that Laughing Knees will contact me to seek my permission for any other use of the images.

NAME (please print) ...
Signature of parent or guardian ..
Date ... Tel. No.
Address
...
...
...
... Email

The above details will be kept on file at the Laughing Knees office and will not be circulated to other organisations or individuals without your consent.

* The period of consent will vary depending on the project. Sometimes a shorter period is more appropriate.

If you wish to stipulate any conditions relating to the use of your image please do so below.

Session Plan Template

Group
Date and time
Aims of session
..............................

Dance artist
Venue

Time	Activity (ice breaker / warm up / development or creative / cool down)	Music / Resources	Notes / Prompts

Evaluation notes
..............................
..............................
..............................

247

Ideas for Creative Dance in Community Settings

My aim, in every dance session, is that the participants will enjoy movement and take pleasure in what their bodies can do. I also look for opportunities to 'make art' and I see it as part of my role to create an environment where people feel safe enough to try something different and express themselves without worrying about what it looks like to an 'outside eye'. If the group is going to perform their work at some stage I can support them to craft a piece which will be interesting for an audience to view. But first I want to help them enjoy *feeling* their bodies dance.

Sometimes I start in a fairly structured way and lead the group gently to more open-ended tasks. Whatever the context of my work – whether it is a one-off taster session, a regularly weekly group or a performance project – I try to establish a playful quality and a sense that there is no *wrong* way of responding.

Starting Points for Creative Dance Activities

Here are some examples of dance activities I have used many times. They are *starting points* and are not meant to be used in a prescriptive way. It is important to be prepared to share the leadership and pick up on ideas which come from members of the group.

I have divided them into the following sections:

- Introductory/warm-up activities
- Ideas for movement development
- Ideas for making dances
- Introduction to dance appreciation
- Ideas for closures

Each section begins with simple activities that are suitable for very young children and progresses through to ideas for older children and adults. With a few exceptions, though, I have used most of these ideas with dancers of all ages – with adaptations to suit different abilities and energy levels.

Introductory/Warm-Up Activities

Choose an activity that will focus group energy and help you gain the attention of all the participants.

- Walk into the movement space in a follow-my-leader line.
- Name game – roll ball to each child. Individuals introduce themselves 'My name is Joe'.
- Name game – throw cushion/soft toy/puppet.
- Perform action rhymes, whilst seated round leader.
- Listen to music and encourage discussion. (What does it make you think of? Does it make you want to move slowly or quickly? Is it sleepy music/exciting music?)
- Talk about recent events (snow/bonfire night/a new pet) – all can be used as starting points for dance.
- Standing in a circle perform 'heads, tums, knees, feet' to rhythmic music (tap heads ×4, tap tums ×4, tap knees ×4, tap feet ×4). This activity can be extended to include other parts of the body and can be made more or less complex by varying the repetitions.
- Self massage – pat all over and focus on particular body parts.
- Circle clap – stand in a circle and establish a simple clapping rhythm (3 beats clapping, 3 beats rest). Leader encourages children to fill in rest pause by shaking different body parts.
- 'Beans' – leader calls out different beans runner/jumping/jelly/chilli/broad/baked beans and participants perform the actions: run/jump/wobble/shiver/make wide shape/lie down.
- Whole group makes an 'X' shape. Repeat with 'L' or any other letter – ending with 'O' if you want them in a circle for the next activity.
- Mexican wave with feet. All seated on the floor in a circle slowly lift feet one after the other round the circle. (Alternatively can be done using arms whilst seated.)
- Name game with rhythms. Clap rhythm of full name then say name. All join in and repeat rhythm.
- Name game move. Each person makes a gesture as they say their name. Everyone repeats name and gesture. This can be developed and used as a basis for making dances.
- Boogie Woogie warm up (with lively music). Leader demonstrates a move which is easy to copy and then passes on to the person next to them, who then leads a different move. It's OK to pass straight on to the next person if you can't think of a move or don't want to lead.

Ideas for Movement Development

- Small elastic – in twos skip round/jump up and down/make stretchy shapes.
- Statues – tiptoe slowly and freeze on tambourine beat.

- Statue shapes – as above but suggest 'wide/low/tall/twisted'.
- Circle statues – children tiptoe slowly and silently as leader taps triangle. When triangle stops children freeze.
- Movement to percussion – strong/shaky/still/melt. Leader beats rhythm on drum 1234 (fourth beat is stronger). Clap the rhythm so they recognise strong beat. Move around the room and stop in strong shape. Split into four groups in corners of the room. Move into the centre, one group at a time, making high and low strong shapes. When all groups are in the centre freeze and, on the beat of a triangle, melt to the floor.
- Newspaper accompaniment – tear the paper and make different moves to different sounds. Contrast sharp, jerky moves with longer, smooth moves. Let the children take turns at tearing the paper.
- Scarves – freeze and move. When the music plays make the scarf dance. Freeze like a statue when the music stops. Open fingers and let scarf fall to the floor. Create group dance by encouraging all those with blue scarves to come into the centre and make their scarves 'talk' to each other. Encourage dancers to improvise their own group scarf dances.
- Musical statues – adapt the rules to allow a dance structure to occur.
- Musical statues with a partner – A makes a shape and holds it. B moves around, over, under the statue. Change roles.
- Free movement around the space then one person stops in a shape. Everyone stops in same shape until all are still. After a moment's stillness any dancer can begin to move again.
- Mirroring – working with a partner, face each other and mirror movement without touching.
- Unison move – working in small groups, all face the same direction standing fairly closetogether in a diamond shape. Person at front begins to move slowly and others follow – as dancers slowly turn there is a new leader. Can be extended to include travelling.
- Floor patterns – move and stop. Move close to another person, round them, away from them. Move in straight lines, curved lines, zig-zag lines. Develop forwards/backwards/fast/slow/curved.
- Floor patterns from art work. Discuss lines and patterns in paintings, photographs, decorative arts and sculpture. Use these as a starting point for floor patterns in dance.

Ideas for Making Dances

- Dramatic themes – use a favourite story/poem/character as a stimulus for developing dance. Avoid asking children to *be* an animal/monster/Jack Frost – encourage them to explore the movement qualities associated with the image.

- Body shapes (angular, curved, twisted) – 4 counts get into shape/4 counts hold shape/4 counts travel in shape/4 counts return to neutral. Encourage clear transitions from one section to another.
- ABC shape – working in threes, A makes a shape, B attaches to A and C attaches to AB shape. When all three are still A detaches and makes a new shape. B and C follow on as before. Develop by lengthening transitions.
- Group sculpture – one person moves into centre and holds a shape, next person moves in and attaches to first. Continue until five or six dancers have formed a group shape. Give directions such as 'move only heads', 'slowly melt into a new group shape'. Participants can experiment in small groups to find different ways of moving in and out of a group sculpture.
- Picture shapes – using paintings or photographs as a stimulus find two shapes and link them together. Work with a partner and learn each other's shapes. Move in unison ... position 1 (4 counts), position 2 (4 counts) and so on Develop by changing levels, direction, size of movement. Try incorporating mirroring/question and answer moves
- Encourage free movement in the space and then respond to the following suggestions: stop/go/floor/contact. This will encourage a more varied range of movement. Dancers can try it in their own time with their own 'inner commands'.

Dance Appreciation

If dancers are encouraged to observe and discuss dance this will help extend their movement vocabulary and help them with making their own dances. In addition to watching each other in dance sessions, try to watch live and recorded dance to develop skills of dance appreciation. The following questions will help: *What?* (Body Action) *Where?* (Space) *How?* (Dynamics) *Who?* (Relationships).

Ideas for Closures

- Shoulder rub – sit in a circle facing the back of the next person.
- Sleeping lions – an old favourite and very good for calming excited children. Just lie down as still as you can.
- Listen to music or poems and discuss ways they can be used for dance next time.
- Relaxation on the floor or sitting in chairs.
- Feedback discussion of work created and how it could be developed.
- Drawing on sheets of paper or in books – just free expression with pastels or felt tip pens.
- Farandole dance – a linked line of dancers making a snaking track across the floor. (Works equally well as an introductory activity.)

Early Years Dance Activities

Anna Daly, Ludus Dance[1]

Ludus's 'Mini Movers' sessions give parents/carers quality interactive time with their toddlers. Together they experience creative and expressive movement play, which is aimed at helping young children move with confidence, imagination and awareness.

Each session lasts approximately 45 minutes and includes the following:

- **Circle** (10 min)
 Focus the group, meet and greet, movement introduction in enclosed circle, recognise the group
- **Warm up** (5 min)
 Physical warm up, standing in circle, bigger movements
- **Space and travelling** (10 min)
 Expanding movements to cover the space, more speed and energy, running, jumping, rolling, turning. Directed travelling through the space together
- **Creative and partner work** (10 min)
 More creative movement play. Exploring the theme. Concentrating on partner work, play, trust, imagination. Less led, more improvisation work between parent and child
- **Game/song** (5 min)
 A quick, fun group game or song – can be related to theme
- **Re-focus and cool down** (5 min)
 Bring the group back together, calm the energy, recognise the group once more, 'goodbyes'

[1] Anna Daly left Ludus in 2009 founded Primed for Life in 2012 www.primedforlife.co.uk

Mini Movers Ideas

Circle

- Hello song
- Squeeze the bear – pass round circle, squeeze and say your name
- Stretching your arms up few times – then waving up to ceiling
- Crawling finger up to ceiling like spiders – turns into raindrops – hear raindrops on floor
- Raindrops again – starting high, feel raindrops on your head, shoulders, knees, to floor
- Shakes – shake hands dry – up, down, up, down, to one side, to other side, behind you
- Magic hands – stretch and close jazz hands
- Shake and freeze – shake whole body like a jelly (with sound effects) and then freeze all together. Repeat 4 times!
- Rub down – rub hands together, work way up body rubbing as warm up – feet, legs, knees, tummy, back, chest (do Tarzan noise here!), shoulders, arms, don't forget elbows, hands then cheeks, chin, nose, ears and eyebrows
- Hide behind hands and after count of three, pull scary tiger face to everyone – repeat 4 times!
- Small curled up shape – changes to grow and stretch as tall as you can. Repeat 3 times
- Crouched down and after count of three JUMP up into the air – repeat 3 times

Moving and travelling with large elastic

- Shakes and freezes with elastic
- Lift high and then low
- Bounce it with your arms
- Wrap it on your belly, knee, toes, head
- Rubber knees (plies)
- Balance with one leg in the circle, other leg
- Jumping up and down
- Stretch circle big – creep in to make circle small. Repeat
- Holding on with one hand – all go round in a circle. Repeat other way
- Lay elastic on floor – jump inside elastic and then outside – repeat
- Tread on the elastic following it all the way round in a circle
- Make the elastic very small into the middle and put away

Races

- Start at one end of the room
- 'Point to the ceiling, point to the floor, point to the windows, point to the door' – we are going to to the end of the floor

- Crawl one way
- Slide backwards one way
- Jump one way
- Roll one way

Creative section – playground theme

- Try out these movements recreating rides in a playground, SLIDE, SWING, ROUND & ROUND
- Slide – small person lying on the floor being gently pulled along the floor by their big person. Can be held by their hands or feet depending on which feels safer for them. Sliding around the floor in straight lines, wiggly lines, circles. Exploring movements and trust
- Swing – be careful of backs with this one; remind adults to bend knees and take care. 1. Adults can carry small person in cradle arms and swing from side to side. 2. Can also hold small person round middle and swing forward and back through wide legs and then from side to side
- Round & Round – 1. On the floor turning round on bottoms. 2. Standing up and turning round on spot. 3. Holding hands and turning round together. 4. Holding on with firm hand grip, big person can swing small person round & round turning on the spot. The grip can be changed to under the arms if preferred
- Once these movements have been practised separately, introduce some music and direct creative work with voice and ideas, standing back to allow interactions

Focus activity with parachute

- Spread out and keep low to the floor – sitting down around the edges the grown ups make the parachute ripple like water
- Minis walk, crawl, roll and move on top
- After a while … keep parachute very still and everyone off
- Team effort – to make parachute go up and down and little people run around underneath – keep parachute going up and down
- After count of three, make big tent – go into parachute, tuck it under and sit on it!
- When inside – wriggle fingers and toes – sing Goodbye song and wave goodbye
- Lift parachute up, over heads and into middle of floor to collect

Session Plan for Adults with High Support Needs

PLAN/SCHEME OF WORK Teacher: Esther KilBride

Session: Dance for people with high support needs	Group: Movement and Creative dance for adults with high support needs	Autumn term Thursdays 9.45–10.30
No of Sessions: 10	Length of Sessions: 45 minutes	Venue: Downstairs Dance Studio, Rubicon

Aim of Session;
To enable participants to enjoy and benefit from dance and movement

Time	Structure	Activities	Objective
09.45–09.55	Warm-up section	Massage, upper body – Shoulders – down arm, massage hand – fingers, wriggle scrunch and stretch – roll wrists. Massage, lower body Hand out foam balls rolling on calves – rolling on thighs – rolling anywhere you like	Give opportunity for structured touch, warm up muscles in upper body, esp. hands and fingers as often source of freest movement, give appropriate form of contact for lower body, encourage reciprocation, and encourage awareness between client and supporter, encourage body awareness and focus.
09.55–10.00	Upper body actions	Clapping, pushing, shaking, tapping, wriggling, grasping, waving, throwing …	Encourage following my moves and leading their own moves … Encourage working in partnership, repetition and shadowing movement, increasing energy and raising cardio, awareness of this body area.

Time	Section	Activity	Purpose
10.00–10.05	Lower body actions	Stamping, kicking, tapping, bouncing, rubbing	Encourage following my moves and leading their own moves … Encourage working in partnership and supported movement, experience of rhythm, increasing energy and co-operative movement, encourage awareness of this body area, extension of lower body, often an area of contraction and tension.
10.05–10.10	Stretching and extending	Encourage stretching and extension of any body parts	Encourage joint mobility, encourage supported movement and change of dynamics.
10.10–10.15	Making dances section	Dance 'any way you like' to a variety of music … Play particular 'favourite' tunes for individuals to dance to Prompt movement with specific stimulations, 'can everyone pick a shaking move' a noisy move, a slow move, a fast move, a stretch move, a tapping move, a side to side move, a upper body move, a lower body move. Then put together into dance … 'All do your high move, all do your low move, and freeze' Choose specific dances for every one to do together, hand jive, twist, salsa	Encourage different movement choices to reflect music. Encourage a sense of ownership, performance and appreciation. Create a way for people to dance together.
10.15–10.20	Props section	Balls, balloons, scarves, ribbons, elastic with bells on	Encourage choice, expression, awareness of and connection to others, socialisation, sense of being part of a group
10.20–10.30	Parachute section	Shaking parachute together, bouncing balls together, going underneath parachute in turns Finish with group focus.	Encourage group involvement, different sensory experiences, taking turns, energy, fun and playfulness

Celebrations and Special Occasions

Here are some cheap and simple ways of creating a special atmosphere. It may be that you want to celebrate the end of a project, a birthday, anniversary or special festival days celebrated by people of different faiths. Aim to surprise and delight – even if you just take one or two of these ideas.

Decorating the Space
Transform an ordinary room with some of the following:

- Unusual lighting – coloured lamps, fairy lights, candles in jars (you can get battery-operated tea lights which are very effective)
- Bunting flags made of crepe paper triangles stapled onto tape; make a more long-lasting version by using fabric triangles and stitching them onto the tape
- Balloons and streamers
- Parachute suspended from the ceiling
- Fresh flowers – in jugs, petals in bowls, single blooms in glasses
- Posters – perhaps a theme which can be followed through in the dancing and food (e.g. a focus on a country such as Spain/India/Africa)

Food and Drink
- Exotic-looking fruit cocktails
- Bite-sized sandwiches with unusual fillings
- Cakes with a little message hidden in the bun case
- Food which celebrates a particular culture or country

If there is time you could involve participants in making some special food and decorating the tables.

- Make a display with fruit and salad – cut into fancy shapes if participants are safe with knives
- Have some messy fun decorating buns with tubes of ready-made icing and a collection of tiny sweets and trimmings

Dance Activities

- Circle dance with all participants holding jars containing tea lights
- Improvisation with LED light sticks
- Dressing up clothes add that something extra – whatever the age group. Swirling circular skirts in bright satin fabric, feather boas, bells for wrists or ankles, silly hats, clown trousers and braces, boaters, walking sticks and bow ties

Little Gifts

Even with little or no budget you will be able to think of a way of giving everyone a small keepsake.

- Card with an individual or group photo
- Miniature box containing one or two chocolates
- Small plant or single flower
- Gift bag containing large cookie or piece of fruit with iced name on
- Poem rolled into a scroll and tied with ribbon

Celebrating Diversity and Making Sure Your Event Is Inclusive

Check the dates of your special events to avoid clashes with key festivals and other important events. Find out about any considerations relating to dress, food and drink. Make sure your venue is accessible and user friendly – the project coordinator checklist will be helpful with this.

The Shap Calendar of Religious Festivals has information about key dates for different world religions. www.shapworkingparty.org.uk/calendar.html

Recognising, Managing and Celebrating Diversity in Dance

We are all individuals viewing the world from a point of view that no-one else shares. We all have our unique abilities, needs and motivations – and we all have different identities within our social groups and within our professions/ organisations.

Stereotyping

Stereotyping is a way of defining groups according to a set of generalised behaviours. We all use stereotypes but are not always aware that we are doing so. Stereotypes are not always negative but they can be. If we make assumptions about people on the basis of their group rather than seeing them as individuals. *Think about stereotypes associated with particular groups eg young people, old people, men, women, disabled people.*

Prejudice

Prejudice usually involves making assumptions that reinforce our stereotypes. We all do this, sometimes and we look for evidence to support our biases. We can't get rid of prejudice but we can look at how our prejudices affect our behaviour, the language we use and our impact on other people.

Discrimination

We need to engage with our own stereotypes and prejudices to understand how prejudice can translate into discrimination. As dance practitioners we come into contact with performers, arts workers, other community professionals and a diverse range of participants. We are responsible for managing this diversity and celebrating the differences in our midst.

Recognising, Managing and Celebrating Diversity – How Do We Do It?

We can do a great deal to create an inclusive culture in dance sessions.

- Engendering co-operation through collaborative tasks/icebreakers
- Reducing the chance of participants feeling isolated by managing selection of groups, partners (at least in the early stages of a group)
- Being aware of the power of the 'in' group and watching out for members who may be excluded/ignored. If this happens you can easily devise activities which reduce the chance of exclusion
- Providing opportunities for the different ideas/skills of each individual to be celebrated
- Challenging language and behaviour which is not respectful of others

Choreography and Performance: No More 'Rabbits in Headlights'

Diane Amans

Reflections on the tension between dance which feels good, where the dancer really enjoys the performance – and dance which is stressful because participants worry about remembering it correctly. Is it possible to produce high-quality work which is interesting to watch and not too stressful to perform?

In Marple Movers, my regular class for adults, we often create improvised pieces, which are great fun to perform and which really look good – in the moment, during our weekly dance session. Participants are then enthused and want to share their work with an audience. This is when the doubts creep in. Will I be able to remember it? ...I can't always hear that cue in the music...What if I forget what I'm supposed to do and just freeze...? To what extent should we try and repeat what we've just done?

Once we start to discuss performing in a festival or showcase, people remember some of their fears and resist anything too 'set'. Most decide they don't want the stress and choose not to join a performance project. 'Why can't we just do what we do on a Thursday night? It looked really good last week.' They're right. It did. But I was gently structuring it as we went along. Framing it, adjusting it. If we're going to perform on a stage, for an audience who have chosen to come and see dance, there are certain expectations – certain conventions.

But maybe we should challenge these expectations? I would rather see embodied movement and confident performers – even if there is the occasional 'mistake'. This is more enjoyable to watch than a predictable technically perfect dance piece performed by worried looking dancers who are concentrating on counting the steps. I can't be alone in noticing the occasional dancers who look like a 'rabbits caught in the headlights' as they try to remember what comes next. Now I accept

that I am presenting two extremes here and I am totally committed to creating quality dance work – but perhaps definitions of quality could be explored.

Marple Movers are at their best when they are dancing 'off-piste'. Some of their most memorable performances have been when we have just more or less done one of our structured improvisations in a space where people were not expecting to encounter dance: in a supermarket, outside the pub, in a hospital ward, at lunchtime in the cricket club. The audience reactions – often demonstrating surprise and delight – generate an energy that nourishes and motivates the group. Now these dance events aren't just 'free-flow wafting'. There is a plan and I sometimes discreetly shape it from the sidelines.

I've discussed performance technique with choreographer Rosemary Lee – here's how she describes what she is looking for in her performers:

… What am I waiting to see? A glimmer of embodiment. A sense that the dancer is overtaken with the activity they are engaged with in such a way that every cell in their body seems involved. They are in synch, they are whole, they are present.

I know what she means – the challenge that interests me is how to achieve this embodied performance by confident dancers? Obviously it can be done – we see it in some inspiring dance events - but if we're going to extend these experiences to more groups whilst still creating quality dance work maybe we need to look closely at how the work is created – and <u>recreated</u> for performance.

The above reflections formed part of a presentation given at the 2014 Elixir Art of Age conference at Sadler's Wells Theatre, London.

Contact Details

People Dancing – the foundation for community dance
The UK development organisation and membership body for those involved in creating opportunities for people to experience and participate in dance. Membership reaches more than 4,500 dance professionals worldwide.
www.communitydance.org.uk

Arts Councils
Arts Council England
The Arts Council is an independent, non-political body responsible for developing sustaining and promoting the arts in England.
www.artscouncil.org.uk

Arts Council of Northern Ireland
Statutory body which are responsible for developing, sustaining and promoting the arts in Northern Ireland
www.artscouncil-ni.org

Arts Council of Wales
Organisation that is responsible for developing, sustaining and promoting the arts in Wales
www.artswales.org.uk

Scottish Arts Council
The national funding and development organisation for the arts in Scotland
www.creativescotland.com

National Dance Organisations
One Dance UK, formed in April 2016, brought together four dance organisations: Association of Dance of the African Diaspora (ADAD), Dance UK, National Dance Teachers Association (NDTA), and Youth Dance England
www.onedanceuk.org

Association for Dance Movement Therapy
The professional association for dance movement therapy in the UK
www.admt.org.uk

British Dance Council
A Co-ordinating organisation to enable ballroom teachers to work together
www.bdconline.org

British Ballet Organisation
Dance examining society offering teacher training and examinations in classical ballet, tap, modern and jazz
www.bbo.dance

Council for Dance Education and Training
Promotes excellence in dance education and training, accredits courses at vocational dance schools, and offers a comprehensive information service
www.cdet.org.uk

Dance United
Aims to bring individuals and communities together to seek creative solutions to artistic challenges, triggering a process that develops social interaction and personal growth in participants. The company believes that dance has a unique quality that can, when delivered through a tried-and-tested methodology, create profound and life-changing experiences for those it works with
www.dance-united.com

Dance Umbrella
Promotes and celebrates contemporary dance
www.danceumbrella.co.uk

Dancers' Career Development
Vocational training and re-training for professional dancers resident in the UK
www.thedcd.org.uk

English Folk Dance and Song Society
The organisation that encourages, documents and develops folk music, dance and song traditions within England
www.efdss.org

Laban Guild
A charitable organisation founded by Rudolf Laban in 1946 to promote and advance the study of Laban-based movement and dance
www.labanguild.org

Language of Dance Centre
Innovative approach to choreography, educational dance and movement analysis. Provides a framework for exploring and experiencing dance
www.lodc.org

Royal Academy of Dance (RAD)
Promotes knowledge, understanding and practice of dance internationally
www.rad.org.uk

South Asian Dance Alliance (SADA)
An alliance of three organisations, Akademi, Kadam and Sampad. These organisations are committed to promoting South Asian dance, music and related initiatives in the UK
www.southasiandance.org.uk

The Royal Scottish Country Dance Society
Society for the protection and promotion of Scottish Country Dancing
www.rscds.org

The Society for International Folk Dancing
A UK based voluntary, non-for profit association of people who enjoy learning and dancing folk dances from many countries
www.sifd.org

YDance
The National Youth Dance Agency for Scotland
www.ydance.org

Dance Agencies and Arts Organisations
DanceEast (National Dance Agency)
www.danceeast.co.uk

The Garage
www.thegarage.org.uk

The Junction, Cambridge
www.junction.co.uk/

East Midlands
Arts NK
www.artsnk.org

Dance 4 (National Dance Agency)
www.dance4.co.uk

Deda
www.deda.uk.com
London

Akademi
www.akademi.co.uk

Chisenhale Dance Space
www.chisenhaledancespace.co.uk

East London Dance
www.eastlondondance.org

Greenwich Dance
www.greenwichdance.org.uk

IRIE! dance theatre
www.iriedancetheatre.org

Sadler's Wells
www.sadlerswells.com

The Place (National Dance Agency)
www.theplace.org.uk

North East
Dance City (National Dance Agency)
www.dancecity.co.uk

Tin Arts
www.tinarts.co.uk
North West

Cheshire Dance
www.cheshiredance.org

Dance Manchester
www.dancemanchester.org.uk

Ludus Dance
www.ludusdance.org

MDI
www.mdi.org.uk
South East

Dance Up
www.hampshiredance.org.uk

Oxford Dance Forum
www.oxforddanceforum.com/

South East Dance (National Dance Agency)
www.southeastdance.org.uk

The Point
www.thepointeastleigh.co.uk/

Woking Dance Festival
www.dancewoking.com

South West
Activate Performing Arts
www.activateperformingarts.org.uk

Bristol Community Dance Centre
www.bristolcommunitydancecentre.co.uk

Dance in Devon
www.danceindevon.org.uk

GDance
www.gdance.co.uk

Pavilion Dance South West (National Dance Agency)
www.pdsw.org.uk

Swindon Dance
www.swindondance.org.uk

Take Art, Somerset
www.takeart.org/danc

West Midlands
Birmingham Royal Ballet
www.brb.org.uk

Dancefest
www.dancefest.co.uk

danceXchange (National Dance Agency)
www.dancexchange.org.uk

Sampad
www.sampad.org.uk

Yorkshire
DAZL - Dance Action Zone Leeds
www.dazl.org.uk

Kala Sangam
www.kalasangam.org

Yorkshire Dance (National Dance Agency)
www.yorkshiredance.com

Northern Ballet
www.northernballet.com/

Northern Ireland
Dance Resource Base
www.danceresourcebase.org

Dance United Northern Ireland
www.danceunitedni.com

Scotland
City Moves Dance Space
www.aberdeencity.gov.uk/arts/nc_citymoves/art_citymoves_dance_space.asp

Dance Base (National Dance Agency)
www.dancebase.co.uk

Dance House
www.dancehouse.org

Shetland Arts
www.shetlandarts.org

SkyeDance
www.skyedance.co.uk

Wales
ACGC Dance (Arts Care Gofal Celf)
www.acgc.co.uk

Dawns i Bawb
www.dawnsibawb.org

Dawns Powys Dance
www.dawnspowysdance.org

Rubicon Dance
www.rubicondance.co.uk

TAN Dance
www.tandance.org/

Valley and Vale
www.valleyandvalecommunityarts.co.uk

National Dance Company Wales
www.ndcwales.co.uk/en

International
Ausdance
The Australian Dance Council – Ausdance, is Australia's professional dance advocacy organisation for dancers, choreographers, directors and educators
www.ausdance.org.au

British Council
The UK's international organisation for educational opportunities and cultural relations
www.britishcouncil.org

ConecteDance
Website about contemporary dance in Brazil
www.conectedance.com.br

Crear Vale la Pena
Argentinian community arts organisation
www.crearvalelapena.org.ar

Culture Action Europe (formerly European Forum for the Arts and Heritage)
A European level advocacy organisation representing the interests of thousands of
artists and cultural organisations
www.cultureactioneurope.org

Dance Ireland
Ireland's primary resource organisation for the professional dance community
www.danceireland.ie

Danseværket
Danish dance organisation
www.theplatform.dk

DANZ, Dance Aotearoa New Zealand
The national organisation for New Zealand Dance
www.danz.org.nz

Dance Info Finland
National information centre for dance
 www.danceinfo.fi/?locale=en_US

Yhteisö tanssii ry
This association operates as a national platform for practitioners in community
dance in Finland http://www.yhteisotanssi.fi/

idanca.net
Website for Brazilian dance professionals
www.idanca.net

International Association for Creative Dance (IACD)
Promotes the development of creative dance founded upon the free approach to
the art of body movement pioneered by Barbara Mettler.
www.dancecreative.org

International Somatic Movement Education and Therapy Association (ISMETA)
Promotes a high level of standards and professionalism in the field of somatic movement education and therapy through advocacy and maintaining a registry of professional practitioners.
www.ismeta.org

Japan Contemporary Dance Network
www.jcdn.org

KunstFactor
Kunstfactor is the national organisation for the development and promotion of the voluntary arts in the Netherlands
www.lkca.nl

Visiting Arts
Aims to strengthen intercultural understanding through the arts, linking England, Scotland, Wales and Northern Ireland with prioritised countries around the world
www.visitingarts.org.uk

Other Useful Contacts
Dance Books
The international centre for books, CD's, DVD's and videos and sheet music on all forms of dance
www.dancebooks.co.uk

Mike Ruff Music
Barn Dances, Ceilidhs, training courses and a shop selling books and music for Maypole and Folk Dancing.
www.mikeruffmusic.co.uk

JABADAO
Developmental Movement Play Specialists offering 'full-bodied whole-hearted events and training'. They also sell resources to support physical play for all ages
www.jabadao.org

Green Candle Dance Company
Dance workshops, projects, training and materials
www.greencandle.org

Walk of Life, established by Helen Poynor on the Jurassic Coast in West Dorset/ East Devon in 1991, includes a public workshop programme and practitioner training.

Participants include experienced movers, emerging practitioners and interested newcomers.

www.walkoflife.co.uk

Glossary

Arts Council England

Arts Council England is the national development agency for the arts in England. It distributes public money from the Government and the National Lottery.

Arts Council of Northern Ireland

Arts Council of Northern Ireland is the lead development agency for the arts in Northern Ireland.

Arts Council of Wales

Arts Council of Wales is responsible for funding and developing the arts in Wales.

CPD

Continuing professional development or ongoing professional learning.

CRB Disclosure Check

This service was run by the Home Office Criminal Records Bureau and is now the Disclosure and Barring Service (DBS). It helps organisations make more thorough checks on people who are going to have contact with children, young people and vulnerable adults.

Creative Partnerships

The UK government's flagship creative learning programme, between 2002 and 2011. It was established to develop young people's creativity through artists' engagement with schools.

Dance and Health

Dance companies and organisations work in partnership with other agencies to promote active lifestyles and tackle health issues through dance.

Dance Animateur

A less-used term for community dance artist/practitioner. Was more commonly used in the early days of community dance provision.

Data Protection

The Data Protection Act 1998 regulates how personal information is used and protects individuals from misuse of personal information.

DCMS

Department for Culture, Media and Sport, responsible for government policy on the arts and creative industries.

Developmental Movement Play

DMP is a framework for supporting the kind of movement that supports children's physical *and* neurological development. It focuses on:

- the *free-flow, spontaneous movement play* that children so readily engage in, in and out of everything they do
- some *specific movement activities* within this free-flow movement play that play a particular part in the development of the body, brain and nervous system

DfES

Department for Education and Skills: a government department with the aims of 'creating opportunity, releasing potential and achieving excellence'. In June 2007, DfES was replaced by the Department for Children, Schools and Families (DCSF).

Duty of Care

The duty which rests on an organisation or individual to make sure that all reasonable steps are taken to ensure the safety of any person involved in any activity for which that organisation or individual is responsible.

Foundation for Community Dance

UK development agency for community and participatory dance. In 2014 it changed its name to People Dancing.

Key Stages (KS1, KS2, KS3, KS4)

The National Curriculum in England operates at four key stages. Key Stages 1 and 2 relate to primary education (7–11 years) and Key Stages 3 and 4 relate to secondary education (11- to 16-year-olds).

Music Copyright

All recorded music is covered by copyright – see Resources section for further information.

National Development Agency

Government-sponsored public body.

Ofsted

Office for Standards in Education – a non-ministerial government agency which inspects and regulates education and childcare provision.

Person Centred

Practice which emphasises the value of the individual.

POVA

Protection of vulnerable adults.

PPL

Phonographic Performance Limited, deals with licence applications for the public use of sound recordings in dance classes.

Process Oriented

Refers to practice where the emphasis is on *experiencing* the dance. It is associated with a person-centred approach to facilitation.

Public Liability Insurance

This is insurance cover in case a member of the public makes a claim against you for injury or death to a third party or damage to the property of a third party.

Quality Assurance (QA)

This incorporates quality management and quality control. QA is aimed at achieving consistent quality standards and is measured using agreed, quantifiable quality criteria.

Reflective Practitioner

Someone who uses their knowledge and experience, together with a theoretical framework, in order to evaluate their practice and adopt a creative approach to problem solving.

Reflexive Practitioner

Someone who engages in an ongoing process of internal reflection. Reflexive practitioners combine the elements of reflective practice, outlined above, with the ability to notice their own feelings and thoughts whilst facilitating dance experiences for other people. They combine sensitivity to the needs of the participants, awareness of their own needs and the ability to respond in the moment.

Risk Assessment

The systematic examination of all aspects of practice to identify any hazards which have the potential to cause harm.

Safeguarding

The practice of keeping children, young people and vulnerable adults safe from abuse and neglect

Scottish Arts Council

Scottish Arts Council is the lead body for the funding, development and advocacy of the arts in Scotland.

Service Provider

An organisation providing a service such as health, social care, housing.

References

ACW & WG (2014) *Creative Learning Through the Arts: An Action Plan for Wales 2015–2020*. Welsh Government & Arts Council.

Adair, J. (1998) *Effective Leadership*. London: Pan Macmillan.

Adshead, J. (1988) *Dance Analysis: Theory and Practice*. London: Dance Books.

Albright, A. C. and D. Gere (2003) *A Dance Improvisation Reader*. Middletown, CT: Wesleyan University Press.

Amans, D. (1997) A Study of Process-Oriented Community Dance. *Unpublished MA Dissertation*. University of Surrey, Guildford.

Amans, D. (2003) *Salford Project Evaluation* (Unpublished), Freedom in Dance.

Amans, D. (2006) *Survey of Community Dance Practitioners and Dance Agency Directors* (Unpublished research).

Amans, D. (2014) *Meaningful Measurement Survey of Community Dance Artists* (Unpublished research).

Amans, D. (2016) *Interview with Norikazu Sato and Sonoko Chishiro* (Unpublished).

Ames, M. (2006) The shadow of a language. *Animated*, Summer, 16–20.

Anderson, B. (1991) *Imagined Communities: Reflections on the Origin and Spread of Nationalism*. Helsinki: Verso (first published 1983).

Andrews, K. (2014) *Culture and Poverty: Harnessing the Power of the Arts, Culture and Heritage to Promote Social Justice in Wales*. Cardiff: Welsh Government.

Annable-Coop, C. (2016) *A Powerful Catalyst in Animated*. People Dancing Foundation for Community Dance.

Archer, J. (2007) Dance Ccity: Embracing diversity. *Animated*, Spring, 34.

Arts Council England (2004) *Self Evaluation Information Sheet*. London: Arts Council England.

Arts Council England (2006) *Dance and Health: The Benefits for People of All Ages*. London: Arts Council England.

Arts Council England (2006) *Dance Included: Towards Good Practice in Dance and Social Inclusion*. London: Arts Council England.

Arts Council of Wales (1996) *Taking Part*. Cardiff: Arts Council of Wales.

Arts Council of Wales (2007) *Draft Art Forms Strategy* (Unpublished). Cardiff: Arts Council of Wales.

ArtsEqual (2016) "ArtsEqual Research Initiative." Available at: http://www.artsequal.fi/en. (Accessed 31.05.2016).

Audit Commission (1998) *A Fruitful Partnership: Effective Partnership Working*. London: Audit Commission.

Barba, E. and N. Savarese (1991) *A Dictionary of Theatre Anthropology, The Secret Art of the Performer*. London: Routledge.

Benjamin, A. (2002) *Making an Entrance*. London: Routledge.

Bishop, Claire (2012) *Artificial Hells: Participatory Art and the Politics of Spectatorship*. London: Verso.

Blanche, R. (2014) *Artworks: Insights for Employers, Commissioners and Funders in Facilitating Quality Impacts Through Participatory Arts*. London: Artworks, Paul Hamlyn Foundation.

Brinson, P. (1991) *Dance as Education: Towards a National Dance Culture*. Basingstoke: The Falmer Press.

British Museum (2015) Defining Beauty: The Body in Ancient Greek Art. Available at: http://www.britishmuseum.org. (Accessed18.02.2015).

Burns, S. (2007) *Mapping Dance. Entrepreneurship and Professional Dance Practice in Dance Higher Education*. Lancaster: Palatine.

Burns, S. and S. Harrison (2009) *Dance Mapping, A Window on Dance 2004–2008, Executive Summary*. London: Arts Council England.

Butterworth, J. and L. Wildschut (2009) *Contemporary Choreography: A Critical Reader*. London: Routledge.

Cavarero, A. (1997) Birth, love and politics. *Radical Philosophy*, **86**, 19–23.

Christie, S. (2005) Sylvia Christie in interview with Diane Amans.

Clinton, L. and A. Glen (1993) Community arts. In *Community and Public Policy* (ed. H. Butler), Chapter 6. London: Pluto Press, pp. 92–105.

Collingwood, R. G. (1938) *The Principles of Art*. Oxford: Clarendon Press.

Department for Education and Science (2002) *In Learning Through PE and Sport: A Guide to the Physical Education, School Sport and Club Link Strategy*. London: Department for Education and Science.

Department for Education and Science (2005) *Dance Links: A Guide to Delivering High Quality Dance for Children and Young People*. London: Department for Education and Science.

Department of Health (2001) *National Service Framework for Older People*. London: Department of Health.

Featherstone, M. (1995) *Undoing Culture: Globalization, Postmodernism and Identity*. London: Sage.

FID (2003) *Freedom in Dance: Tameside Healthy Communities Collaborative, Project Evaluation* (Unpublished).

FID (2006) *Evaluation report on 'Big Dance' Intergenerational Project* (Unpublished), Freedom in Dance.

Finnan, K. (2003) Holding the balance. *Animated*, Summer.

Foster, Raisa (2012) The Pedagogy of Recognition. Dancing Identity and Mutuality. *Doctoral Dissertation*. Acta Electronica Universitatis Tamperensis 1253, Tampere University Press, Tampere. Available at: http://urn.fi/urn:isbn:978-951-44-8958-7. (Accessed 16.05.2016).

Foster, Raisa (2015) *Tanssi-innostaminen. Kohti yksilön ja yhteisön hyvinvointia*. Helsinki: BOD – Books on Demand.

Foster, S. (1986) *Reading Dances*. Berkeley: University of California Press.Foundation for Community Dance (1996) *Thinking Aloud: In Search of a Framework for Community Dance*. Leicester: Foundation for Community Dance.

Foundation for Community Dance (2001) *Dancing Nation*. Handbook accompanying film commissioned by Foundation for Community Dance, Leicester.

Genné (2016) Maria Dubois Genné in interview with Diane Amans.

Greenland, P. (ed.) (2000) *What Dancers Do That Other Health Workers Don't*. Leeds: JABADAO.

Greenland, P. (2005) We can do hard things. *Animated*, Spring, 30.

Greenwood, C. (2007) Come and join the dance: Young people, dance and diversity, *Animated*, Spring 2007, 23.

Halprin, A. (1979) *Movement Ritual*. Kentfield, CA: Tamalpa Institute/Dancers Workshop.

Halprin, A. (1995) *Moving Toward Life*. Hanover and London: Wesleyan University Press.

Halprin, A. (2000) *Dance as a Healing Art*. Mendocino, CA: Life Rhythm.

Halprin, L. (1969) *The RSVP Cycles, Creative Processes in the Human Environment*. New York: George Braziller.

Heimonen, Kirsi (2005) "Tanssi etsii paikkaansa yhteisössä." In Ventola Marjo-Riitta and Renlund Micke. *Draamaa ja teatteria yhteisöissä*. Helsinki: Helsingin ammattikorkeakoulu Stadian julkaisuja, sarja B, oppimateriaalit 5, 100–105.

Heimonen, Kirsi (2009) *Sukellus liikkeeseen – liikeimprovisaatio tanssimisen ja kirjoittamisen lähteenä*. Doctoral Thesis. Acta Scenica 24. Performing Arts Research Centre, Theatre Academy Helsinki, Helsinki.

Heinsius, Joost and Lehikoinen, Kai (eds.) (2013) *Training Artists for Innovation: Competencies for New Contexts*. Kokos Publications Series. Helsinki: Theatre Academy of the University of the Arts Helsinki.

Ings, R. (1994) No time to dance. *Animated*, Winter, 2–3.

JABADAO (1995) National Development Agency for Specialist Movement Work, Autumn (brochure), p. 1.

Jameson, F. (1991) *Postmodernism, or The Logic of Late Capitalism*. London: Verso.

Jasper, L. (1995) Tensions in the definition of community dance. In *Border Tensions: Dance and Discourse. Proceedings from the Fifth Study of Dance Conference*, University of Surrey, Guildford, p. 189.

Jasper, L. (1997) *Moving Definitions of Community Dance*. Research Paper, Department of Dance Studies, University of Surrey.

Jasper, L. and J. Siddall (2010) *Managing Dance: Current Issues and Future Strategies*, 2nd edn. Horndon: Northcote House.

Johnson, D. and F. Johnson (1991) *Joining Together: Group Theory and Group Skills*. London: Prentice Hall International, p. 69.

Kelly, O. (1984) *Community Art and the State: Storming the Citadels*, London: Commedia, p. 5.

Kirschenbaum, H. and V. L. Henderson (eds.) (1990) *The Carl Rogers Reader*. London: Constable.

Lee, R. (2004) The possibilities are endless. *Animated*, Spring, 12–13.

Lehikoinen, Kai et al. (eds.) (2016) *Taiteilija kehittäjäksi: taiteelliset interventiot työssä*. Helsinki: Theatre Academy, University of the Arts Helsinki.

Macfarlane, C. (2007) An evolving dance dialogue. *Animated*, Spring, 18.

Mackenzie-Blackman, J. (2014) Lord of the flies. *Animated*, Summer 2014, 19–20.

Marks, V. (1998) Community Dance? Connecting the Evolution of Theory and Practice. In *Community Dance: Current Issues in the Field, Seminar Papers*, University of Surrey, Guildford, pp. 3–19.

Maslow, A. H. (1970) *Motivation and Personality*. London: Harper & Row.

Matarasso, F. (1994) *Regular Marvels*. Community Dance and Mime Foundation.

Matarasso, F. (1996) *Defining Values: Evaluating Arts Programmes*. Gloucester: Comedia, p. 3.

Matarasso, F. (1998) Use or Ornament? The Social Impact of Participation in the Arts. In *Paper to Creative Communities Conference*, London.

Matarasso, F. (2005) Slow dancer: Moving in the material world. *Animated*, Autumn, 20–4.

McConnell, F. (2006) A generation game. *Animated*, Summer, 13–15.

McCretton, N. (2006) Playing along with the audience. *Animated*, Winter, 12–14.

Nancy, J. (1993) *The Birth to Presence* (transl. Brian Holmer). Stanford: Stanford University Press.

National Assembly for Wales (2005) *Dance in Wales: A Review*. Cardiff: National Assembly for Wales.

Olsen, A. (2002) *Body and Earth, an Experiential Guide*. Hanover & London: University Press of New England.

Pallaro, P. (ed.) (1999) *Authentic Movement: Essays by Mary Starks Whitehouse, Janet Adler and Joan Chodorow*. London: Jessica Kingsley.

Peppiatt, A. and K. Venner (1993) *Community Dance: A Progress Report*. London: ACGB.

Peppiatt, A. (1997) *Community Dance – Education Plus?* Research Paper, Department of Dance Studies, University of Surrey.

Powys Dance (1999) *Background Information for Tutors* (Unpublished), Powys Dance.

Poynor, H. and J. Simmonds (eds.) (1997) *Dancers and Communities*. Sydney: Ausdance.

Preston-Dunlop, V. and A. Sanchez-Colberg (2010) *Dance and the Performative: A Choreological Perspective: Laban and Beyond*. London: Dance Books.

Quin, E., Rafferty, S. and C. Tomlinson (2015) *Safe Dance Practice*. Champaign, IL: Human Kinetics.

Risbridger, P. (2005) Peer pleasure. *Animated*, Summer, 15–17.

Ross, J. (2006) *Anna Halprin: Experience as Dance*. Berkeley, CA: University of California Press.

Rubidge, S. (1984) Community dance – A growth industry. *Dance Theatre Journal*, **2**(4).

Schechner, R. (2002) *Performance Studies an Introduction*. London: Routledge.

Scholey, L. (1998) New definitions. *Animated*, Summer, 30–1.

Sherwin, J. (2009) Social role valorisation theory as a resource to 'person centred planning'. *The SRV Journal*, **4**(2), 6–9.

Siddall, J. (1997) *Community Dance – Education Plus?* Research Paper, Department of Dance Studies, University of Surrey.

Silvestrini, L. (2014) Panel Discussion 'But Is it Art? In *The Artist and Participatory Practice' At the People Dancing Conference in Cardiff*, November, 2014. Available at: http://www.communitydance.org.

Skates, K. (2015) Arts Council of Wales Remit Letter 2015–2016. Available at: http://www.arts.wales/33225.file.dld. (Accessed 18.02.2016).

Spafford, J. (2005) Why Dance …? *Animated*, Spring, 12.

Silvestrini, L. (2006) Alfresco – Intergenerational performance. *Animated*, Winter, 20.

Tannenbaum, R. and W. H. Schmidt (1973) How to Choose a Leadership Pattern. *Harvard Business Review*, May–June, p. 163.

Tanssin aluekeskusverkosto. (2014) "Tanssin aluekeskusverkoston jukilausuma." Available at: http://www.l-tanssi.fi/index.php/49-uutiset/235-tanssin-aluekeskusverkoston-julkilausuma. (Accessed 31.05.2016).

Taylor, C. (1992) *The Ethics of Authenticity*. Cambridge, MA: Harvard University Press.

Thomson, C. (1988) Community Dance: What Community … What Dance? In *Fourth International Conference of Dance and the Child International: An International Perspective*, Vol. iii. London: Dance, Culture and Community.

Thomson, C. (1994) Dance and the concept of community. *Focus on Community Dance, Dance and the Child International Journal*, **3**, 20.

Thomson, C. (2006) We are a dancing nation. *Animated*, Spring, 5–8.

Tomkins, A. (2006) To keep or not to keep the word community in community dance. *Animated*, Summer, 31.

Tönnies, F. (1887) *Community and Society* (transl. and ed. C. P. Loomis). New York: Harper & Row (1963 edition).

Törmi, Kirsi (2016) Koreografinen prosessi vuorovaikutuksena. Acta Scenica 46. Helsinki: Performing Arts Research Centre, Theatre Academy of the University of the Arts Helsinki.

Trueman, R. (1998) Was I Alright? An Examination of the Effect of Performance on Self-Esteem in Community Dance. In *Community Dance: Current Issues in the Field, Seminar Papers*. Guildford: University of Surrey, pp. 65–73.

Turner, P. (2016) Paula Turner in interview with Diane Amans.

Wang, Q. (2015) *Guangchang wu: An Ethnographic Study of Dance in Public Spaces Chinese University of Hong Kong*. Thesis, M. Phil in Anthropology.

White, M. (2005) Well being or well meaning? *Animated*, Spring, 10–11.

Willis, P. (1996) *Common Culture*. Milton Keynes: Open University Press

Williams, D. and M. Kemple (2011) *Delivering Male: Effective Practice in Male Mental Health*. National Mental Health Development Unit.

Wilson, H. (2000) Community Dance in Performance. *Unpublished MA Dissertation*, University of Surrey, Guildford.

Woolf, F. (1999) *Partnerships in Learning*. London: Arts Council England.

Woolf, F. (2004) *Partnerships for Learning*. Arts Council England, *Self Evaluation and Grants for the Arts* Information Sheet (2016), Arts Council England.

Woolf, J. (1993) *The Social Production of Art*. 2nd edn. London: MacMillan.

Worth, L. and H. Poynor (2005) *Anna Halprin*. London: Routledge.

Yhteisö Tanssii ry (2016a) "Historiaa." Available at: http://www.yhteisotanssi.fi/historiaa/. (Accessed 15.04.2016).

Yhteisö Tanssii ry (2016b) "Yhteisö Tanssii ry – yhteisöllisyyden ytimessä." Available at: http://www.yhteisotanssi.fi/2016/04/03/yhteiso-tanssii-ry-yhteisollisyyden-ytimessa/. (Accessed 31.05.2016).

Ysgol Cedewain (2016) *Dance Story Around the World, Audience Feedback* (Unpublished).

Index